PAINTING
Butterflies & Blooms

with Sherry C. Nelson

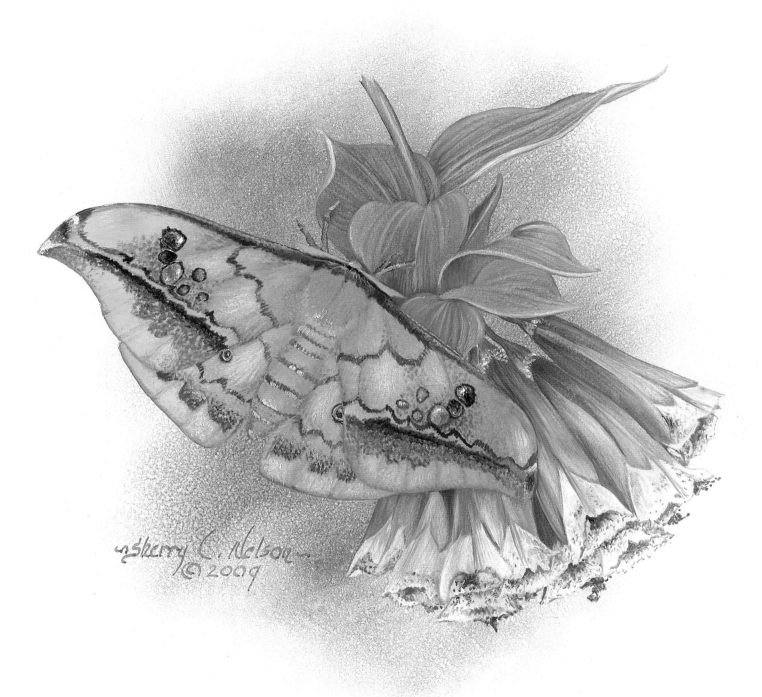

PAINTING
Butterflies
& Blooms

with Sherry C. Nelson

NORTH LIGHT BOOKS
CINCINNATI, OHIO
www.artistsnetwork.com

Published by North Light Books, an imprint of F+W Media, Inc., 4700 East Galbraith Road, Cincinnati, Ohio, 45236. (800) 289-0963. First edition.

Other fine North Light Books are available from your local bookstore, art supply store, online supplier or visit our website at www.fwmedia.com.

14 13 12 11 10 5 4 3 2 1

DISTRIBUTED IN CANADA BY FRASER DIRECT
100 Armstrong Avenue
Georgetown, ON, Canada L7G 5S4
Tel: (905) 877-4411

DISTRIBUTED IN THE U.K. AND EUROPE BY DAVID & CHARLES
Brunel House, Newton Abbot, Devon, TQ12 4PU, England
Tel: (+44) 1626 323200, Fax: (+44) 1626 323319
Email: postmaster@davidandcharles.co.uk

DISTRIBUTED IN AUSTRALIA BY CAPRICORN LINK
P.O. Box 704, S. Windsor NSW, 2756 Australia
Tel: (02) 4577-3555

Library of Congress Cataloging-in-Publication Data

Nelson, Sherry C.
 Painting butterflies & blooms with Sherry C. Nelson / Sherry C. Nelson. -- 1st ed.
 p. cm.
 Includes index.
 ISBN 978-1-60061-332-6 (pbk. : alk. paper)
 1. Butterflies in art. 2. Moths in art. 3. Flowers in art. 4. Painting--Technique.
I. Title. II. Title: Painting butterflies and blooms with Sherry C. Nelson.
 ND1380.N446 2010
 751.45'43--dc22 2009036079

Edited by Kathy Kipp
Cover designed by Clare Finney
Layout by Doug Mayfield
Production coordinated by Mark Griffin

Photograph on page 8 used by permission of John Cody.
Photographs on pages 112, 122 and 151 used by permission of Kirby Wolfe.
Photograph on page 145 used by permission of Genevieve Allen.
Photographs on pages 28 and 32 used by permission of P.J. Dalton.

All step-by-step and other reference photography by Deborah Ann Galloway.

METRIC CONVERSION CHART

To convert	to	multiply by
Inches	Centimeters	2.54
Centimeters	Inches	0.4
Feet	Centimeters	30.5
Centimeters	Feet	0.03
Yards	Meters	0.9
Meters	Yards	1.1

DEDICATION

This book is dedicated to my friend, my business partner and my cohort in butterfly and moth photography, Deborah Ann Galloway. Deb and I began working on the references necessary for this book several years ago. It's Deby who shot all the step-by-step photos for this book, provided most of the beautiful shots used as reference for the designs, took a botany class to learn more about plant identification, and helped me in countless ways through the many steps and hundreds of hours of work that goes into a book such as this. Without her, this book would not be in your hands. And without her help, I could not do what I do. Thanks, Deb, one more time!

And thanks to all of you who have bought this book, for the love of butterflies (and moths!). May the book encourage your creativity and inspire your brush. Your desire to paint realistic butterflies and blooms has been our inspiration.

ACKNOWLEDGMENTS

Many thanks to my dear friend and teacher, John Cody. John's beautiful book, *Wings of Paradise*, was the contributing factor in my fascination for the beautiful *Saturniidae*. Classes with John and my friendship with this renowned artist, whose watercolor paintings of silkmoths have hung in galleries and museums worldwide, has been a highlight in my life.

Kirby Wolfe, *Copaxa* expert and professional moth man, your friendship and support is priceless. Thank you for generous permission to paint from your incomparable photography, for sharing your knowledge unstintingly, and for pointing us amateur moth-ers in the "light" direction. We cherish memorable nights on a mercury-vapor-lit mountaintop in Costa Rica and in Cave Creek Canyon in the company of moths and good friends.

Thank you, Dr. Marilyn Loveless, professor of Biology at Wooster College, Ohio. Your help with identification of all things green and growing is so much appreciated. We might someday get better at it with your help.

Many thanks to Kim Garwood, co-author of the only series of photographic checklists of living butterflies of the Neotropics, who has been a steady support and resource for me. For North America, use the *Kaufman Guide*. For the tropics, all you need is Kim.

Several of the designs in this book have been inspired by the gracious contributions of friends who have shared their lovely photography with me: Marilyn Kerr, Genevieve Allen and P.J. Dalton all helped make this book special.

And thanks to Laura Nordin, who raises butterflies, is a knowledgeable resource on caterpillar host plants and keeps me excited about the leps on a day-to-day basis.

Jan and Pete Peterson, many thanks for allowing two tired photographers on a butterfly mission to share your home.

And at North Light Books: Thanks without measure to Kathy Kipp, dear friend and ace editor, who makes it all happen. Kathy is incredibly skilled at bringing out the best in her authors, and I cannot thank her enough for her help, her talent, her limitless patience and most of all, her friendship through the eclosion of another book. Thanks also to other members of my editorial team, who each bring their own special skills to bear in making yet another lovely book come to life: Clare Finney and Doug Mayfield, who designed the beautiful cover and interior, Adam Hand, who so ably assisted us with the technicalities of digital photography, and Mark Griffin, production coordinator who shepherded this book through the printing process.

ABOUT THE AUTHOR

Sherry C. Nelson's career in painting has stretched across nearly 39 years, and has been shaped by her love of the natural world and its creatures. First and foremost she is a teacher, and has shared her wildlife painting techniques with thousands of students in every single state and in many countries around the world.

If painting and teaching are her career and first love, then field study and identification are Sherry's obsession. Travel teaching has provided an unparalleled opportunity to see the moths and butterflies of the world along with her students. Sherry is an accomplished and knowledgeable naturalist and shares her love of the world's creatures, as well as painting, with her students. She claims that field study is so addictive that it's often tempting to forsake paintbrush for binoculars. And it's the field work that brings realism to the butterflies and flowers she paints, endowing each species with the special characteristics that make it look real.

Sherry has developed a unique approach to teaching, breaking down the instructions into a step-by-step sequence that allows almost anyone to learn quickly and easily master the techniques needed to produce beautiful and realistic wild subjects.

Sherry was born in Alton, Illinois, and received a B.A. from Southern Illinois University. The lure of the mountains of the Southwest prompted a move to New Mexico, where her children Neil and Berit were raised. She now lives and paints on her 37 acres of spectacular wilderness in the Chiricahua Mountains of southeast Arizona. Nine species of hummingbirds and the occasional black bear frequent the feeders, and the coatis and gray foxes come by frequently for hand-outs.

Sherry's field seminars offer students the chance to find an unspoiled serenity and a reprieve from workaday hassles, while learning to paint and identify the creatures which surround them.

Now, from her studio in wooded Cave Creek Canyon, Sherry invites you to join her in painting some of your favorite butterflies and flowers.

Table of Contents

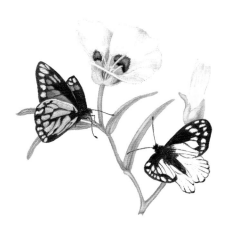

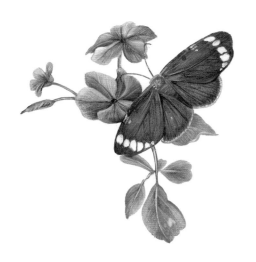

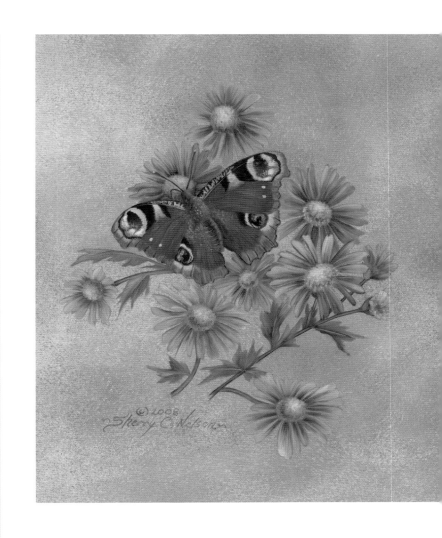

4 Complete Painting Projects

Foreword

Oculea Moth
Private collection. Used by permission of John Cody.

Sherry Nelson is a great teacher. I have participated in several of her workshops in Arizona and enjoyed and learned every minute of them. She is also a very fine artist. Of her many paintings I have studied and admired there is not one that was not gracefully composed, subtly and harmoniously colored, and with a range of convincing botanical, avian and entomological textures. In other words, you could practically feel the dew on her flowers and fly with those feathers. People who have studied with this charming and inspiring artist are most fortunate. I have myself seen how much and how quickly they grow in their own art under her tutelage, and how much fun they have in the process. Studying this book is the next best thing to learning from Sherry Nelson in person.

The background plants and other real-life material for my painting of the Oculea Moth (*Antheraea polyphemus oculea*) were gathered while I was with Sherry and Deborah Galloway in Arizona.

I do not have Sherry's skill with oils and acrylics and have generally confined myself to transparent watercolor (which, I have to say, has a charm of its own.) Though it is probably immodest of me to proclaim it, as far as I know, I am the only artist ever to have fully exploited the beauty of the *Saturniid* moths and consistently established them as his dominant theme. One of the former editors of the magazine *Audubon* once told me, "John, you are the Audubon of moths." Dazzling compliment, certainly, but I am still waiting for the day when somebody will say of that fine 19th Century bird painter, "Oh, Audubon. Isn't he considered the Cody of birds?"

Enough bragging. I only did it to establish my bona fides as something of an authority on Sherry Nelson's stature as an artist, naturalist, and teacher. I have learned much from her, and with this book, if you are attentive, so will you.

—John Cody, September 2009

Welcome to the World of Butterflies

Butterflies and moths belong to the order of *Lepidoptera*, derived from the Greek word *lepidos* for "scales" and *ptera* for "wings." Thus it is the scaled wings of all butterflies and moths that make them what they are, and separate them from all other insects. It's much like birds, whose feathers are the characteristic that sets them apart from all other animals on earth.

Butterfly scales are more uniform than are moth scales, which have evolved in a hairlike fashion that give many of them, especially the Silkmoths, a wonderful furry look.

The sheer diversity and variety of butterflies and moths is endless. In North America alone there are those whose wingspan may range from the length of your hand to less than an inch. Color and patterns are extraordinary, a treasure for the artist to explore. To make sense of all this diversity, we'll place the species we'll be painting into families and learn a bit about what makes each unique, with the end goal of painting them realistically.

Butterflies and butterfly gardening have become a national pastime, at least in part because of three important developments. First, the technological marvel of binoculars with the close-focus capacity to see and identify a 1-inch (25mm) long butterfly from just a few feet away. To remember the details long enough to identify might be impossible without the second important development, the digital camera. Even a poor digital shot combined with the third critical factor, a good field guide, makes it possible to learn the names of most of the butterflies you see. *Kaufman's Butterflies of North America* (published by Houghton Mifflin Harcourt) is the best guide on the market today. Small enough to carry everywhere with you, it has a prodigious amount of information about every single butterfly that you are likely to see in the United States. Thus with just a nominal investment you can explore the lives and habits of these fascinating creatures.

You may also enjoy a membership in the North American Butterfly Association. NABA sponsors local chapters in cities around the country, a great website with lots of info on everything from butterfly gardening to identification, and is developing the native International Butterfly gardens on the border in south Texas, where so many of our tropical species are found. For more information, visit their website at www.naba.org.

— Sherry C. Nelson

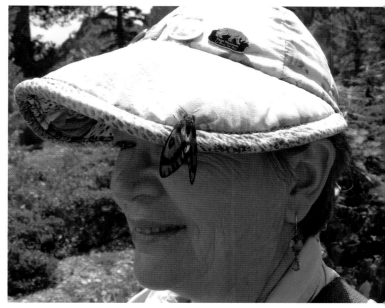

Sherry Nelson with an "Elegant Sheep Moth" perched on her cap. You'll see how to paint this moth on pages 118-119.

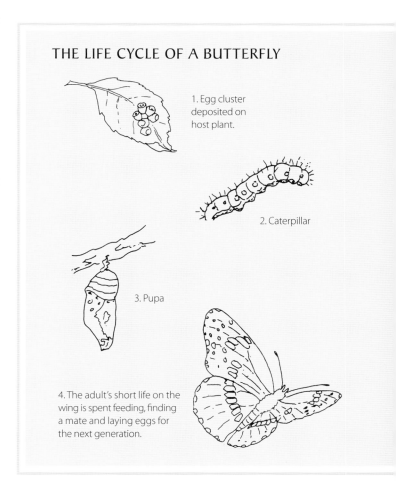

THE LIFE CYCLE OF A BUTTERFLY

1. Egg cluster deposited on host plant.

2. Caterpillar

3. Pupa

4. The adult's short life on the wing is spent feeding, finding a mate and laying eggs for the next generation.

Materials

For this entire book, I've used only 11 different tubes of oil paint! I've limited what you'll need so you can afford to buy the best. Artists' Oils last a long time because you only need a small amount for a project. Buying inexpensive paint is not a savings; they are mostly oil and not much pigment.

Buy the best red sable brights and round brushes you can afford. If you are a beginning painter and you attempt these projects with poor quality brushes, you may blame yourself if your paintings don't turn out right. Using good, short, red sable brights will make my techniques work for you.

If you've painted in oils before, you may have some of the supplies you need. If not, just purchase what you need for your favorite projects from this book to minimize expense. But whatever you need, buy the very best you can afford. That's your best guarantee for success.

BASIC SUPPLIES

Listed here are the painting supplies you will need for every project in this book.

• **Palette pad:** A 9 x 12-inch (22.9cm x 30.5cm) strip palette for oils is best.

• **Palette knife:** A flat painting knife is best for mixing in drier.

• **Cobalt Drier:** This product is optional, but I encourage you to try it. When used as I do, your painting will dry overnight, yet it leaves the palette workable until you are finished with the painting.

• **Brushes:** Red sable short brights in size nos. 0, 2, 4, 6 and 8. Also red sable round liner brush in size nos. 0 and 1.

• **Artist's odorless thinner:** You need a tiny capped jar to pour a little into when you paint. I use a small empty lip balm jar and I keep it capped until I need it.

• **Turpenoid Natural:** a non-toxic, oily brush cleaner and medium for oils.

• **Masonite panels** in the sizes suggested for each project. You can purchase large sheets and cut it yourself or have it cut at the home center. Use the low-priced 1/8-inch (3mm) thick hardboard. Cardboard-colored is the best.

• **Dark gray artist's graphite paper,** for transferring the designs. Purchase at an art supply store in a large sheet, not in a roll

from a craft store. Craft papers may be hard to remove from the surface and may not be thinner soluble.

• **Tracing paper:** A 9 x 12-inch (22.9cm x 30.5cm) pad.

• **Stylus:** You can also use an old ballpoint pen.

• **Ballpoint pen:** not a pencil, for transferring the designs.

• **Paper towels:** Soft and very smooth. Viva are best, and will save lots of wear and tear on your brushes. Don't use the cheap, bumpy ones.

- **Spray varnish:** Final finish for the completed paintings.

- **Artgel** is a product for cleaning oil brushes and works wonderfully for removing oil paint from clothing and hands. Made by Winsor & Newton.

- **A square foot of cotton cheesecloth** is almost like having an extra brush. See page 13 for tips on its use.

BACKGROUND PREPARATION

If you've not painted before, you may wish to simplify your background preparation and concentrate on learning the basic painting skills. Any project in this book may be painted on just a single neutral acrylic color, for example. As you complete more projects, you may wish to purchase some or all of the acrylic colors I used, which are shown on page 12.

Here are the basic materials you'll need to prepare the backgrounds:

- **Masonite or hardboard panel** to paint on.

- **Sponge roller:** I apply all background colors with these 2-inch (51mm) foam rollers. They give an even, slightly textured surface for painting.

- **Acrylic Retarder:** This slows the drying time of acrylic paints. I use Jo Sonja's Retarder & Antiquing Medium.

- **220-grit wet/dry sandpaper:** Available in packs at home centers.

- **Krylon Matte Finish #1311:** A must. This acrylic matte spray will seal the surface of the background lightly, allowing the oil paints to move easily for blending. (NOTE: The formulation problems we had for several years with Krylon Matte Finish 1311 have been corrected. We can once again use this product, thanks to the helpful folks at Sherwin-Williams.)

- **Newspaper** to protect your work surface.

- **Paper towels:** These can be the less expensive ones, since they'll just be used for clean-up.

WHAT SHERRY USES

Try to avoid substitutions. Use materials as close as possible to the ones I use for the best results.

Oil paint: Winsor & Newton Artists' Oils. They are the best and only oil paints that I use.

Brushes: Sherry C. Nelson Series 303 red sable short brights, nos. 0, 2, 4, 6, 8. Sherry C. Nelson Series 312 red sable mix rounds, nos. 0, 1.

Palette knife: I use my flat-bladed painting knife, Sherry's Choice, styled after the Italian painting knives. It's best for mixing in drier and keeps my hand out of the paint.

Cobalt Drier by Grumbacher

Delta Ceramcoat acrylic paints: Coastline Blue, Denim Blue, Dolphin Grey, Black, Oyster White, Green Tea, Eucalyptus, Green Sea, Cactus Green, Dark Victorian Teal.

Spray finishes: Krylon Matte Finish #1311.

Krylon Varnish Spray, #7002, for final finish.

SUPPLY RESOURCE

If you have problems locating what you need in your local stores, you may purchase most supplies by mail order from:

The Magic Brush, Inc.
P.O. Box 16530
Portal, AZ 85632

Phone or fax: (520) 558-2285.
www.sherrycnelson.com
orders@sherrycnelson.com

Send $3.00 U.S. to receive a black & white copy of the catalog.

Colors

SHERRY'S TOP 10 + 1 OIL COLORS

I used my Top Ten +1 Winsor & Newton Artist's Oils for all the projects in this book. That's right, all 54 projects are painted with just these eleven colors!

This is my palette set-up too. I put the most frequently used colors in the bottom row closest to me, and the less used further away. That way I don't have to keep reaching over to get to the colors I use the most!

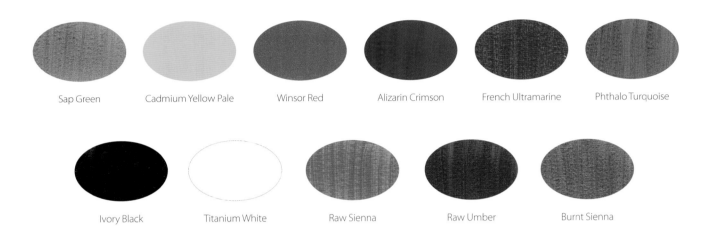

Sap Green Cadmium Yellow Pale Winsor Red Alizarin Crimson French Ultramarine Phthalo Turquoise

Ivory Black Titanium White Raw Sienna Raw Umber Burnt Sienna

ACRYLIC BACKGROUND COLORS

The acrylic colors I used to paint the backgrounds in this book are by Delta Ceramcoat. If you cannot find them at your local craft supply store or if a particular color is discontinued, take this color chart to your supplier and match them as closely as possible to what's available. An exact match is not necessary for the end result to be attractive.

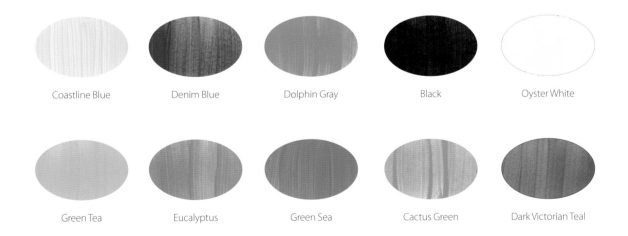

Coastline Blue Denim Blue Dolphin Gray Black Oyster White

Green Tea Eucalyptus Green Sea Cactus Green Dark Victorian Teal

Brushes

CHOOSING THE RIGHT BRUSH FOR THE JOB

I use only seven brushes, so it's easy to learn to pick the best one. In the painting demos in this book, I'll only mention the brush sizes when there's a choice in what you might choose for a particular technique.

In general, the red sable brights are blenders and the rounds are detail brushes. Use brights for most paint applications and for most blending between values. Choose the brush that fits the area you are working on.

WHAT EACH SIZE DOES BEST

Round brushes: The no. 0 round is used for fine detail like butterfly antennae lines, flower stamen filaments, placing tiny markings, and for signing your name.

The no. 1 round is the stippling brush, my "workhorse" texturizer for butterflies. First, an application of slightly more generous paint is applied to the wet basecoated surface. Then squeeze the brush dry between folds of a paper towel. Finally, with your fingertips, "flatten" the brush so it looks a bit splayed like a filbert. Then tap into the previously applied paint, walking bits of color away from the area of thicker paint, to create a textured value gradation that then appears iridescent. If the instructions say "stippling," reach for the no. 1 round.

Brights: There are only five brights. The no. 0 bright is used for flat brushwork in tiny blossoms, buds, narrow section lines or spots and in areas where no other flat brush will fit.

The no. 2 and no. 4 brights are my other "workhorse" brushes, which I used for most all the painting for the vignettes in this book. When the step-by-step painting instructions say to "base" a color onto your design, 99 percent of the time you'll be using one of these two brushes. How to decide? Choose the one that fits best in the area on which you are working.

The no. 6 bright is for blending and basing large leaves and flowers in pieces such as "Project 1: Common Green Birdwing with Angel Trumpet," which is designed on a larger scale. It may also be used for clean-up or lift-out in tiny areas where the no. 8 is a bit cumbersome.

The no. 8 bright is my usual choice for cleaning up graphite, removing bits of messy paint from within the design, and lifting out an area of paint for another application. Dip the brush into thinner, blot on a paper towel and proceed. The larger brush has more body and the corner works wonderfully for lifting out what will be white or light spots in a wing pattern.

AND A PIECE OF CHEESECLOTH…

I think of this as an extra brush. I use about a 12-inch (30.5cm) square piece, folded softly into a pad. You can pat surfaces to make paint more translucent, soften large areas to remove excess brushstrokes, remove excess paint, soften detail or lines that are too harsh, and blend and soften shadows. It's kind of like a big mop brush, but a lot cheaper and you don't have to clean it.

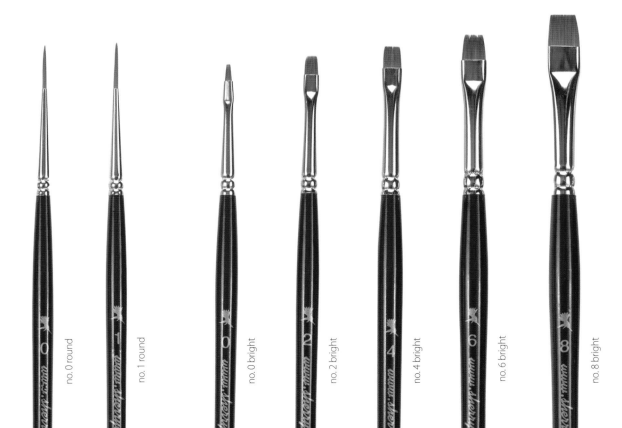

no. 0 round no. 1 round no. 0 bright no. 2 bright no. 4 bright no. 6 bright no. 8 bright

Preparing the Backgrounds

A background should stay in the background. It shouldn't be so complex or colorful that it detracts from your subject. Simplicity and neutral colors will allow your design to be focal.

All the backgrounds used in this book are done with the wet-on-wet acrylic method shown here. Before beginning, reconstitute the acrylic paint. For new bottles, unscrew the lid, fill with water to the bottom of the neck, recap and shake well. For used bottles, add a little water and shake, until it has the same "liquid" sound.

Sand the edges of the Masonite panel; do not sand the painting surface. If the back is fuzzy, sand that too, so the particles don't get into your paint. It's best to do the backs with a small electric sander, out of doors.

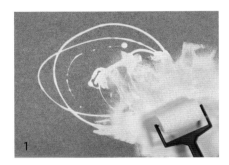 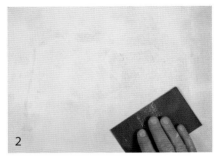 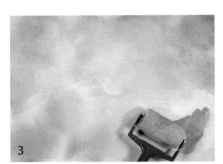

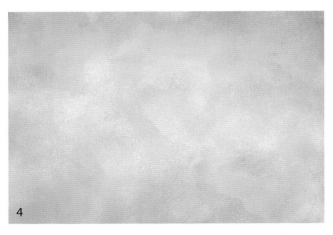 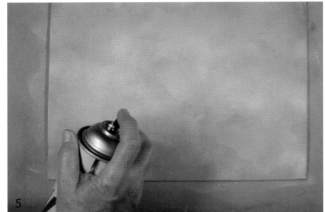

1. The wet-on-wet acrylic backgrounds used in this book all begin with a basecoat of one of the colors. Here I've drizzled on Oyster White, quite generously. How do you know when too much is too much? If the paint remains bubbly after you've coated the entire surface, you've put on a little too much. If it's sticky, and disappears right away into the surface, too little.

Use the sponge roller in one direction until the surface is covered. Then go across in the other direction for a smoother finish. Lighten the pressure on the roller when you change directions. If you've put on too much paint, just change directions another time. The paint will gradually smooth out.

2. After the first coat dries (it will no longer feel cool to the touch), sand well. Sand the edges again and the painting surface too, to remove any "cruddies" that may have gotten into the paint. Press lightly on the sandpaper and move it around on the surface as if you were polishing it.

3. Recoat the surface with Oyster White and roll evenly over the surface, using a little less than before and working more quickly, since the other colors must be applied while the surface is wet. Now add the shading colors, Eucalyptus and Denim Blue. I placed two drizzles of each on opposite corners of the surface. Roll lengthwise into them, not across the stripe. Move the roller around a bit to distribute the colors, and to blend them into the background.

4. Blend colors until the appearance pleases you. Let dry, then resand.

5. Take the surface outside, preferably on a windless, warm, sunny day and shake the can of Krylon Matte Finish #1311 well. Hold the can about a foot from the surface and begin spraying at the top. Working from side to side, let the spray go off the edge before starting back across in order to prevent pileup. Hold the surface to the light so you can see the spray fall, and move on as you see it beginning to coat the surface. Spray one light even coat. You'll soon learn how much is too little (the oils won't blend easily) or too much (when the oils slide around too readily). Let dry outside for 15 minutes before bringing it indoors.

OIL-ANTIQUING TO ENHANCE A PLAIN BACKGROUND

Many of the butterfly demos in this book were painted on plain white backgrounds vignette-style, often with just a bit of color in the background to enhance the designs (see pages 30-131). To prepare your backgrounds for the vignettes, first paint the surface with your choice of an acrylic color, using a sponge roller. I used a true white for all the vignettes. Let dry, sand and recoat. Sand again, and then seal with Krylon Matte Finish #1311. The surface is now ready to accept an oil glaze that can enhance and enrich the painting on it.

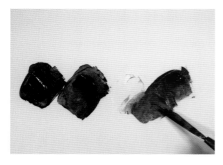

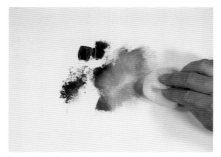

1. I've decided on an oil glaze that includes both green and blue. I've chosen four oil colors: Ivory Black, Sap Green, Titanium White and French Ultramarine. First, I dip the palette knife into odorless thinner, scooping up a few drops and mixing it into each patty of paint, along with a fraction of a drop of Cobalt Drier.

I'll make a mix of Black + Sap Green for a pleasing, reduced-intensity green, and a second mix of White + Blue in about a medium value.

2. On the left side of the surface you can see the "scrapes" of sparse paint I applied with the palette knife. Put about three scrapes of each color in the center of the surface, leaving about 1 inch (25mm) of space between them. Then, with a cheesecloth pad, soften the edges of each sparse scrape of paint, gradually blending into the surface.

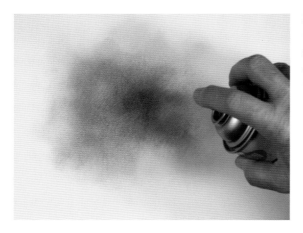

3. When the appearance pleases me, I allow the surface to dry and then spray once again with Krylon Matte Finish #1311 to seal the oils.

FINAL FINISH

Not all oil paints dry with an even finish. Some reds and umbers can become dull. Others look wet even when dry. To give the surface a uniform sheen, it is necessary to apply a final finish. The finish also protects the paint.

When cobalt drier is used to speed the drying time of your palette, it also shortens the time you must wait before you can apply the final varnish. The thickness of the paint you've applied to the painting also impacts the drying time. Obviously the thicker the paint, the longer you have to wait for the paint to cure. Remember: just because the paint is dry to the touch, does not mean it is ready for the final finish.

Since my painting style involves only the thinnest of paint applications and since I live in a warm dry climate, I can varnish sooner than those of you hampered by cold weather and lots of humidity.

Generally, I feel safe varnishing my paintings by the second week, though I've done it sooner with no problem. I'll leave that decision to you. I use Krylon Spray Varnish, #7002. It is a satin finish, oil based varnish that gives a very light even coating and brings out the beautiful rich colors for which oils are noted. I've never experienced crazing or other varnish related problems with this particular product.

Transferring the Design

For each of the projects and vignettes in this book, there is a line drawing to make it easier for you to begin painting. Because accuracy is so essential for making your butterfly and moth paintings realistic, if at all possible, transfer the design from a photocopy of the line drawing given here, not a traced copy.

If you cannot make a photocopy of the design, you will have to trace it. Make as exact a copy as possible; every variation from the line drawing will impact the final appearance of your painting. Use artist's graphite, sold in sheets in art supply stores, for transferring. It is important to use graphite that is thinner soluble, so you can come back later and clean off the excess graphite. I'll show you how in Step 2 below.

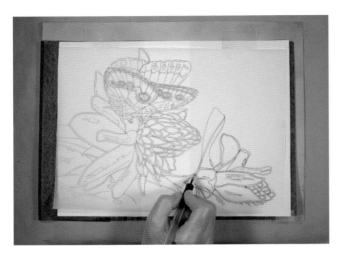 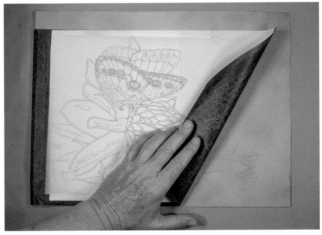

1. Lay a piece of dark graphite on top of the prepared background. Lay the line drawing on top of the graphite and position it as you desire. Tape one edge of the line drawing, *not* the graphite paper, to the painting surface. Now lay a piece of tracing paper over the design and tape it down too. Begin making the transfer, using a *ballpoint pen*. Check after you've drawn a few lines. Is the transfer too light or too dark? Adjust the pressure to get it right. Do not use a pencil, which tends to make less accurate lines as the point wears down. Carefully transfer all detail included in the line drawing. I even transfer spots and other tiny pattern areas so they will show through my sparse basecoat later. The tracing paper helps you determine if you've skipped any areas, and it will protect your line drawing for another use.

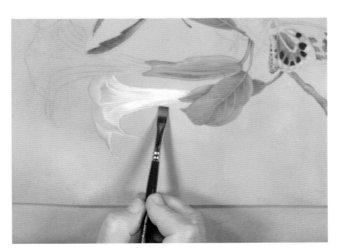

2. When you've completed a design and it is dry, remove any graphite that still shows around design edges. Dip the no. 8 bright (because of the firmness of the bristles) into odorless thinner. Blot the brush well on paper towel. Scrub the brush along the edge to lift up the graphite line. As you can see, it's very important to have graphite that is thinner soluble. Remember I spoke of doing very complete transfers, including all pattern detail? With thinner soluble graphite, you never have to worry about removing graphite lines that could show underneath your sparse basecoats; they simply dissolve in the paint as you blend, in a way that water-soluble graphite, made for use with acrylics, won't do.

Setting Up the Palette

Not all disposable palettes are equal. A 9 x 12-inch (22.9cm x 30.5cm) size is easier to work from and takes up less space than the larger sizes more appropriate for large canvas work. Make sure the palette you buy is oil-impervious. If you put out paint and later discover an oil ring around each color, the palette is NOT impervious to oil and will ruin the paint by soaking most of the oil out of them.

You'll also have the choice between a wax and a matte surface. Either will do a good job.

Do not tear off a single sheet to put the paint on. Leave the sheets attached so the palette doesn't slide around as you work. If you must use a single sheet, in a class for example, tape it in a comfortable position on your painting table so you don't have to hold it down while you load your brush.

HOW TO KEEP YOUR PALETTE FRESH

If you stop painting for a while, cover the palette to reduce exposure to air. Cobalt drier is an oxidizer (drying the paint on contact with the air) so the more airtight you can keep the palette, the longer you can extend the life of the paint. A palette keeper with a tight fitting lid is something you may want to invest in.

The paint will dry quicker on exposure to heat. Keeping the palette cool will preserve it. Conversely, if you want your painting to dry quicker, put it in a warm place.

If you cannot finish your painting within a day or two, simply toss out the old paint and put out fresh, since the drier eventually makes the palette unworkable. If you store the palette in a palette keeper, keep it cool, and do not use drier, the paint will stay workable almost indefinitely. If a color becomes sticky, use the palette knife to mix in a drop of thinner to reconstitute it for another painting session.

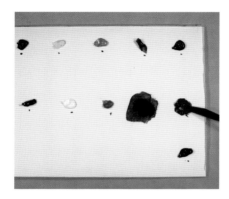 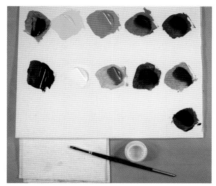

1. Here's how I put out my oil paints onto the palette; 1/4-inch (6mm) of paint from the tube of each color is plenty. I lay Sherry's Top 10 colors in two rows: the most used black, white and earth colors on the bottom row, closest to me, and the least used reds, greens and yellows in the top row, furthest from my hand. When I need Phthalo Turquoise I sometimes place it in the bottom right corner or add it to the end of the top row.

Leave space between colors for mixing the cobalt drier into the paint, and for making loading zones and mixes with the different colors.

Dip the palette knife into the drier and bleed excess off the knife on the inside of the bottle neck. Immediately recap the bottle to keep it from drying out. Now, with less than a drop of drier on the knife, tap the knifepoint next to each patty of paint. Use only this amount and *no more*. You want the palette to stay workable for many hours and yet, with the sparse amounts of paint you'll apply, have the painting dry overnight.

2. Mix the drier into the paint thoroughly before it dries on the palette. Then scrape the paint up into a tight pile to leave less surface area exposed to drying. That will extend the life of the palette even further. Wipe the palette knife thoroughly between colors. Now you are ready to paint.

Fold two or three paper towels in quarters and stack the folded ends under the edge of the palette pad. That way you'll have a flat surface to dry-wipe the brush on, open folds to slide the brush between to squeeze dry, and the palette will hold them down so you don't have to handle them or have them in your way. Then, if you are right handed, put the whole arrangement on your right. These are small details; attention to them up front will save lots of time for the real fun—painting!

Loading the Brush & Mixing Colors

A painting surface has a certain amount of tooth and will hold only so much paint stuck down to that surface. Any excess paint you apply over and above that slides around, mixing too readily with other colors. It makes what oil painters refer to as "mud." Mud comes from getting too much paint on the brush and transferring too much of it to the surface.

Butterflies are very patterned creatures. If you apply the base colors too thick, the surface detail of iridescent areas and other small sections of color and texture will simply blend into the basecoat and disappear.

Painting realistic butterflies and flowers in oils means learning to paint with sparse, small amounts of paint so you have maximum control over the detail that goes on top. I load one side of the brush only, and I load only a small amount of dry paint. Sparse paint on a dry brush results in good control.

The best way to control the amount of paint you pick up is by loading your brush from loading zones.

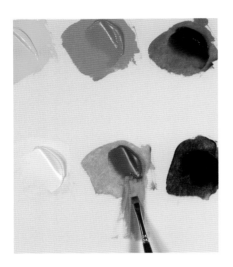

1. This is what a "loading zone" looks like. I've laid the brush into the edge of the Raw Sienna and pulled it down to create a strip of sparse color, using a no. 4 bright. Work the paint until the loading zone is flat and dry and the paint evenly distributed. The purpose, remember, is to reduce the amount of paint you carry, so the loading zone should contain no excess. Check the surface: the main patty of paint will be shiny; the loading zone should be a dry-looking matte finish.

You should be able to pick up enough paint from a dry loading zone for 8 or 10 applications of paint before the zone becomes too dry. Then go up to the patty and pull down just a smidgen of paint to "feed" the loading zone. Distribute the fresh paint into the zone and again you're ready to load your brush. Don't add more paint to the loading zone until it becomes difficult to get paint off the brush and onto the surface.

The process of creating a loading zone puts excess paint in the brush. Always dry wipe the brush on paper towels and reload in the sparse zone before going to your painting surface.

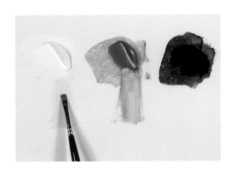

2. Here are two loading zones, one made from the Raw Sienna and one from the White. To make a mix of two colors, pull the brush through the Raw Sienna loading zone, then the White, then back to the Sienna, and back to the White. If you desire a darker mix, load last in the Raw Sienna loading zone. If it's a lighter mix you need, load last in the White. The color you load last will be the majority color on the brush.

THINNING THE PAINT

Here's what to do when the instructions say a color or mix should be "slightly thinned":

Dip a clean round brush into the odorless thinner. Take the wet brush to the edge of the desired color on the palette and mix the thinner into it to make a puddle of thinned paint. Wipe the round brush on the paper towel. Now go back and roll just the tip of the brush into the slightly-thinned paint and use it for the detail.

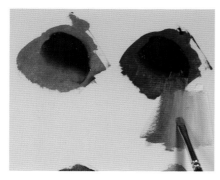

3. Sometimes it's easier to take some paint to another part of the palette to facilitate mixing. Here I've picked up a little glob of White on my brush, and carried it to the French Ultramarine. Now I'm making a "double" loading zone, pulling a little of each color down and working between them until I have a fairly even mix of the two. When you need to load repeatedly in a same or similar mix, this is often an efficient way of doing it. Plus you can make instant intensity or value adjustments by adding a bit more of one hue or the other.

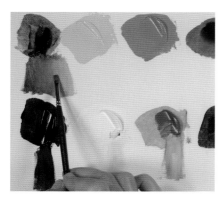

5. Carry a small glob of Raw Sienna to the Sap Green mix. Pull an adjacent loading zone and gradually mix the Raw Sienna and the Sap Green together where they meet. Then pick up a small glob of White and put it next to the Raw Sienna. Pull another loading zone, gradually working the edge of it into the greens.

Now you've created a lovely range of green values that you can use for all the leaf steps without having to continually mix colors.

4. The leaf green mixes can be tricky. Start by making loading zones at the edge of the Black and the Sap Green. Work between them to get the dark value mix, loading last in the Black. The dark value should be green enough to look green but not bright and dark enough that it's not muddy looking. Then move to the Sap Green and widen the loading zone a bit.

6. After working in the Raw Umber, I've brought the dry-wiped brush over to the White and created a new loading zone at the side. I'm using it to make "dirty brush + White." That is a term you will see often in the instructions and it just means that you'll have a little of whatever color or mix you've been using left on the brush—and you'll use that to tint the White.

USING A "DIRTY" BRUSH

Often you'll find this phrase in my instructions: "Highlight with dirty brush + White." That means we use small bits of one color to tone and control the next mix. Simply dry-wipe the brush on a paper towel, and go into the loading zone for the next mix.

Try not to get in the habit of washing out your brights between colors or when you reload. Washing out the brush removes the dirty color—which is just what you need to help tone and control the strong intensities in your painting. If you pick up clean color at every step, you will have a much more difficult time keeping your colors compatible and controlled.

Occasionally you must wash out the brush when changing to a new color that must remain "clean." The strength of the Phthalo Turquoise pigment, for example, would change the color of any mix that comes after.

We do use thinner to extend the oils for detail work, normally done with the no. 1 round brush. Round brushes are longer and more flexible; when the paint is thinned, the round brush can better control the application.

Good rule of thumb: Keep the lid on the thinner and rinse your flat brushes only when needed.

Butterfly Basics

Learning a few terms that identify the different areas of a butterfly's wings and body will make the painting much easier. Each time you find a reference in the instructions that you don't understand, come back to this page. Soon you'll know the basic anatomy and the name of each of the parts.

Understanding the anatomy helps when observing butterflies too. You'll quickly become more aware of where on the wings certain colors or patterns appear, helping to confirm an i.d. on the creature you're watching. For example, the diagrams below are of a brush-footed butterfly in the family *Nymphalidae*.

Upperside (Dorsal Side) of the Wings

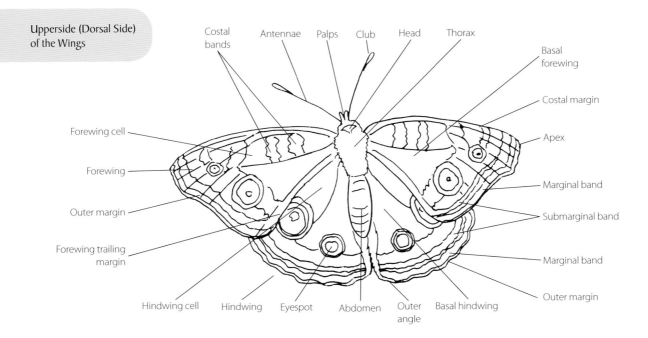

Costal bands
Antennae
Palps
Club
Head
Thorax
Basal forewing
Costal margin
Apex
Forewing cell
Marginal band
Forewing
Submarginal band
Outer margin
Marginal band
Forewing trailing margin
Outer margin
Hindwing cell
Hindwing
Eyespot
Abdomen
Outer angle
Basal hindwing

Underside (Ventral Side) of the Wings

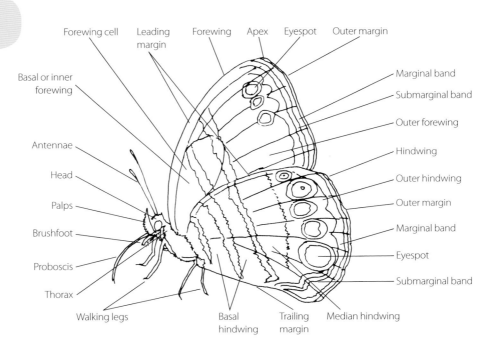

Forewing cell
Leading margin
Forewing
Apex
Eyespot
Outer margin
Basal or inner forewing
Marginal band
Submarginal band
Outer forewing
Antennae
Hindwing
Head
Outer hindwing
Palps
Outer margin
Brushfoot
Marginal band
Proboscis
Eyespot
Thorax
Submarginal band
Walking legs
Basal hindwing
Trailing margin
Median hindwing

Painting Butterfly Wings

USING BLACK ACRYLIC

1. Simplify a complex wing by basing all or part of the black areas with black acrylic. Much as I love my oils, there are times when, for the sake of clean, sharp detail, it's nice to have some areas dry before going on to the next step. Here I'm applying Black acrylic with a no. 0 round brush. When going around spots, outline them first, then fill in. Tap the brush to detail fine, almost dotted lines. With dark detail done in acrylic, I don't have to worry about losing the detail or muddying the white oil paint.

2. Pull the round brush across the submarginal band, allowing the brush to create an irregular edge and more realistic growth direction than if it were smoothly painted along the length of the bands. Check that nice dry detail on the eyespots. No worries when I go back to fill in with my oils. Special brushes? No, I use my no. 0 or no. 1 red sable round. Squirt a little puddle of regular glass cleaner (I prefer Windex) on your (waterproof!) work surface. Dip the round brush in it and wipe out any oily residue. Now load the acrylic. When finished, rinse the acrylic paint out of the brush in same puddle. The glass cleaner dries out of the brush almost immediately, allowing me to use the brush right away in my oils.

CREATING PERFECT SECTIONS

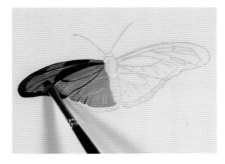

1. Begin by basing the sections with appropriate mixes of sparsely applied paint. Here I'm using a dark, medium and lighter value of the red-orange family. To get good value gradations between the colors, blend on the line where the values meet, using the chisel edge and following the growth direction. And please—use your best bright brush with a perfect chisel edge.

2. Lay the tracing paper cover sheet on top of the wet butterfly and draw over the section lines. Use a fine-tip ball point pen for best results. When you lift the pattern, the original section lines are in the wet paint to use for a guide once more.

3. Use the dark mix to clean up around edges of the orange sections where you want them sharp. Blend with the corner of the brush into the edges where you want them a bit irregular. When the main areas are based, reload the chisel with same mix and tap the brush down the section line as you see here, right on top of the line you drew in the previous step.

BLENDING FOR VALUE GRADATIONS

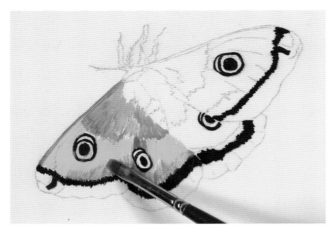

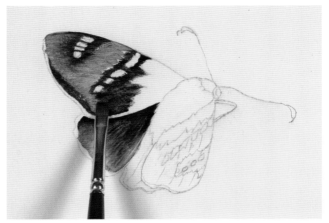

1. Shade, highlight and accent areas of color on butterfly wings just as you would on a flower or leaf. Here I'm blending on the line, where the values meet, to soften the orange accent into the basecoat.

2. When blending between values, wipe the brush dry, then use the chisel to blend on the line where values meet, following growth direction, and using a brushstroke length that fits well within the section. Lifting paint? Hold the chisel at a lower angle to the surface.

CREATING IRIDESCENCE

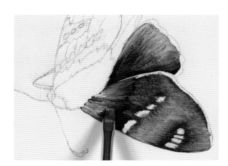

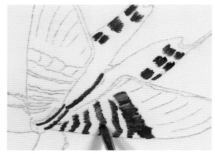

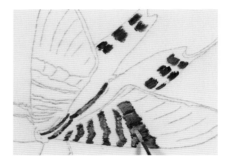

1. I'm applying the white highlight on top of the turquoise mix in this shot. The brush is loaded generously, and I'm dabbing the paint on a bit thickly. Wipe the brush, and gently tap the edges of the highlight to soften a bit into the basecoat. Allow the thicker, whiter areas to remain so for texture and iridescence.

2. The bands across the wings are based with a deep turquoise blue. I'm adding a bit of iridescent yellow-green here, applying a bit generously as in the previous step. Note that I've switched to a smaller brush (the better to fit into the narrow bands, my dears).

3. You can get only so much iridescence with a bright. Eventually you must switch to the flexible round brushes to apply the paint so that it does not blend to the basecoat. Here I'm stippling on a lighter, brighter value of yellow with the round, building the glittery look. Note the irregular edges and that I'm still working with the growth direction of the wing, even though the bands are just a fraction of an inch wide. Eventually, I'll highlight the very lightest lights on top of the yellow, using White.

CREATING TRANSLUCENCE WITH CHEESECLOTH

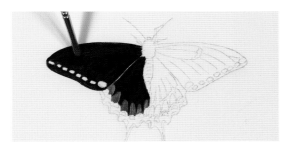

1. I've based the hindwing blue sections with a medium value and am filling in the remaining dark areas on the wings of this swallowtail.

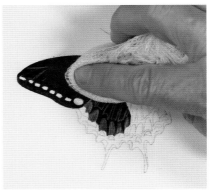

2. With a soft pad of cheesecloth wrapped around my finger, I'm patting and softening the basecoat to lift some paint and get a more translucent look to the mid-wing area. It's OK not to lift paint all the way to the wing margins and in fact looks more natural when you don't.

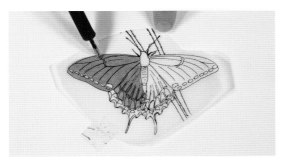

3. Lay the tracing paper pattern over the wet paint. Take time to tape it down—one slip and you've got a botched job. Use a fine tip ballpoint pen to transfer detail.

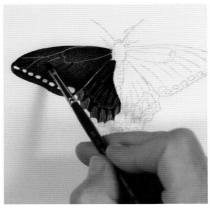

4. Look how interesting the translucent look in the midwing is. And now, when I place the black section lines with the chisel, they'll show up as they do on the real butterfly.

WALKING THE ROUND BRUSH FOR CONTROLLED IRIDESCENCE

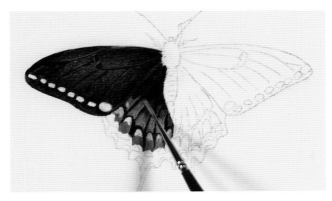

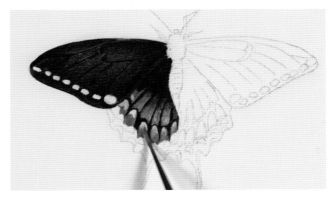

1. The outer blue sections were based in Step 1 above. Now we'll add the extra paint needed for iridescence. I've made a mix of light blue two values lighter than the basecoat, loaded the no. 1 round generously and have dabbed the highlight value on the top third of the outer sections. Now I'm basing a similar amount of the same color on top of the dark basecoat, again about a third of the length of the section. I'm leaving a narrow band of basecoat visible between blue sections and also between rows of sections.

2. When sufficient paint is applied, squeeze the round brush gently between the folds of a paper towel. Then flatten the bristles between your fingernails. Use the splayed, flattened brush to tap from the middle of the light stippling color on each section, walking the brush over and over from light application into dark basecoat until the color fades. Leave the outermost bit of highlight color; it becomes the highest highlight. Wipe the brush frequently and re-flatten the tip of the bristles. Repeat this process on the outer row of sections.

CREATING SECTION LINES WITH SHADING AND HIGHLIGHTING

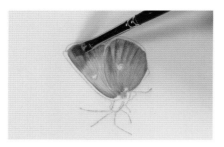

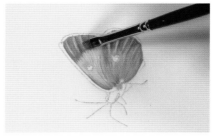

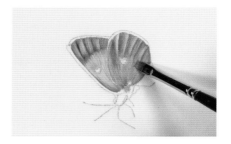

1. The sulphur's wing should appear a bit ruffled. Begin by applying lines of shading on each outer wing section line using a chisel edge. After each shading line is applied, blend most of the line into the wing using the chisel held parallel to the line. Be consistent; blend to the same side of each section line.

2. Apply a light value adjacent to the original shading line.

3. Now blend the light value to the opposite side, away from each line of shading. End result? The wing colors now appear a bit ridged, changing from light to dark to light. This method creates individual sections a bit differently than simply basing and drawing in a section line.

APPLYING TINY MARKINGS AND DETAIL BANDING

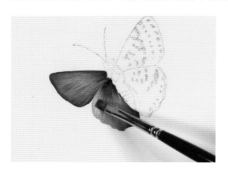

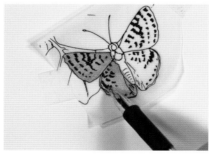

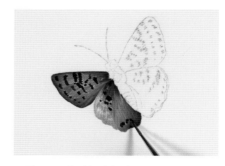

1. Base the wings with various values of blue mixes, then finalize the blend between the lightest value and the median area of the hindwing.

2. Tape the tracing paper pattern over the painted surface and draw in the tiny markings with a ballpoint pen.

3. The transfer lifted the basecoat, giving a guideline for placement of the markings. Using a slightly-thinned dark mix and the tip of a no. 0 round, replace each marking with tiny short strokes following the natural growth of the wing.

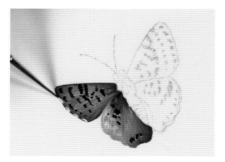

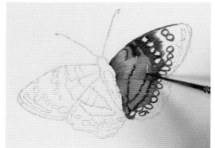

4. With White on a no. 0 round brush, apply the wing margin detail that makes the edge of the wing look scalloped. Pull short lines with the brush to create the shape; don't just dab them on.

5. These wing sections have been shaded, highlighted and are ready for detail. When creating irregular bands across the wings, thin the paint slightly and pull the width of the band with the no. 0 round.

Painting Butterfly Bodies

Bodies don't have to be perfect (mine's not!). But it is important to understand the basic structure of the creature so you don't end up with a "fake" body on a gorgeously-detailed and otherwise realistic butterfly. Try these easy steps to help you understand the process.

THE VIEW FROM THE TOP

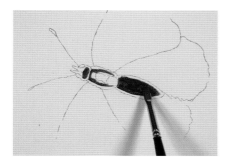

1. Begin by basing the dark value on the head, the thorax and the abdomen. Since we want good detail in a very small area, use sparse paint.

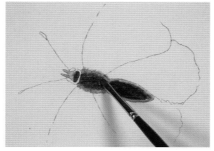

2. Base the outer edges of the abdomen and thorax, as well as the palps and the top of the head with a lighter value. Blend where values meet from light toward dark. The light value on the thorax is where the body connects to the wings: that's why you want it fuzzy and broken at the edges, so that it appears attached.

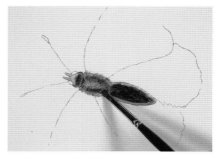

3. Highlight in the middle of the thorax with a light value. Chop the brush a bit as you add color and blend. Again, think texture. Sometimes, as here, the head carries a little bit of intense color.

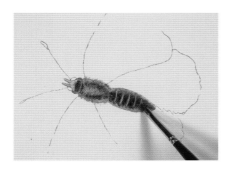

4. Place curved lines across the abdomen with a light value to divide the abdomen into segments.

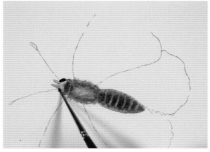

5. Soften the bands on the abdomen, patting with cheesecloth. Add the eyes with a round brush for better control. Blend the final highlights with choppy strokes of the chisel or by tapping with the flattened tip of the no. 1 round.

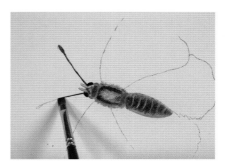

6. Sometimes I do the antennae on larger butterflies with the chisel edge of a good brush. I get a more perfect curve and can simply increase the brush pressure at the end to form the club. Detail the head with a bit of dark for more interest.

THE VIEW FROM THE SIDE: A SMOOTHER-BODIED SPECIES

Often times the body is "countershaded." That means the darker values are on the topside and the lighter values underneath. The shadow from the body itself then makes the underside appear darker and the darker topside, which is in direct light, appear lighter. This may help the butterfly become less visible to predators. This pattern of value placement is common with birds as well, which often have light breasts and bellies and dark backs.

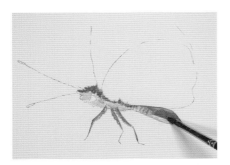 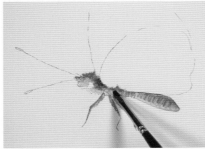 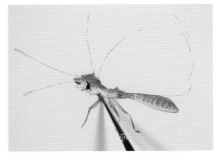

1. This Longwing shows the typical "countershading" value placement. Darks lay under the edges of the wings, on top of the abdomen and on the head. On the side of the abdomen, blend a bit where values meet to create form and suggest segments. Consider the legs: the upper segment is usually a bit fuzzy, and wider than the rest of the leg and foot. And remember: All six butterfly legs are attached to the thorax, NOT to the abdomen.

2. Add shading under the wing to "attach" the wings to the body.

3. Add dark values on the head to indicate eyes, palps and other details. Extend the legs with fine lines of the chisel. Best help with complex detail? A good reference photo!

THE VIEW FROM THE SIDE: A FUZZIER-BODIED SPECIES

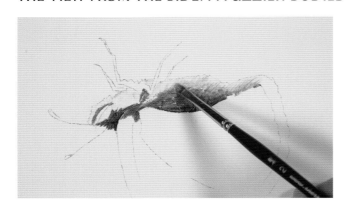 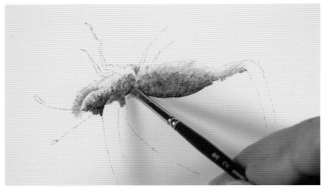

1. On this Brushfoot, countershading is again evident. Using a small bright, stronger darks on the thorax are applied where the wings join the body (I turned my surface upside down for easier brushwork). The abdomen in this species is actually hidden behind the wing, so what you see behind the legs is the edge of the wing coming down across the body. Note the tiny band of shading applied the length of the palp, which is a sensory organ having to do with taste.

2. Add the light value on the underside and blend between the values using a no. 2 bright. Keep in mind the need to create texture and a fuzzy appearance to the body. The wing margin is based with the same light value. The light value has been placed next to the shading on the palp.

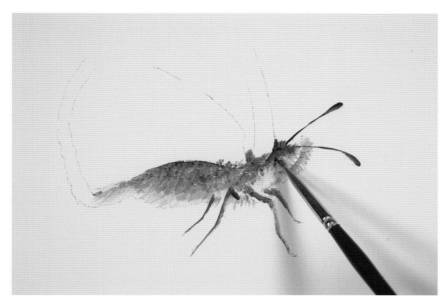

3. Additional shading on the thorax and the head next to the base of the wing helps establish the body as an entity separate from the wings. After blending, the palp looks like a little brush sticking out from the head.

With a round brush, legs have been added, and the position, angle and width at the upper segment are all typical of what to strive for. This is a Brush-footed butterfly, so there are only four visible "walking" legs. The two "brushfeet" are tucked next to the body behind the head and are often invisible except on a butterfly in the hand.

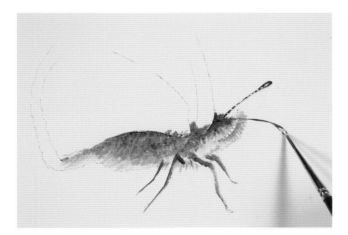

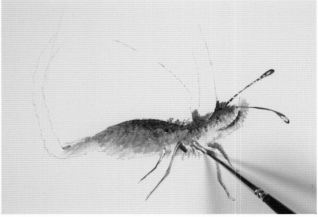

4. Many butterflies have antennae that are banded alternately in black and white. Base the antennae with a dark value using either a round brush or the chisel edge as in Step 6 on page 25. Then, with slightly thinned paint, using the no. 0 round, touch a row of tiny dots spaced equally the length of each antennae. The clubs may be highlighted or tipped with a bit of light value.

5. The legs may be highlighted, particularly on the middle segment which usually sticks outward, catching the light. Note how the legs appear quite dimensional due to the value placement. Again, use a round brush.

Butterflies

BUTTERFLIES ARE ABUNDANT throughout the world and come in all shapes and patterns. Scientists who study them have classified them into "families" and assigned Latin names so they can be identified no matter where they live.

The butterfly families shown on these two pages are some of the most beautiful and interesting creatures you'll ever see. The reference photos were taken in the field, in many different countries, and show the butterflies in their native habitat, often feeding or resting on a favored plant.

From each of the butterfly families shown here, I've chosen several examples for the step-by-step painting demonstrations coming up on the following pages. I'm calling these demos "vignettes" because they are painted very simply on clean, white paper. Many have just a hint of background color to help give the final step a finished look (see "Oil-Antiquing to Enhance a Plain Background" on page 15).

The floral element shown in the vignette with each butterfly may be a food source, the caterpillar host plant, or is part of the environment where the butterfly is found. Together, they make exquisite little "stand-alone" designs that I hope you will enjoy painting!

Unless otherwise noted, all photos by Deborah A. Galloway.

Swallowtails & Parnassians

Swallowtails are the largest butterflies in North America, and their relatives, the Birdwings of tropical Eurasia, are the largest in the world. Many species in this group are noted for their long "tails" and iridescent spots which decorate the hindwings, drawing a predator to focus on the less vital parts of the creature, allowing the butterfly to survive the attack to mate and lay eggs.

 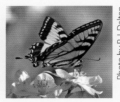

Photo by P. J. Dalton

Pipevine Swallowtail (*Bateus philenor*). A female, darker than the male with less dramatic blue iridescent markings.

Giant Swallowtail (*Papilio cresphontes*). The largest butterfly in North America; the upper wing surfaces are dark brown with golden-yellow bands that make identification easy.

Eastern Tiger Swallowtail (*Papilio glaucus*). A beautiful swallowtail nectaring on a blossoming fruit tree.

Gossamer-winged Butterflies— *Lycaenidae*

This large family is composed of very small butterflies: the Coppers, Blues and Hairstreaks. The hairstreaks and some blues may have one or two hair-like tails extending from each hindwing, along with dramatic eyespots. These have a characteristic behavior of rubbing the hindwings back and forth as they feed, making the "tail" end seem more important to a predator than the "head" end! A bit of confusion—and the butterfly may survive another day.

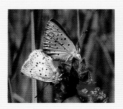

A mating pair of Greenish Blues (*Plebejus saepiolus*).

Silver-banded Hairstreaks (*Chlorostrymon maesites*) have varied colors and patterns to help break up their shape and make them less visible as they feed.

Sylvan Hairstreak (*Satyrium sylvanis*) at Milkweed—a valuable plant used by virtually all butterflies that feed on flowers.

Statira and Apricot Sulphurs (*Aphrissa statira, Phoebus argante*). Large numbers of sulphurs gather at a puddle party in Brazil. "Puddling" on moist sand is an important means for butterflies to obtain minerals and other nutrients, which are taken up through the proboscis.

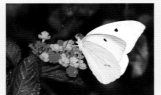

Giant White (*Ganyra josephina*). A tropical white, found only in the most southern tip of Texas.

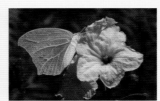

White Angled-sulphur (*Anteos clorinde*). A tropical sulphur found in states that border Mexico, this butterfly is white above and green below. Note the raised white vein structure.

Whites & Sulphurs—*Pieridae*

Conspicuous and abundant, these mostly white, yellow, or orange butterflies flutter about gardens and fields, nectaring on a variety of flowers, and making themselves obvious to even the non-butterfly person. It is thought that the yellow sulphurs were responsible for the common name "butter"-fly.

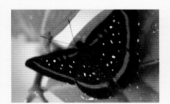

Meneria Metalmark (*Amarynthis meneria*). Photographed in Brazil, this is "just another" one of those fabulous tropical *riodinidae*.

Ares Metalmark (*Emesis ares*). The mid-elevation oak woodlands around my home in the mountains of southeast Arizona provide perfect habitat for this Metalmark.

Theodora Metalmark (*Chalodeta theodora*). Tiny but spectacular, this iridescent mite fed quietly on my rather sweaty hand for some time, within sight of Iguaçu Falls.

The Metalmarks—*Riodinidae*

Named for the many species that carry reflective or metallic markings on the wings, this family includes many profoundly exotic creatures—which have unusual behaviors. They may fly low to the ground, then flip upside down under leaves to hide. Not flower feeders, they prefer nutrients found in enriched surfaces such as mineral-laden sand banks, bird droppings or oils from your skin.

The Common Ringlet is clearly a *Nymphalidae*. The photo shows 4 visible "walking" legs and a portion of the "brushfoot" right behind the head.

Photo by Sherry C. Nelson

The Milkweed butterflies are Brushfoots too. The Monarch is renowned for its long-distance migrations and huge numbers that gather in winter roosts.

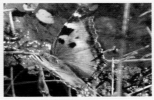

The Typical Brushfoots: California Tortoiseshell. Many of the most well-known butterflies in the U.S. belong to this group: Mourning Cloak, Painted Ladies, Admirals, Sisters and Buckeyes.

Brush-footed Butterflies—*Nymphalidae*

A definitive characteristic of all insects, including butterflies, is that they have 6 legs, 3 on each side of the body. However, Brush-footed butterflies have developed very differently. The front pair of legs have become reduced in size and are often covered with fuzzy, short hairs. These "brushfeet'" are not used for walking but instead have become a sensor used by the female to test the suitability of a host plant for laying her eggs.

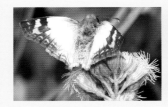

Laviana White-skipper (*Heliopetes laviana*), with a blue thorax! A flashy little skipper and a fast flier, it usually feeds with wings open. Mallows are the caterpillar host plants.

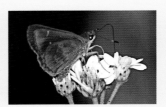

Clouded Skipper (*Larema accius*), a skipper of the southeast U.S. Note the large eye, long feeding tube (proboscis) buried in the flowers, and attractive patterning on the underwings.

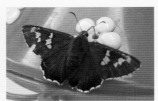

Dull Firetip (*Pyrrhopyge araxes*) on my hummingbird feeder. Dull Firetips are anything but, with rich gold underwings and bodies and glassine-like windows in the wings.

The Skippers—*Hesperiidae*

Skippers make up about a third of all the butterflies in North America. They have one characteristic that makes them different from the "true" butterflies: the clubs of the antennae are bent, and each is tipped with a little pointed projection called an *apiculus*. When you start learning to identify butterflies and come upon one that seems confusing, look at the shape of the antennae. Maybe you've got yourself a skipper!

Pale Swallowtail & Leopard Lily

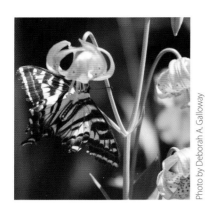

Photo by Deborah A. Galloway

THE PALE SWALLOWTAIL (*Papilio eurymedon*) belongs to the family *Papilionidae*, which are the largest butterflies in North America. Most species have tails on the hindwings and the Pale is easy to recognize since it's the only black-and white swallowtail in the Western U.S. Shown here nectaring on a Leopard lily (*Lillium pardalinum*), it uses buckthorn, coffeeberry, wild plum and alder on which to lay its eggs.

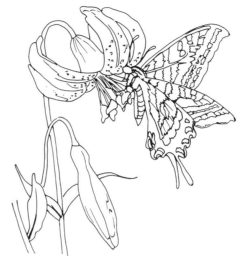

Pattern: Enlarge at 164% to bring up to full size.

OIL COLOR MIXES

Burnt Sienna + Winsor Red + Cadmium Yellow Pale

Cadmium Yellow Pale + Raw Sienna

Cadmium Yellow Pale + Titanium White

Ivory Black + Sap Green + Raw Umber

White + Raw Sienna

Black + Raw Umber + White

French Ultramarine + White

Cadmium Yellow Pale + Winsor Red

Burnt Sienna + Winsor Red

Black + Raw Umber

Raw Sienna + Raw Umber

Sap Green + White

French Ultramarine + White

1 STEP ONE

Butterfly: Use a no. 2 or 4 bright for all steps unless otherwise noted. Base off-white sections with Raw Sienna + White.

Flower: Base dark areas on petals with Burnt Sienna + Winsor Red + Cad Yellow Pale. Base far petal with Raw Sienna + Raw Umber; highlight with White. Base stamens with Cad Yellow Pale + Raw Sienna + a bit of Winsor Red. Base bud and dark value on trumpet with Cad Yellow Pale + Raw Sienna. Base light value on trumpet with Cad Yellow Pale + White. Blend where values meet.

Leaves/Stems: Base the dark values with Ivory Black + Sap Green + a bit of Raw Umber.

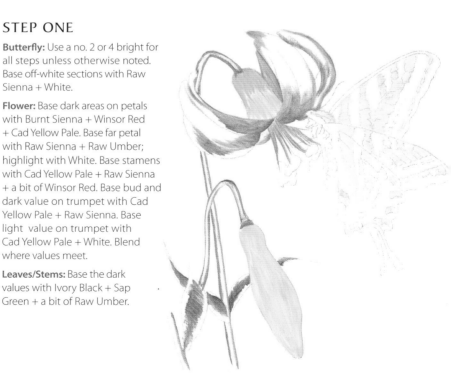

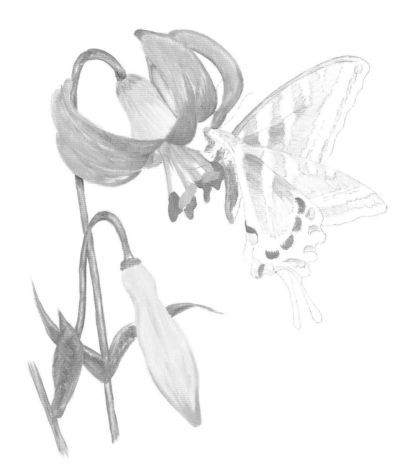

STEP TWO

Butterfly: Shade the pale spots with Raw Sienna. Add gray forewing margin with Black + Raw Umber + White. Base blue spots on wings and body with White + French Ultramarine. Base orange on body with Cad Yellow Pale + Winsor Red.

Flower: Base remaining petal areas with Cad Yellow Pale + Raw Sienna. Base red-orange anthers with Cad Yellow Pale + Winsor Red and the orange anthers with Cad Yellow Pale + Raw Sienna. Shade with a little of the dark green mix. Shade the bud with Burnt Sienna + Winsor Red.

Leaves/Stems: Base the rest with Sap Green + White or French Ultramarine + White.

STEP THREE

Butterfly: Base red spots with Winsor Red + Cad Yellow Pale. Stipple blue spots and abdomen with White to highlight. Base all dark wing and body areas with Black + Raw Umber, using chisel edge of bright to make irregular connections to the pale spot areas. Use the dark mix to add faint section lines in wings. Add White detail lines and edges on wing margins with a round brush. Add black detail on head, antennae, legs and abdomen.

Flower: Blend between values on bud and flower petals with chisel edge. Highlight both with White. Accent far petal with Winsor Red + Cad Yellow Pale. Highlight stamens with White. Highlight all anthers with Cad Yellow Pale + White. Accent trumpet with Winsor Red + Cad Yellow Pale and blend to soften the green shading. Add green shading at base of bud. Add final detail lines and spots with Winsor Red + Cad Yellow Pale. Blend red mix into the trumpet and do final blending on bud. Highlight anthers with Cad Yellow Pale + White.

Leaves/Stems: Blend with growth direction of leaves and down center of stems. Highlight with White and reblend.

Spicebush Swallowtail & Lantana

Photo by P.J. Dalton

THE SPICEBUSH SWALLOWTAIL (*Papilio troilus*) gets its name from *Lindera benzoin* or Spicebush, the preferred food plant of the caterpillars of this species. The adult butterfly enjoys nectaring on many flowers, and is shown here with Lantana. The closeup photo of the wing (at left) shows why I was inspired to develop the stippling technique used in this lesson to produce that shimmery iridescent quality. Note the individual dots—very much like what we do with the tip of a round brush!

OIL COLOR MIXES

Ivory Black + Raw Umber

Titanium White + Raw Sienna

White + French Ultramarine

White + Cadmium Yellow Pale

French Ultramarine + White

Cadmium Yellow Pale + Winsor Red

Raw Sienna + Cadmium Yellow Pale

Black + Sap Green

Sap Green + Raw Sienna + White

Previous mix + White

Dirty brush + White + French Ultramarine

Pattern: Enlarge at 185% to bring up to full size.

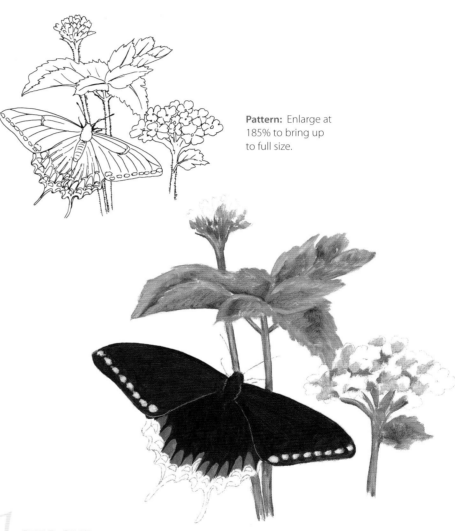

STEP ONE

Butterfly: Use a no. 2 or 4 bright for all steps unless otherwise noted. Base the forewings with Ivory Black + Raw Umber. If you get a little of the dark mix into the light spots, lift paint out with the corner of a no. 8 dampened in odorless thinner. Base the blue spots on the hindwings with French Ultramarine + White and the dark areas, including the body, with the same dark mix as for the forewings. Use a stylus to draw the division lines between the fore- and hindwings and the body.

Flower: Base some shadow areas between flowers with Cad Yellow Pale + Winsor Red, and other areas with Raw Sienna.

Leaves/Stems: Base the dark values with Ivory Black + Sap Green. Base some light edges with a pale green mix of Sap Green + Raw Sienna + White and others with a light mix of dirty brush + White + French Ultramarine.

STEP TWO

Butterfly: Usng a soft pad of cheesecloth, pat the interior areas of the forewings and the dark area of the hindwings, lifting out a little bit of the basecoat for a translucent look. Lay the tracing paper cover sheet on the painting, carefully aligning with the pattern underneath. Use a ballpoint pen to draw over the section lines back into the wet paint. Highlight ends of forewing cell and outline and highlight body with White + Raw Sienna. Base yellow markings on hindwings with White + Cad Yellow Pale. Base inner half of bicolored markings with Winsor Red + Cad Yellow Pale. Fill in remaining dark areas with Black + Raw Umber.

Stippled detail: With tip of no. 1 round brush, lay dabs of White on inner tips of blue submarginal sections. Tap on a similar amount of French Ultramarine + White above the blue sections in the median hindwing area, leaving a narrow border between this application and the blue sections below.

Flower: Base rest of the petals with Cad Yellow Pale + Winsor Red and blend a bit where values meet.

Leaves/Stems: Blend between values with the growth direction of leaves and stems. Highlight with light value mix + more White.

STEP THREE

Butterfly: Apply section lines on forewings with Black + Raw Umber using chisel edge of a bright brush.

Stippled detail: With flattened tip of round brush, tap brush into edge of blue value, walking the blue upward into the dark hindwing, allowing color to fade to basecoat. Stipple the bottom half of the white highlights in blue sections, until that value gradates back to the basecoat as well. Blend a bit between the yellow and red mixes on hindwing spots with no. 0 bright. Add White + Cad Yellow Pale spots on forewings using round brush. Soften detail on body by stippling with tip of round brush. Thin a little puddle of Black + Raw Umber and apply legs and antennae.

Flower: Highlight lightest flower petals with White, blending to soften into yellow basecoat. Add center dots with Cad Yellow Pale + Winsor Red.

Leaves/Stems: Blend highlights softly into leaves, following growth direction, using no. 4 bright. Add central vein structure with light value green mix using chisel edge. Thin a little of the same mix and use the no. 0 round to apply very fine hairs perpendicular to all the stems.

wSherry C. Nelson
© 2009

Clodius Parnassian & Bleeding Heart

CLODIUS PARNASSIAN (*Parnassius clodius*) is a tailless member of the swallowtail family. This enchanting white butterfly is found in the woodlands of western North America. It may be found at many kinds of blossoms, but uses Bleeding Heart (*Dicentra formosa*) as the host plant for its offspring. The photo shows a ventral view of this beautiful butterfly. Note the translucent hindwing, through which you can see the markings of the forewing.

OIL COLOR MIXES

White + Black + Sap Green (gray-green)

Black + a tad of White

White + gray-green mix + tad of Cadmium Yellow Pale

Alizarin Crimson + Winsor Red + White

Alizarin Crimson + Winsor Red

White + Black + touch of previous mix

Alizarin Crimsom + Raw Sienna

Alizarin Crimson + Winsor Red + Raw Sienna

Previous mix + White

Black + Sap Green

Previous mix + Sap Green + White

Previous mix + more White

Pattern: Enlarge at 147% to bring up to full size.

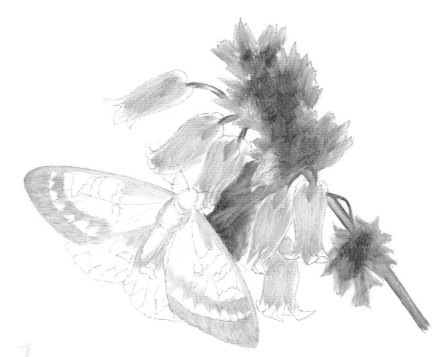

1 STEP ONE

Butterfly: Use a no. 2 or 4 bright for all steps unless otherwise noted. Base gray-green areas, including sides of body, with White + Black + Sap Green.

Flower: Base sparsely within each blossom where shown with White + Black + a touch of the red mix, Alizarin Crimson + Winsor Red.

Leaves/Stems/Flower Calyxes: Base the dark values with Black + Sap Green. Base light edges with the dirty brush + Sap Green + White.

STEP TWO

Butterfly: Base the dark costal bands with Black + a bit of White to gray. Base light sections with White + a touch of the gray-green base mix. Add a little bit of Cadmium Yellow Pale to the mix if needed to warm. Base the pink spots with Alizarin Crimson + Winsor Red + White. Base the red spots with Alizarin Crimson + Winsor Red. On the forewing margins, apply section lines with the gray-green base mix + a bit of Black. Base the dark value on the body with Black + White. Base head with Cadmium Yellow Pale. Shade a bit at the base of the head with the dirty brush + Black.

Flower: Base remaining areas of most blossoms with Alizarin Crimson + Raw Sienna. In a few places use Alizarin Crimson + Winsor Red + Raw Sienna.

Leaves/Stems/Calyxes: Blend between values with the growth direction of the leaves and stems. On leaves and calyxes, apply highlights using the light value green mix + more White.

STEP THREE

Butterfly: Apply remaining section lines on forewings with Black + tad of White, using a good chisel edge brush. Highlight in between dark lines with White, on lightest sections. Highlight pink spots with White. Accent with a bit of pink mix next to body on forewing. Highlight red spots with White. Outline with a bit of slightly-thinned Black. Highlight body with a little dirty White, creating a patch of stippled white behind head and a few lines to indicate segmented abdomen. Thin a little puddle of Black + Raw Umber and apply legs and antennae.

Flower: Blend a bit where values meet. Highlight with White, blending to soften into light base mix. Add a few streaks and striations using the chisel edge and the Alizarin mix. Highlight flipped petal tips with pure White.

Leaves/Stems/Calyxes: Blend highlights softly into leaves, following growth direction, using no. 4 bright. Add central vein structure with light value green mix using chisel edge.

Sherry C. Nelson ©2009

Chiricahua White & Sego Lily

Photo by Deborah A. Galloway

THE **CHIRICAHUA WHITE** (*Neophasia terlootii*) is endemic to the Chiricahua Mountains in southeast Arizona. It belongs to the family of whites and sulphurs known as *Pieridae*. To add this unusual butterfly to your list, you must visit the high pine country above 8,000 feet. Shown here is the female. The caterpillar host plants are Ponderosa Pine and Englemann Spruce, but adults will readily nectar on flowers such as Sego Lily found in the upland meadows and clearings.

OIL COLOR MIXES

Ivory Black + Raw Umber

Raw Umber + Black

Cadmium Yellow Pale + Winsor Red

Previous mix + Cadmium Yellow Pale

White + Cadmium Yellow Pale

Cadmium Yellow Pale + Raw Sienna

Black + Raw Umber + White

Black + Sap Green

Winsor Red + French Ultramarine

Cadmium Yellow Pale + Sap Green

White + French Ultramarine + Black

Black + Sap Green + White

Previous mix + Cadmium Yellow Pale

Pattern: Enlarge at 196% to bring up to full size.

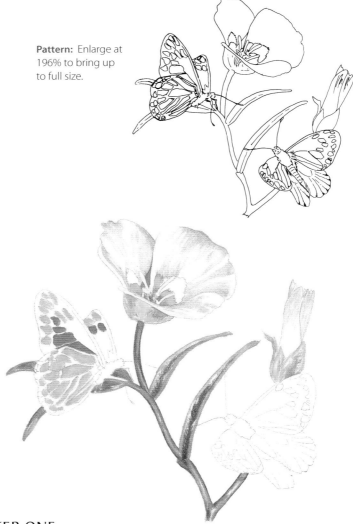

1 STEP ONE

Butterfly, female: Use a no. 2 or 4 bright for all steps unless otherwise noted. Base red sections with Winsor Red. Base yellow-orange sections on hindwing with Cad Yellow Pale + a bit of Winsor Red. Base spots at margins of both wings with very sparse Cad Yellow Pale + Raw Sienna.

Flower cup and bud calyx: Dark value is Black + Sap Green. Light value is Cad Yellow Pale + Raw Sienna. Flower center: Base yellow areas with Cad Yellow Pale. Shade at deepest part of the center with Black + Sap Green. Flower petals: Base gray areas with White + French Ultramarine + a tad of Black. Base remaining area with White.

Leaves/Stems: Base the dark values with Black + Sap Green. Base light areas with the dirty brush + Sap Green + White.

STEP TWO

Butterfly, female: Highlight red sections with Cad Yellow Pale. Tap on color with tip of a no. 0 round brush to cover no more than about one third of each section. Tap on Cad Yellow Pale + White highlights on yellow and yellow-orange sections. Base dark areas around wing spots and sections and the body of the female with Raw Umber + Black.

Butterfly, male: Base all dark areas including body with Black acrylic using no. 0 round brush. When finished, clean acrylic out of brush well before continuing with oils. Fill in white sections with White oil paint. Thin Black + Raw Umber and apply legs and antennae.

Flower cup and bud calyx: Blend between values with growth direction. Highlight with White. Add the violet accent areas on flower cup with a mix of Winsor Red + French Ultramarine. Flower center: Highlight at base of stamens with White. Base stamens with White + Cad Yellow Pale or yellow + a little Raw Sienna. Base dark band with Black + Raw Umber. Base violet patches with Winsor Red + French Ultramarine. Flower petals: Blend between values with dry brush, establishing growth direction in each petal area.

Leaves/Stems: Blend between values with growth direction. Apply highlights using light value green mix + more White.

STEP THREE

Butterfly, female: Stipple to blend all highlight colors applied to sections in Step 2 using the flattened tip of a no. 1 round brush. Remember, your goal is to create a gradation of value within each section.

Butterfly, male: Highlight white sections with more White to strengthen.

Butterflies, male and female: With a bit of White, stipple some highlights at the base of the forewings next to body, blending to soften. Then walk a bit of stippled White along the costal margin (the leading edge of the forewing) on both wings. Start with fresh White on the round brush and let the paint run out as you tap the light up the wing margins. Bodies: Highlight with a little dirty White, creating bits of stippled white on and behind head and a few lines to indicate segmented abdomen. Antennae: With slightly thinned white on a no. 0 round, tap on a row of tiny dots down the length of the antennae, starting with the tip and letting brush run out of color as you near the butterfly's head.

Flower cup and bud calyx: Blend highlights to soften. Flower center: Highlight stamens with stippled White. Soften violet patches just slightly into base of petals. Flower petals: Highlight with White, then blend to soften into base mix. Accent bud with violet mix.

Leaves/Stems: Blend highlights softly into leaves, following growth direction, using no. 4 bright. Add central vein structure with light value green mix using chisel edge.

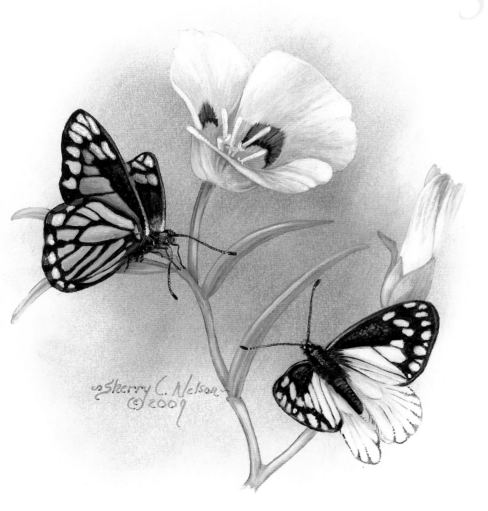

Checkered White & Sierra Arnica

Photo by Sherry C. Nelson

WIDESPREAD AND COMMON, Checkered Whites (*Pontia protodice*) are found in all of the lower 48 states, where both males and females are attracted to nectar-producing flowers of many kinds. The females lay their eggs on mustards of many species. The beautiful female (shown at left) is much more strikingly marked with dark than is the lighter male.

OIL COLOR MIXES

Ivory Black + Titanium White

White + Black

White + Black + French Ultramarine

Cadmium Yellow Pale + Raw Sienna

White + Cadmium Yellow Pale

Cadmium Yellow Pale + Burnt Sienna

Black + Sap Green

Sap Green + Raw Sienna + White

Previous mix + White

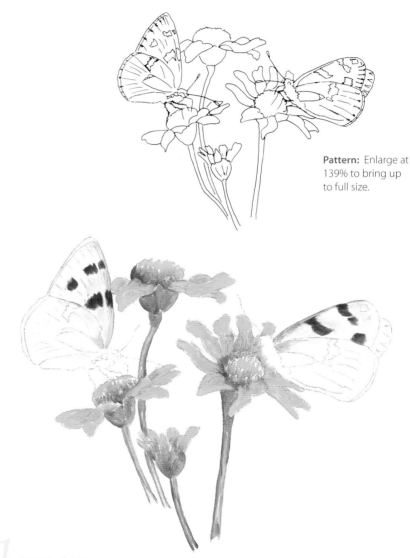

Pattern: Enlarge at 139% to bring up to full size.

1 STEP ONE

Butterfly: Use a no. 2 or 4 bright for all steps unless otherwise noted. Base forewing markings with Black + White. Base leading edge of forewing and a portion of hindwing margin with Raw Sienna. Base white areas with a very pale gray mix of White + Black + French Ultramarine.

Flower center: Use a no. 0 bright to base dark in centers with Burnt Sienna. Base median areas with Cad Yellow Pale + Burnt Sienna. Base lightest value with Cad Yellow Pale. Flower petals: Base dark value with Raw Sienna + Cad Yellow Pale. Base light value with Cad Yellow Pale.

Stems/Calyxes: Base the dark values with Black + Sap Green. Base light areas with Sap Green + Raw Sienna + White.

STEP TWO

Butterfly: Highlight markings on forewing with a little White + Black. Blend Raw Sienna margins slightly into wing. Soften markings into wings, just enough to connect colors. Shade hindwing with White + Black to indicate shadows of spots, and the shadow of the body visible through the hindwing. Body: Place dark on head and body with no. 0 bright using Black + White.

Flower center: Chop where values meet with chisel edge of no. 0 bright to create a value gradation. Flower petals: Blend between values with dry brush, establishing growth direction in each petal area. Add highlights with White + Cad Yellow Pale on the tips of some of the dominant petals and on overlapping edges to separate.

Stems/Calyxes: Blend between values with growth direction of leaves and stems. Apply highlights using light value green mix + more White.

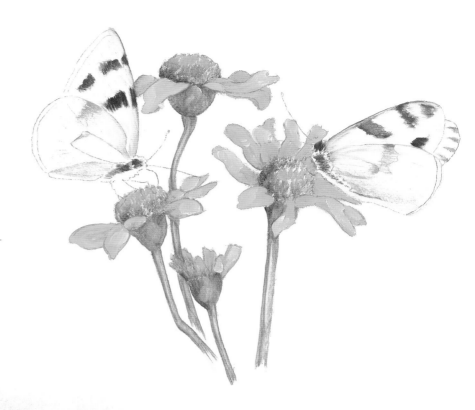

STEP THREE

Butterfly: Highlight Raw Sienna wing margins with a bit of White. Highlight whitest sections on both wings with pure White. Soften shading on hindwing. Add final detailing on wing margins and section lines using a no. 0 round brush and slightly thinned White + Black. Body: Fill in rest of body with dirty White, slightly softening into dark value on thorax. Highlight head with a bit of White. Antennae: Thin a little puddle of Black + a bit of White and apply legs and antennae with no. 0 round. Dot tips of antennae with White.

Flower center: Highlight in lightest areas with stippled White + Cad Yellow Pale. Blend highlights on petals to soften into base mix. Re-highlight with White if needed.

Stems/Calyxes: Blend highlights softly in all areas, following growth direction, using a no. 2 or 4 bright.

Orange Sulphur & Marigold

VERY COMMON IN ALL of the lower 48 states and much of Canada, this female is a member of the most widespread species of our native orange sulphurs (*Colias eurytheme*). They utilize many open habitats, and may be seen fluttering in the hundreds in alfalfa fields, one of many host plants for the caterpillars besides locoweed, clovers and other legumes. Easily confused at certain times of the year with Clouded Sulphurs, care is needed when identifying these for your checklist.

OIL COLOR MIXES

White + Cadmium Yellow Pale + Sap Green

White + Black + French Ultramarine

Black + White

White + Black + French Ultramarine + Sap Green

White + Alizarin Crimson + Burnt Sienna

Black + Raw Umber

Raw Umber + Raw Sienna

Cadmium Yellow Pale + Winsor Red

White + Cadmium Yellow Pale

Black + Sap Green

Previous mix + Sap Green + White

Previous mix + more White

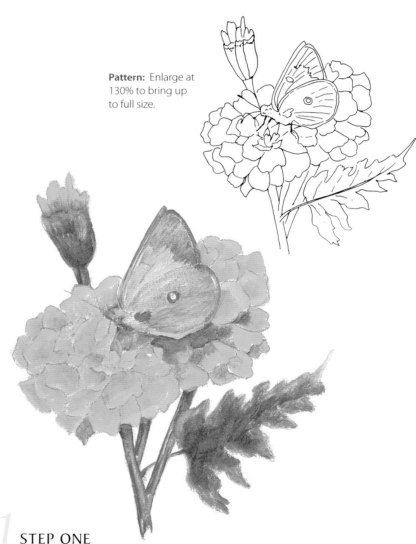

Pattern: Enlarge at 130% to bring up to full size.

1 STEP ONE

Butterfly: Use a no. 2 or 4 bright for all steps unless otherwise noted. Base greenish yellow area on forewing and underside of body with a bit of White + Cad Yellow Pale + Sap Green. Rest of yellow on forewing is based with Cad Yellow Pale. Base upper half of hindwing with the same greenish mix of White + Cad Yellow Pale + Sap Green. Base gray areas on both wings and body with White + Black + French Ultramarine. Base pinkish margins on both wings, around spot on hindwing and on body with Burnt Sienna + Alizarin Crimson + White.

Flower petals: Base darkest values under butterfly with Raw Sienna + Raw Umber. Base dark value within most petals with Raw Sienna. Base light values with Cad Yellow Pale.

Leaves/Stems/Calyx: Base the dark values with Black + Sap Green. Base light areas with the dirty brush + Sap Green + White.

STEP TWO

Butterfly: Blend between values in yellow forewing. Accent with Cad Yellow Pale + Winsor Red. Blend to connect colors on hindwing. Soften yellow on body into hindwing. Set in section lines and shade with Black + White on all gray wing areas. Shade reddish margins with a bit of Raw Umber. Highlight forewing margins with dirty brush + White. Outline spot on forewing with Black + Raw Umber.

Flower petals: Blend between values with dry brush, establishing growth direction in each petal area. Accent some tips and edges of petals with Cad Yellow Pale + Winsor Red. Shade in darkest shadow areas with Raw Sienna + Raw Umber.

Leaves/Stems/Calyx: Blend between values with growth direction of leaf and stems. Apply highlights using light value green mix + more white. Accent bottom half of leaf, a place or two on the stems, and on calyx with Raw Sienna.

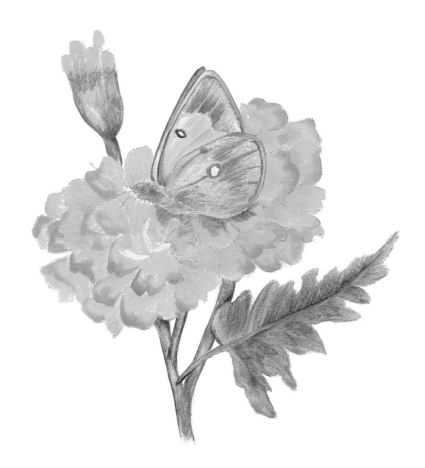

STEP THREE

Butterfly: Soften the red-orange shading on forewing into the basecoat. Add faint White or White + Cad Yellow Pale section lines to connect to those in gray areas. Soften shading in between veins in gray outer wing areas. Highlight on opposite side of section line with white and blend slightly, leaving a line to define the section. The end result is to create a ridged look of a raised vein structure (see page 24). With slightly-thinned reddish mix used on wing margins and a no. 0 round, base legs and antennae. Highlight with White on legs and tips of antennae.

Flower petals: Blend between values with a dry brush, re-establishing growth direction in each petal area. Highlight with White + Cad Yellow Pale and then with White alone, blending to soften into base mix.

Leaves/Stems/Calyx: Blend highlights and Raw Sienna accents softly into leaf, following growth direction, using no. 4 bright. Add central vein structure with light value green mix using chisel edge. Add a few dark veins of dark green mix to detail calyx.

Sherry C. Nelson © 2009

Stella Orangetip & Rockcress

Photo by Deborah A. Galloway

THE STELLA ORANGETIP (*Anthocharis stella*) is one of the most difficult butterflies to photograph. An early-spring flier, it is often the first butterfly to be seen in February and March here in Arizona. Painted here with rockcress, a favored food plant for the caterpillars, the preferred habitat for Orangetips includes canyon slopes in foothills, creek bottoms and mountain meadows and hillsides, such as the one in this photo.

Pattern: Enlarge at 156% to bring up to full size.

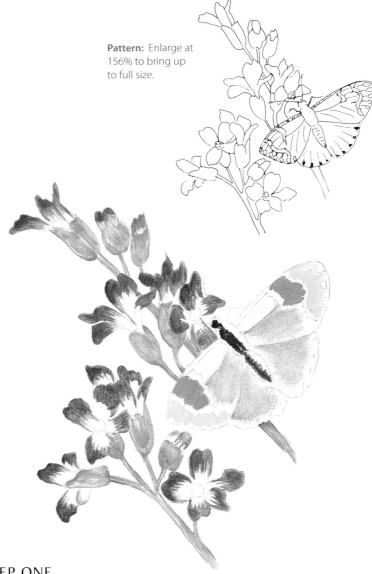

OIL COLOR MIXES

Cadmium Yellow Pale + Winsor Red

Previous mix + more Cadmium Yellow Pale

White + Cadmium Yellow Pale

Black + Raw Umber

White + Cadmium Yellow Pale + Black

White + Black + Raw Umber

Raw Sienna + Burnt Sienna

Alizarin Crimson + French Ultramarine

Raw Sienna + Sap Green

STEP ONE

Butterfly: Use a no. 2 or 4 bright for all steps unless otherwise noted. Base orange forewing markings with Cad Yellow Pale + Winsor Red. Base yellow submarginal band with White + Cad Yellow Pale. Base central area of wings with White + Cad Yellow Pale + a tad of Black. Base dark value on body with Black + Raw Umber.

Flower petals: Base dark value with Alizarin Crimson + French Ultramarine.

Stems/Calyxes: Base the dark values with Burnt Sienna + Raw Sienna. Fill in greenish areas with Raw Sienna + Sap Green + White.

STEP TWO

Butterfly: Highlight orange forewing sections with base mix + Cad Yellow Pale. Apply color on one-half of the section and stipple gradually into the other half, using the flattened tip of a no. 0 round brush. Highlight yellow submarginal spots with stippled White. With pure White on a no. 4 bright, overlay the central wing areas, blending white into the greenish basecoat, following growth direction. Base rest of body with no. 0 bright using White + Black + Raw Umber. Blend a little where values meet.

Flower: Base flower centers with Raw Sienna + Sap Green. Base rest of petals with White. Blend with growth direction where values meet. Re-highlight with White.

Stems/Calyxes: Blend between dark and light values with growth direction of calyxes and stems. Apply highlights using light value green mix + more White.

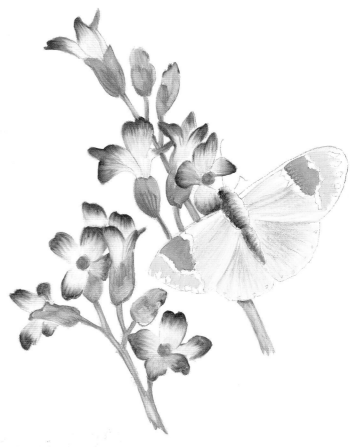

STEP THREE

Butterfly: Add Burnt Sienna section lines within orange sections. Highlight white wings with pure White. Accent with a bit of White + Cad Yellow Pale. Use slightly thinned Black + Raw Umber to detail all the black markings on either side of the orange sections and along wing margins. Using a good chisel, touch in the dark section lines, faintly, onto the white wings. Body: With small chisel edge, pull a little dark value mix across the abdomen to suggest body segments. Add Black eyes. Highlight head with a bit of White. Thin a little puddle of Black and apply legs and antennae with no. 0 round. Dot clubs of antennae with orange mix. Detail antenna with dots of White applied with no. 0 round.

Flower: Detail the centers with three round, evenly spaced dots of Cad Yellow Pale + Winsor Red using the round brush. Blend highlights on petals to soften into base mix.

Stems/Calyxes: Blend highlights softly in all areas, following growth direction, using a no. 2 or 4 bright.

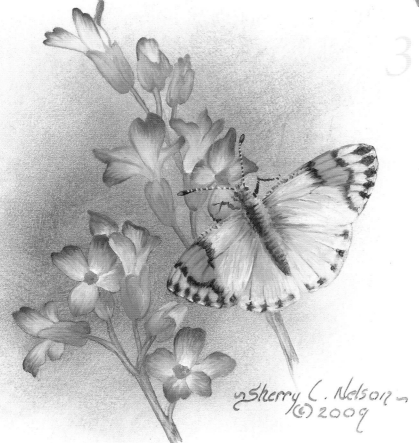

Sherry C. Nelson
(c) 2009

California Marble & Tansy Mustard

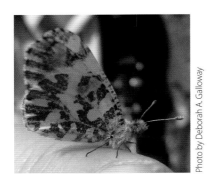

Photo by Deborah A. Galloway

THE COMPLEX PATTERNING of the underwing of this interesting White makes the California Marble (*Euchloe hyantis*) a personal favorite. It is painted here with Tansy Mustard, one of the choice larval food plants for this species. At left is a close-up photo of the extraordinary marbling on the underside from which this butterfly gets its name. Note the interesting yellow veining, yellow next to the body, and the bulbous clubs on the antennae.

OIL COLOR MIXES

Black + White

White + Cadmium Yellow Pale

Raw Umber + Cadmium Yellow Pale

Black + Cadmium Yellow Pale

Black + Raw Umber

Black + Sap Green

Sap Green + Raw Sienna + White

Raw Sienna + Cadmium Yellow Pale

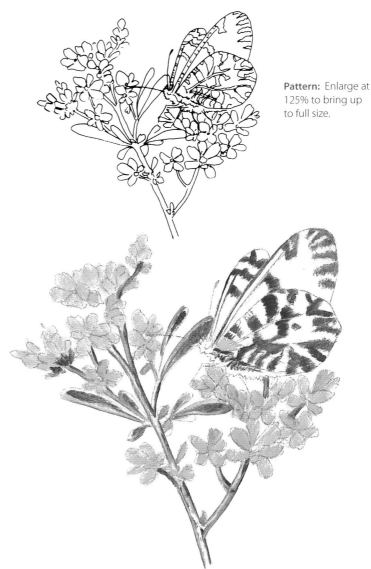

Pattern: Enlarge at 125% to bring up to full size.

STEP ONE

Butterfly: Use a no. 2 or 4 bright for all steps unless otherwise noted. Far forewing: Base dark markings with Black + White. Near forewing: Base dark markings with Raw Umber + Cad Yellow Pale. Near hindwing: Base dark markings with Raw Umber + Cad Yellow Pale. Base the yellow spot at the base of the wing with Cad Yellow Pale. Base dark area on body with Black + White.

Flower petals: Base roughly with Raw Sienna + Cad Yellow Pale.

Leaves/Stems/Calyx: Base the dark values with Black + Sap Green. Base some stem edges and one side of each leaf with Raw Sienna.

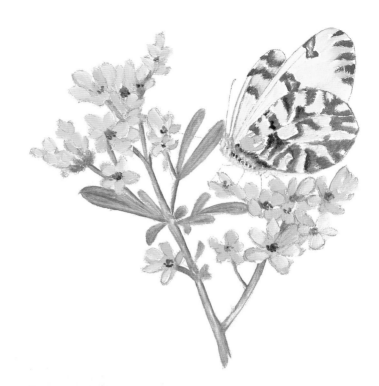

STEP TWO

Butterfly: Far forewing: Base light value with White + just a tad of Cad Yellow Pale. Near forewing: Base between margin detail with Cad Yellow Pale. Fill in remaining light value areas with White + Cad Yellow Pale. Near hindwing: Shade a few of the brown markings with Black + Cad Yellow Pale. Fill in all light value areas with White + Cad Yellow Pale. Body: Fill in rest of body with pale yellow mix and blend slightly with a no. 0 bright into the dark value.

Flower petals: Fill in remaining areas of petals with White + Cad Yellow Pale, and blend into the basecoat to smooth and shape. Add dark centers with dabs of Burnt Sienna or some dark green mix.

Leaves/Stems/Calyx: Base remaining areas with the previous mix + Sap Green + White. Blend where values meet.

STEP THREE

Butterfly: Far forewing: Highlight between dark markings with pure White. Add dark detail markings with Black + White. Near forewing: Highlight with White. Highlight within some dark markings with White + Cad Yellow Pale. Add detail markings on forewing margin with Black + White using a round brush. Lay in yellow vein lines with chisel edge of no. 2 bright. Near hindwing: Highlight between markings with pure White. Highlight within some markings with White + Cad Yellow Pale. Body: Highlight head and bottom of thorax with White. Base legs with White, slightly thinned, using no. 0 round. Shade legs with a bit of Raw Umber + Cad Yellow Pale mix, again using round. Base antennae with slightly thinned White, using no. 0 round. Tip with Cad Yellow Pale.

Flower petals: Highlight with White + Cad Yellow Pale and then with White, blending to soften into base mix. Highlight a few flower centers with tiny dabs of White using no. 0 round brush.

Leaves/Stems/Calyx: Highlight with light green mix + more White. Blend with growth direction.

Sherry C. Nelson
© 2009

Purplish Copper & Bulbine Candescens

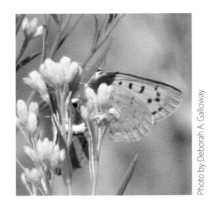

Photo by Deborah A. Galloway

THOUGH SUBTLE, THE VIOLET tinge on the underwing of a fresh male in the sun is quite striking. Purplish Coppers (*Lycaena helloides*) often set with wings folded, so it's not easy to get a glimpse of the patterned red-orange upperside of the wings that gives them the name "copper." They are part of the gossamer-winged butterfly family, *Lycaenidae*. The caterpillar host plants for this species include dock, knotweed and cinquefoil. *Bulbine candescens* is a perennial plant native to South Africa but naturalized in several states.

OIL COLOR MIXES

Alizarin Crimson + French Ultramarine

White + Black

Raw Sienna + Cadmium Yellow Pale

White + Raw Sienna

Cadmium Yellow Pale + Winsor Red

Black + Raw Umber

Raw Sienna + Cadmium Yellow Pale + Winsor Red

Black + Sap Green

Sap Green + White

White + Cadmium Yellow Pale

Black + Sap Green + White

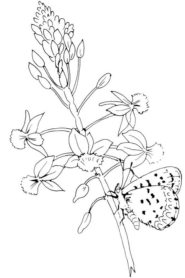

Pattern: Enlarge at 135% to bring up to full size.

STEP ONE

Butterfly: Use a no. 2 or 4 bright for all steps unless otherwise noted. Base purplish bands on both wings with Alizarin Crimson + French Ultramarine. Base gray at base of wings with Black + White. Base yellow on hindwing with Raw Sienna + Cad Yellow Pale. Base yellow on forewing with Raw Sienna + Cad Yellow Pale + Winsor Red. Base underside of abdomen with gray mix and upperside with yellow mix.

Flower: Base petals with Cad Yellow Pale + Winsor Red. Flower stems: Base outside edges with Burnt Sienna, filling in remainder with Raw Sienna. Stamens: Base yellow areas with Cad Yellow Pale. Buds: Base dark value with Burnt Sienna. Base light tips with Cad Yellow Pale.

Stems/Green Buds: Base the dark values with Black + Sap Green.

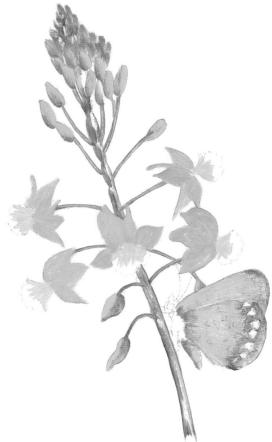

STEP TWO

Butterfly: Blend values where they meet using chisel edge of small bright. Highlight in yellow wing areas with White + Raw Sienna. Fill in spots on hindwing margin with White. Highlight along margin of forewing with White. Body: Blend between values. Fill in rest of body with White. Thin a little puddle of Black + Raw Umber and apply legs and antennae.

Flower: Shade petals with Alizarin Crimson. Highlight with White + Cad Yellow Pale. Flower stems: Highlight with White + Raw Sienna. Stamens: Shade at base of cluster with Raw Sienna + Raw Umber. Buds: Blend where values meet. Highlight with White + Cad Yellow Pale.

Stems/Green Buds: Base light areas with Black + Sap Green + White.

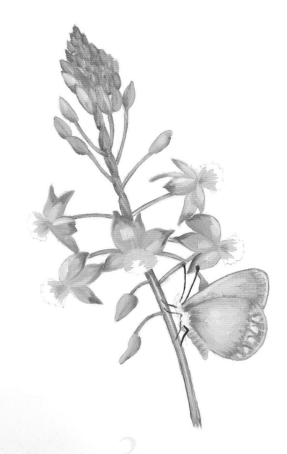

STEP THREE

Butterfly: Do spot detail on wings with slightly-thinned Black + Raw Umber using the round brush. Create orange submarginal band on hindwing with Cad Yellow Pale + Winsor Red, using a no. 0 bright. Highlight outer edge of both wing margins with White, using a round brush to create a fringed look. Body: Highlight with bits of stippled White on and behind head and a few lines to indicate segmented abdomen. Fill in eye with Black. Antennae: With slightly thinned White, tap on a row of tiny dots down the length of the antennae, starting with the tip and letting brush run out of color as you near the butterfly's head. Tip antennae with Cad Yellow Pale. Highlight legs with a bit of White.

Flower: Blend petals where values meet. Add center vein line with dark red. Re-highlight if needed. Flower stems: Blend if needed. Stamens: Base rest of stamen area with stippled White. Add a few dots of White to indicate pollen at tips of fuzzy area. Buds: Blend highlights.

Stem/Green Buds: Blend between values with growth direction. Apply highlights using Sap Green + White.

Gray Hairstreak & Texas Bluebonnet

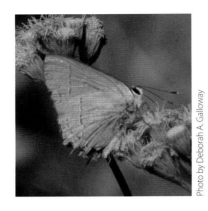

Photo by Deborah A. Galloway

ALL ACROSS THE UNITED STATES, this is the hairstreak that the observant butterfly fan is most likely to see. Since these gossamer-wings occur in every single state of the lower 48, if you see a "gray" hairstreak, odds are, it's this one (*Strymon melinus*). The caterpillar host plants include the flowers of legumes, mallows and many others. Note the missing "tails" on the hindwing of this Gray Hairstreak in the photo at left, nipped away by a predator who was no doubt attracted by the twiddling of the hindwing filaments.

OIL COLOR MIXES

Cadmium Yellow Pale + Winsor Red

Black + Raw Umber + White

Black + Raw Umber + a bit of White

Previous mix + White

White + French Ultramarine

Cadmium Yellow Pale + Sap Green + White

French Ultramarine Blue + Alizarin Crimson

Alizarin Crimson + French Ultramarine Blue + White

Black + Sap Green

Cadmium Yellow Pale + Sap Green + more White

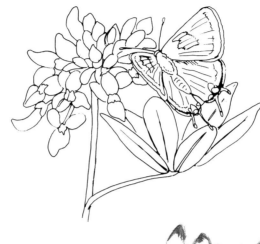

Pattern: Enlarge at 120% to bring up to full size.

1 STEP ONE

Butterfly: Use a no. 2 or 4 bright for all steps unless otherwise noted. Base the orange spots with Cad Yellow Pale + Winsor Red. Base the black spots with Black. Base gray on both wings and the body with Black + Raw Umber + White.

Flower petals: Base tips of upper petals with sparse French Ultramarine. Base centers of older blossoms with Alizarin Crimson + French Ultramarine + White.

Stems/Leaves/Unopened Buds: Base the dark values with Ivory Black + Sap Green. Base light values with Cad Yellow Pale + Sap Green + White.

2 STEP TWO

Butterfly: Shade median forewings and edges next to white margins with Black + Raw Umber + tad of White. Base wing margins with White. Body: Shade thorax and interior of abdomen with Black + Raw Umber + tad of White. Outline thorax with irregular band of White + French Ultramarine. Base filaments at ends of hindwings with Black. Thin a little puddle of Black + Raw Umber and apply antennae using no. 0 round.

Flower petals: Fill in remainder of upper lighter petals with White. Base the darker blue petals on flowers below with French Ultramarine. Highlight some of the petals with White. Highlight centers with White.

Stems/Leaves/Unopened Buds: Blend where values meet with growth direction. Highlight with light green mix + White.

3 STEP THREE

Butterfly: Stipple pointed tops of orange spots with Cad Yellow Pale using round brush. Blend shading to soften into wing. Accent at base of hindwings next to body with White + French Ultramarine. Soften into basecoat. Add a bit of faint White detailing at edge of sub-marginal band—on top of where the darker band ends and the light inner wing begins. Highlight filaments with White. Add section lines with chisel edge of no. 4 using Black + Raw Umber + a bit of White. With pure White on round brush, stipple clean, textured white along wing margins for highlight. On trailing edge of forewings, break through the white "border" so that the wing edge appears a bit hairy and frayed. Body: Using round brush, highlight head with White. Add a few curving lines of White to indicate segmented abdomen, using a round brush. Place a Black line behind the white on head. Add an orange band behind that, using round brush. Tip antennae with Cad Yellow Pale + Winsor Red highlight dots. With White, add a row of spaced dots using round brush.

Flower petals: Blend where values meet on lighter petals. Accent older flowers with Alizarin Crimson + French Ultramarine for a violet cast and blend a little to connect values. Re-highlight with White to enhance. Add center line of light on a few petals.

Stems/Leaves/Unopened Buds: Blend high-lights with growth direction. Add sufficient White highlight in unopened buds that they are almost White, with just a greenish cast.

Sherry C. Nelson
© 2009

Separata Stripestreak & Crinum

Photo by Deborah A. Galloway

OIL COLOR MIXES

Raw Sienna + Burnt Sienna

Raw Sienna + Raw Umber

Alizarin Crimson + Sap Green

Previous mix + White

White + Black

Black + Sap Green

White + Sap Green + Raw Sienna

Sap Green + Raw Sienna + White

Previous mix + White

THIS SUPERB SEPARATA STRIPESTREAK (*Arawacus separata*) was photographed in Ecuador. Many hairstreaks in the tropics amaze and delight with their decorative patterns and long filaments projecting from the hindwings. The Separata's hindwing has adapted into a strange shape that looks far more like the head than the head itself does. And just like North American gossamer-wings, this beautiful bug "twiddles" its hindwings to draw a predator's attention to the filaments rather than the head. It is painted here with Candy-striped Crinum.

Pattern: Enlarge at 152% to bring up to full size.

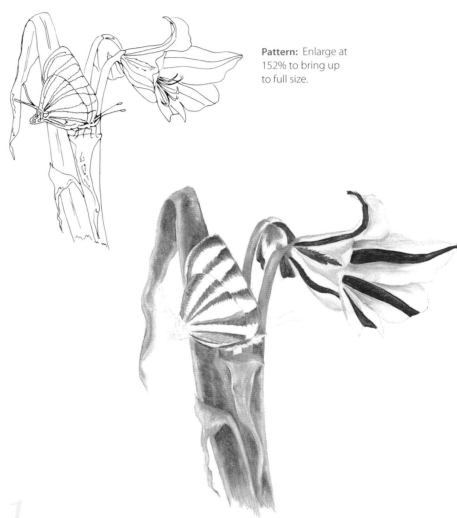

1 STEP ONE

Butterfly: Use a no. 2 or 4 bright for all steps unless otherwise noted. Base rust stripes on wings with Raw Sienna + Burnt Sienna. Base darker stripes with Raw Sienna + Raw Umber. Body: Base dark area under the wings with Raw Umber.

Flowers: Apply shading within petals using Black + Sap Green or Raw Sienna or both. Then apply White + Black, primarily along undersides of petals and where petals would roll and turn. Fill in rest of petals with White. Base red streaks with Alizarin Crimson + Sap Green.

Leaves/Stems: Base the dark values with Ivory Black + Sap Green. Base light values with Sap Green + Raw Sienna + White. Base tips of tendrils with Raw Sienna.

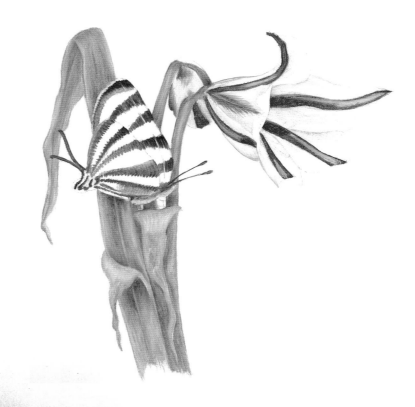

2 STEP TWO

Butterfly: Blend where rust bands meet darker stripes. Shade the darker stripes with Raw Umber. Base tails with Raw Umber using a no. 0 bright. With a round brush, place narrow bands of Raw Umber in the hindwing fold to which the tails are attached. Body: Base rest of body with White. Blend a little where the dark and light values meet. Thin a little puddle of Raw Umber and apply antennae using a no. 0 round brush.

Flowers: Blend where values meet on light areas of petals, following the growth direction of the petal in each area. Highlight red stripes with Alizarin Crimson + Sap Green + White.

Leaves/Stems/Calyx: Blend where values meet with growth direction. Highlight with light green mix + White. Accent leaf tips with Burnt Sienna.

3 STEP THREE

Butterfly: Blend the shading color to soften. Highlight with pure White on white stripes, concentrated on outer wing next to the margin, and blending with the direction of the section lines. With a dry no. 2 bright, gently work brush where dark bands meet the white so they appear connected. With White, highlight a bit on the "tails." Body: Highlight with White. Use slightly-thinned Raw Umber to draw in legs. Highlight legs with a bit of White. Using no. 0 round, tip antennae with White.

Flower petals: Highlight with White on white parts of petals and reblend. Blend highlights on pink stripes to soften.

Leaves/Stems: Blend highlights following growth direction. Soften Burnt Sienna accent into basecoat. Re-highlight where leaves fold down if needed.

Western Pygmy Blue & Slender Cinquefoil

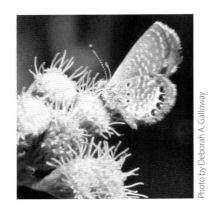

Photo by Deborah A. Galloway

THE **PYGMY BLUES** (*Brephidium exilis*) are the smallest butterflies in North America with the entire wingspan just a bit more than 1/2 inch (13mm). During the summer, despite its minute size, this tiny creature migrates northward to lay its blue-green eggs. The caterpillars, which are nearly invisible except with a magnifying lens, feed on pickleweed, saltbush and Russian thistle. Adults use many flowers for nectar; here it's painted with slender cinquefoil.

OIL COLOR MIXES

Cadmium Yellow Pale + Burnt Sienna

Cadmium Yellow Pale + Winsor Red

Alizarin Crimson + French Ultramarine + White

Black + Raw Umber

Black + Raw Umber + White

White + Black + Raw Umber

Black + Sap Green + a tad of White

Sap Green + Raw Sienna + White

Previous mix + White

Sap Green + Raw Sienna

Raw Sienna + Burnt Sienna

Cadmium Yellow Pale + Raw Sienna

White + Cadmium Yellow Pale

Pattern: Enlarge at 159% to bring up to full size.

STEP ONE

Butterfly: Use a no. 2 or 4 bright for all steps unless otherwise noted. Base orange mid-wing with Cad Yellow Pale + Burnt Sienna. Base red-orange areas with Cad Yellow Pale + Winsor Red. Body: Base upper half of abdomen with Cad Yellow Pale + Winsor Red.

Flowers: Base centers and base of each petal with Raw Sienna + Cad Yellow Pale. Base outer edges of petals with Raw Sienna.

Stems/Leaves/Calyxes: Base the dark values with Black + Sap Green + a tad of White.

Magnifier: Base handle with Black + Raw Umber. Base metal bracket with Black + Raw Umber + White. Around the metal rim of the lens, place all dark values with Black + Raw Umber + White. Use sparse paint to define edge.

2 STEP TWO

Butterfly: Blend between the orange and red-orange mid-wing areas. Establish faint rows of yellow markings following curvature of the wing, using Cad Yellow Pale on a no. 1 round brush. Add violet marginal bands and basal wing areas with Winsor Red + French Ultramarine + White. Base wing margins with White. Body: Base the base of the abdomen and the upper body with violet mix. Thin a little Black + Raw Umber and apply antennae using a no. 0 round.

Flower: Fill in remainder of petals with White. Highlight flower centers with Cad Yellow Pale + White.

Stems/Leaves/Calyxes: Base light value areas with Sap Green + Raw Sienna + White. Blend where values meet. Highlight with light green mix + White.

Magnifier: Highlight handle and metal bracket with White + Raw Umber + Black. On the metal rim, base light value with White + Raw Umber + Black. Blend between values. On the glass lens, scruff a little light gray mix in the direction of the reflective "sheen" using a dry brush.

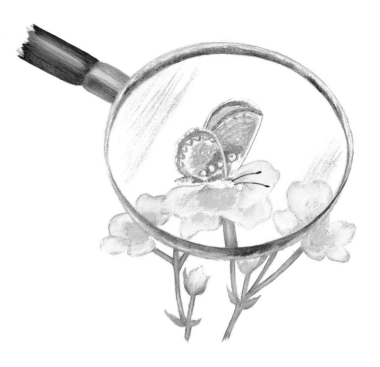

3 STEP THREE

Butterfly: With pure White on a no. 0 bright, base white sections on fore- and hindwings. Use a no. 0 round to base all white spots and markings with White. Highlight wing margins with additional White. Add dark spots with Black + Raw Umber. Base rest of body with White. Soften into dark values. Add eye with Black using round brush. Add legs with White. Tip antennae with White highlight dots and add row of spaced dots along antennae.

Flower: Blend petals where values meet. Highlight with White to enhance. Detail around edges of centers with Raw Sienna + Burnt Sienna using round brush. Stipple a little more highlight on centers with White + Cad Yellow Pale.

Stems/Leaves/Calyxes: Blend highlights with growth direction.

Magnifier: Blend highlights on handle and metal bracket to soften. Rehighlight with slightly lighter gray value if needed for shine. On the metal rim, blend vertically between values. Add White highlights on some edges to create a bit of shine. On the glass lens, rub with cheesecloth to remove most of the light gray mix, leaving a hazy look.

Sherry C. Nelson
© 2008

Common Blue & Bird's Foot Trefoil

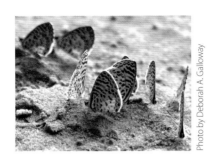

Photo by Deborah A. Galloway

OIL COLOR MIXES

Burnt Sienna + Raw Umber

Cadmium Yellow Pale + Burnt Sienna

White + Black + Raw Umber

White + Black + Raw Umber + French Ultramarine

Cadmium Yellow Pale + Raw Sienna

White + Black + Raw Umber

Black + Sap Green + a tad of White

Previous mix + Sap Green + White

Previous mix + more White

THIS BUTTERFLY IS EUROPE'S most common and widespread blue (*Polyommatus icarus; Astralagus*), and is found north to the Outer Hebrides and in a range of habitats from meadows, coastal dunes, woodland clearings and gardens, wherever its preferred food plants, such as the Bird's Foot Trefoil (*Lotus pedunculatus*) are found. The photo at left shows a group of Cassius Blues having a puddle party, sipping minerals and nutrients from damp sand and mud along an artery of the Amazon River. This species was photographed in Brazil but it may be found as far north as Florida and South Texas, just as the Common Blue painted here is European—but has a very close cousin in the U.S.—the Anna's Blue.

Pattern: Enlarge at 120% to bring up to full size.

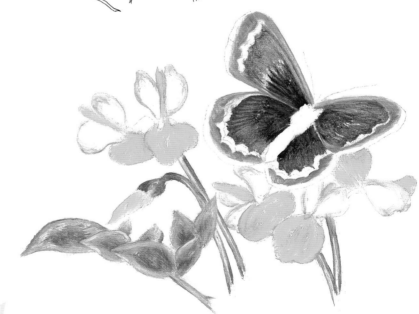

1 STEP ONE

Butterfly: Use a no. 2 or 4 bright for all steps unless otherwise noted. Rusty orange midwing: Base with Burnt Sienna. Basal wing areas: Base with French Ultramarine. Dark gray bands: Base with White + Black + Raw Umber. Wing margins: Outline with previous mix + more White and fill in with pure White.

Flower petals/Bud: Outline white petals with a gray mix of White + Black + Raw Umber. Base yellow petals with Cad Yellow Pale + Raw Sienna.

Leaves/Stems/Calyxes: Base the dark values with Black + Sap Green + a tad of White. Base light values with the previous mix + Sap Green + White.

STEP TWO

Butterfly: Blend between the rusty-orange and the blue midwing areas with chisel edge of brush. Establish a scalloped row of strong yellow markings following curvature of the wing, using Cad Yellow Pale + Raw Sienna on the round brush. Next to that, fill in remaining markings with White to which just a bit of Cad Yellow Pale has been added. Base body with White + Black + Raw Umber + French Ultramarine. Thin a little puddle of Black + Raw Umber and apply antennae using no. 0 round.

Flower petals/Bud: Fill in remainder of light petals with White. Blend where values meet. Shade yellow petals with Burnt Sienna. Highlight with White.

Leaves/Stems/Calyx: Where values meet, blend with growth direction. Highlight with light green mix + White.

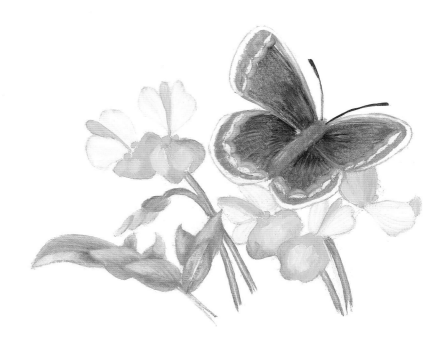

STEP THREE

Butterfly: Begin detailing at edge of wing. With slightly-thinned Black + Raw Umber, use a no. 0 round to dot in a very fine line of black inside the margin of wing. With same color, but on a no. 2 bright, lay in short dark section lines to bisect the gray bands. Then, with same dark mix on the round brush, lay in dark scallops inside gray bands. Shade body with blue-gray mix. Highlight with fuzzy White detail on thorax and add a few faint lines to segment abdomen. Add eyes with Black using round brush. Using no. 0 round with slightly-thinned White, add a row of spaced dots along the antennae.

Flower petals/Bud: Blend yellow petals where values meet. Streak in a few lines of slightly-thinned Burnt Sienna for detail. Highlight with White to enhance. Detail flower centers with two firm round dots of Cad Yellow Pale. Highlight with a speck of White.

Leaves/Stems/Calyx: Blend highlights with growth direction.

Red-Bordered Pixie & Yellow Elder

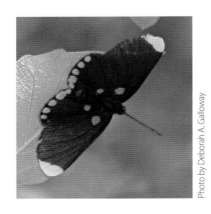

Photo by Deborah A. Galloway

IN THE NEXT FIVE DEMOS, we will look at the butterfly family known as Metalmarks (*Riodinidae*), named for the reflective or metallic markings often found on their wings. The Red-bordered Pixie shown here was photographed in South Texas. Unlike other species, this butterfly holds its antennae straight out and very close together. Pixies may fly in overcast, drizzly weather, unlike most other butterflies. Adults feed on nectar from a variety of plants, including Lantana and citrus. In the U.S., they are found only in South Texas and south to Costa Rica.

OIL COLOR MIXES

Cadmium Yellow Pale + Raw Sienna

Cadmium Yellow Pale + Winsor Red

White + Cadmium Yellow Pale

Winsor Red + a tad of Cad Yellow Pale

Black + Raw Umber

Previous mix + White

Sap Green + Raw Sienna

Burnt Sienna + Raw Sienna

Black + Sap Green

Sap Green + White

Previous mix + White

Pattern: Enlarge at 161% to bring up to full size.

1 STEP ONE

Butterfly: Use a no. 2 or 4 bright for all steps unless otherwise noted. Base red spots with Winsor Red. Base apex of each wing with Cad Yellow Pale + Raw Sienna.

Flowers: Base petals with Cad Yellow Pale + Raw Sienna. Shade with Sap Green + Raw Sienna. Shade some petal edges and other shadows with Raw Sienna + Burnt Sienna.

Stems/Leaves: Base the dark values with Black + Sap Green. Base light values with Sap Green + White.

2 STEP TWO

Butterfly: Stipple Cad Yellow Pale on bottom edges of red marginal spots and inner ends of those at base of wings. Accent yellow wing tips with Winsor Red + Cad Yellow Pale. Base all dark areas with Black + Raw Umber. Blend just a bit with chisel edge to connect to yellow tips. Center tracing paper pattern carefully on top and draw the section lines and wing divisions into the wet paint (see page 21). Base body with Black + Raw Umber. Thin a little puddle of Black + Raw Umber and apply antennae using a round brush.

Flowers: Blend where values meet. Highlight with White + Cad Yellow Pale. Lift out lines in throat back to surface with a no. 8 bright dampened with odorless thinner.

Stems/Leaves: Blend where values meet, following growth direction. Add highlight areas with light green mix + White.

3 STEP THREE

Butterfly: Pat inside wings with a dry pad of cheesecloth to lift paint, suggesting some translucence. Using a no. 4 bright, apply section lines with the dirty brush + a bit of White, then highlight at margins and on outer ends of forewing sections with the same brush. Using the flattened tip of a round brush, stipple highlights on red spots to achieve iridescence. Highlight body with a little dirty White, stippling on head and body. Add a few lines to indicate the segmented abdomen. Using no. 0 round, highlight tips of antennae with a bit of White.

Flowers: Blend petals where values meet. Re-highlight if needed with more White. Place Burnt Sienna + Winsor Red lines in throats using the chisel edge of a bright brush.

Stem/Leaves: Soften highlights. Then apply central vein line using Sap Green + White. Accent the tips of some leaves with Burnt Sienna.

Sherry C. Nelson

Black-patched Metalmark & Wild Jasmine

PHOTOGRAPHED AT IGUAÇU FALLS, this brilliant, iridescent metalmark is painted here on a Wild Jasmine. It would not be feeding on the flower itself, but rather searching for minerals on leaf surfaces, such as those deposited by birds in their droppings. The Blue Metalmark, found only in south Texas, is in the same *Lasaia* genus as the Black-patched Metalmark, and looks very similar.

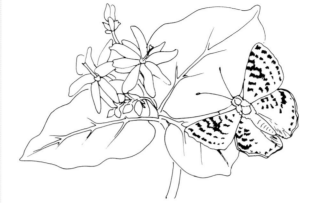

Pattern: Enlarge at 133% to bring up to full size.

OIL COLOR MIXES

White + Raw Umber + Black

French Ultramarine + Phthalo Turquoise

Previous mix + White

White + Sap Green

Black + Sap Green

Sap Green + Raw Sienna + White

Previous mix + White

White + French Ultramarine

White + Black + French Ultramarine

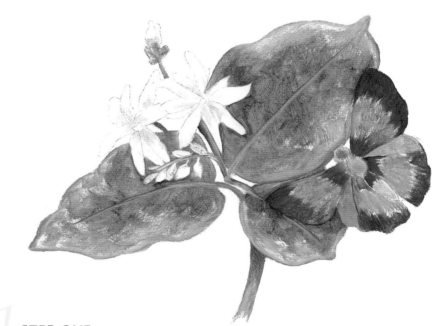

1 STEP ONE

Butterfly: Use a no. 2 or 4 bright for all steps unless otherwise noted. Base the gray hindwing sections with a mix of White + Raw Umber + Black. Base dark blue wing areas with French Ultramarine + Phthalo Turquoise. Base lighter areas with French Ultramarine + Phthalo Turquoise + White. Body: Base gray abdomen and areas on thorax with same gray mix as for hindwing. Upper third of abdomen is based with the dark turquoise mix and the turquoise on the head with the light value mix.

Flowers/Buds: Base dark value with White + Black + French Ultramarine. Base light value with White.

Stems/Leaves/Calyxes: Base the dark values with Black + Sap Green. Base light values with Sap Green + Raw Sienna + White.

STEP TWO

Butterfly: With chisel edge, blend where values meet between turquoise mixes and between the turquoise areas and the gray on the hindwings to create gradations. Follow growth direction to keep wing shapes accurate. Highlight gray on hindwings with a little White. Reblend. Center tracing paper pattern carefully on top of butterfly and draw the tiny markings back into the wet paint using a ballpoint pen (see page 21). On the body, blend between values. Thin a little puddle of Black + Raw Umber and apply antennae using a no. 0 round brush.

Flowers/Buds: Blend where values meet. Highlight with White. Fill in centers with Black + Sap Green. Base stamens with White.

Stems/Leaves/Calyxes: Blend where values meet. Add a few highlight areas with White + French Ultramarine.

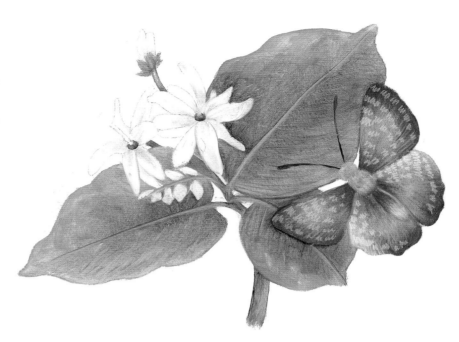

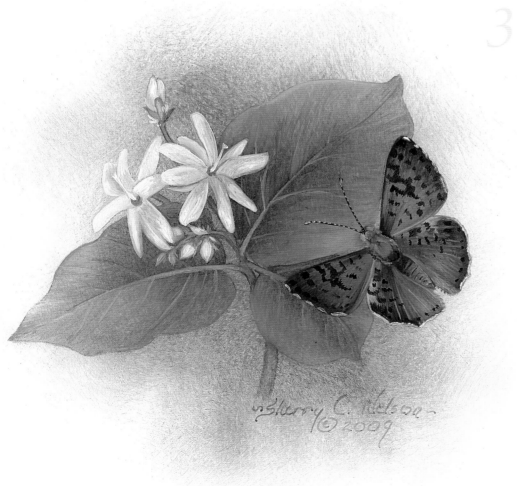

STEP THREE

Butterfly: Using a no. 1 round, detail with White on the outer wing margins. With a no. 2 bright, shade a little with Black near apex of wing. On inner angle of hindwings, accent with a little White + Sap Green. Blend to soften. Use a slightly-thinned mix of Black + Raw Umber on the round brush to detail all the tiny markings. Using a no. 2 bright with dirty White, touch in a few section lines in hindwings. Shade body with Black between abdomen and thorax. With a little White + Sap Green, paint the eyes, and create bits of stippled highlight on and behind head and on abdomen. Add a few lines of Black to indicate segmented abdomen. Using no. 0 round and a bit of White, highlight tips of antennae and add a row of spaced dots down each one.

Flowers/Buds: Blend where values meet. Re-highlight if needed with White. Highlight stamens with White.

Stems/Leaves/Calyxes: Soften initial highlights. Add additional highlights with the previous mix + White. Reblend. Then apply central vein structure using same mix.

Theodora Metalmark & Wild Orchid

Photo by Deborah A. Galloway

OIL COLOR MIXES

Black + Raw Umber + French Ultramarine

White + Black

White + Phthalo Turquoise

Black + Sap Green

White + Sap Green

Burnt Sienna + Alizarin Crimson

White + Raw Sienna

White + Raw Sienna + Sap Green

CAN YOU IMAGINE THIS MUCH spectacular iridescence and detail wrapped up in a wingspan of just 9/10ths (24mm) of an inch? Here the lovely Theodora Metalmark (*Chalodeta theodora*) is shown feeding on old wood, no doubt having discovered a source of nutrients in the bark crevices. Its caterpillar host plants include passion vines, melastomes, bay cedar, elm and cocoa trees. The tiny Theodora is painted here with a wild orchid.

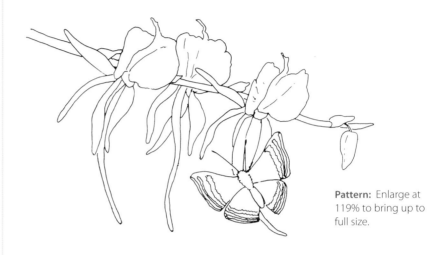

Pattern: Enlarge at 119% to bring up to full size.

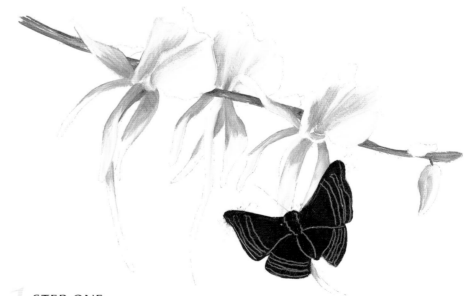

1 STEP ONE

Butterfly: Use a no. 2 or 4 bright for all steps unless otherwise noted. Base entire butterfly with Black + Raw Umber + French Ultramarine. Center tracing paper pattern carefully on wet paint and draw the section lines and wing divisions back into the wet paint (see page 21).

Orchid petals and lip: Base dark values with sparse White + Raw Sienna + Sap Green for overall lighter value. Base light areas with White. Orchid sepals: Base dark values with White + Raw Sienna + Sap Green. Base light areas with White.

Stem: Base the dark values with Black + Sap Green. Base the light values with White + Sap Green.

STEP TWO

Butterfly: Lift out dark paint in iridescent wing pattern on all four wings with the corner of a no. 8 bright dampened in odorless thinner (as shown on left wings). Fill in slightly irregular turquoise bands with White + Phthalo Turquoise (as shown on right wings). Base margins with White. Thin the Black base mix and apply antennae using a round brush.

Orchid petals and lip: Blend where values meet. Shade with a bit of White + Black to neutralize greens. Highlight with pure White. If you have too much green, simply lift out a bit of it with a damp brush and replace with White. Orchid sepals: Blend where values meet. Highlight with more White. Calyxes: Base with Alizarin Crimson + Burnt Sienna.

Stem: Blend where values meet. Add highlights with light green mix + White.

STEP THREE

Butterfly: With White + Black, apply dirty highlights to create wing separations, and a little light value at leading margin of forewing. Use same mix to suggest a few faint section lines in dark areas. To create iridescence, load a no. 1 round generously with White + Phthalo Turquoise and lay on short strokes across the sections. Blend a bit with dry flattened tip of the round brush to soften. Then load a no. 0 round with pure White to apply short strokes on top of the previous step to build the iridescence even stronger. Do not overwork. Highlight body with a little dirty White, stippling on and behind head and a few lines to indicate segmented abdomen. Highlight antennae with spaced dots of White along the length of the antennae.

Orchid petals and lip: Blend where values meet. Re-highlight as needed with more White. Orchid sepals: Blend highlights to soften. Calyxes: Highlight with White + Raw Sienna.

Stem: Soften highlights.

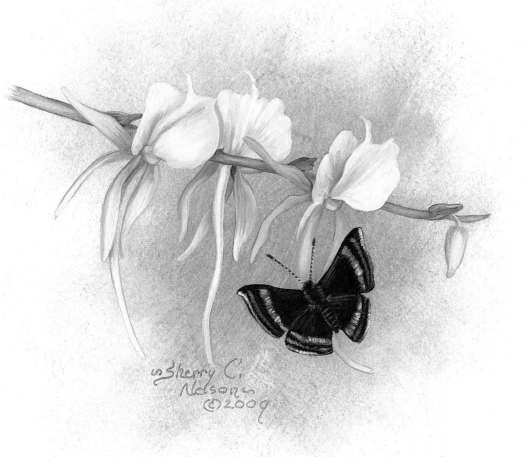

Trochilus Metalmark & Walking Iris

Photo by Deborah A. Galloway

PHOTOGRAPHED AT THE RIO CRISTOLINO LODGE in Brazil, this scintillating metalmark (*Caria trochilus*) is painted here with a Walking Iris. It likely would not nectar at the flower itself, but like others in the metalmark family, is attracted to deposits of minerals on leaf surfaces. The oddly-shaped black wings, overlaid with remarkable bits of iridescence in red, blue and brilliant green, combine to make this one of my favorite tropical butterflies.

OIL COLOR MIXES

White + French Ultramarine

Previous mix + White

Phthalo Turquoise + Cadmium Yellow Pale

Cadmium Yellow Pale + Phthalo Turquoise

Winsor Red + Alizarin Crimson

Black + Raw Umber

Black + Raw Umber + White

White + Black

White + Cadmium Yellow Pale

Raw Sienna + Sap Green

French Ultramarine + Alizarin Crimson

Black + Sap Green

Previous mix + Sap Green + White

Previous mix + White

Pattern: Enlarge at 133% to bring up to full size.

STEP ONE

Butterfly: Use a no. 2 or 4 bright for all steps unless otherwise noted. Base the areas of gray on the wings with a mix of Black + Raw Umber + White. Base the following iridescent basecoats with a no. 0 bright: base the dark blue with French Ultramarine + White; base the green with Phthalo Turquoise + Cad Yellow Pale; base the red with Winsor Red + Alizarin Crimson. Body: Base the green areas with Phthalo Turquoise + Cad Yellow Pale.

Iris petals: Base dark value on standards with Raw Sienna + Sap Green; base light value with White. Base dark value on falls with White + Black; base light value with White + Cad Yellow Pale.

Leaf/Calyx: Base the dark values with Black + Sap Green. Base light values with previous mix + Sap Green + White.

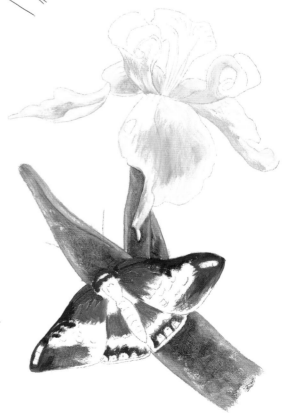

2 STEP TWO

Butterfly: Base hindwing margin and forewing red spots with Winsor Red + Alizarin Crimson. Detail on either side of apex spots with Black using round brush. Add bits of White for highlighting in red and blue areas on forewings. Apply Cad Yellow Pale on green areas of wing and thorax to provide paint for stippled iridescence. Base rest of the wings with Black + Raw Umber. Work dark up into edges of the other colors to create their correct shape, but do not blend the dark mix into the bright colors. Blend where gray areas meet the black mix, with the growth direction. Center tracing paper pattern carefully on top of butterfly and draw the many tiny markings back into the wet paint using a ballpoint pen (see page 21). Base rest of body with Black + Raw Umber. Blend between values.

Iris petals: Blend standards where values meet. Add violet accent color inside curl of standards with very sparse French Ultramarine + Alizarin Crimson. Add vertical blue detail with White + Black + a little French Ultramarine. Let dry. Transfer the complex pattern of variegated markings onto the dry surface for a guide to color placement. On the falls, blend where values meet. Highlight with White. Let dry, then transfer pattern as you did for the standards.

Leaf/Calyx: Blend where values meet, following growth direction. Add a few highlight areas with light leaf mix + White.

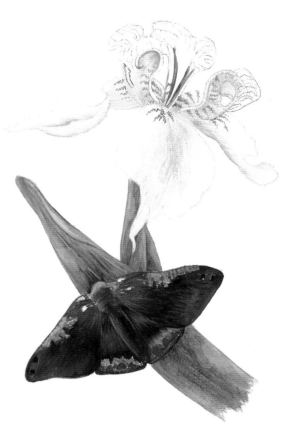

3 STEP THREE

Butterfly: With flattened tip of no. 1 round, tap into the yellow in each green area on wings and thorax, walking some of the bright yellow down to blend slightly into the green, and walking those areas over into the dark basecoat. Soften yellows only enough to achieve iridescent look; don't overwork or the result will be mud. Stipple White into blue and red areas to complete the iridescent blends. Use a slightly-thinned mix of Black + Raw Umber on the round brush to detail all the tiny markings on the dark wing areas, and to add round dots inside the red hindwing sections. With White + Black on a small bright, touch in a few section lines in hindwings and lighten edges of forewings to separate hindwings from forewings. Body: With White + Black, create bits of stippled highlight on and behind head and on abdomen. Add a few lines of Black to indicate barely visible segmented abdomen. Thin Black + Raw Umber and apply antennae using no. 0 round.

Iris petals: Using slightly-thinned paint and a no. 0 round, lay in all markings on the standards. Use French Ultramarine + Alizarin Crimson for the violet markings, most of which lay on the underlying greenish basecoat. Use French Ultramarine for the markings in the curled blue areas. Shade with a little violet mix to deepen in strongest dark areas. Let dry, then stipple on more White between blue markings for drama. On the falls, blend where values meet. Re-highlight if needed with more White. Add faint violet outlines around torn petal edges and hole in near petal. Finally, add the few markings where the falls connect to the flower center using the violet mix.

Leaf/Calyx: Soften initial highlights. Add more highlights with light value green mix + White if needed. Reblend. Apply central vein using same mix.

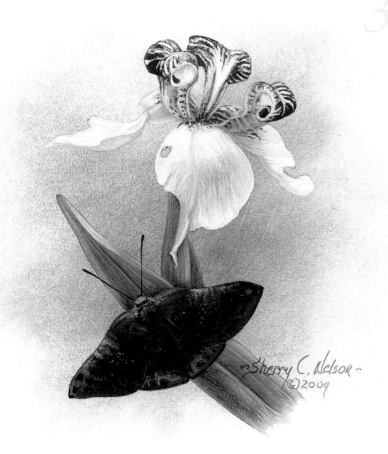

Sherry C. Nelson
(C) 2009

Periander Swordtail & Combretum

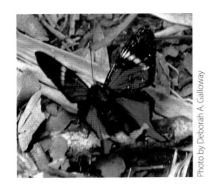

Photo by Deborah A. Galloway

OUR FINAL BUTTERFLY IN THE metalmark family is the Periander Swordtail (*Rhetus periander*), painted here with a probable caterpillar host plant, *Combretum grandiflorum*, commonly called Combretum. An extraordinary sighting can make such an indelible impression—you never forget that "Oh, wow!" moment in time. My first Swordtail was that way—a spectacular thing, appearing out of the riverine forest and into my life.

OIL COLOR MIXES

White + Cadmium Yellow Pale

French Ultramarine + White

White + French Ultramarine + Phthalo Turquoise

Black + Raw Umber

Raw Umber + White

Winsor Red + Burnt Sienna

Previous mix + White

Cadmium Yellow Pale + Winsor Red

Black + Sap Green

Sap Green + Raw Sienna + White

Previous mix + White

Pattern: Enlarge at 125% to bring up to full size.

1 STEP ONE

Butterfly: Use a no. 2 or 4 bright for all steps unless otherwise noted. Base the blue wing sections with French Ultramarine + White. Draw section lines back in with stylus, or by laying design on top and drawing over it with a ballpoint pen (see page 21). Base red spots on hindwing with Winsor Red. Base white spots on forewings with White. Base inner portions of body with same blue mix used on wings.

Flower/Buds: Base dried calyxes with Raw Sienna. Base the red areas of calyxes with Winsor Red + Burnt Sienna. Base top of calyxes with Cad Yellow Pale. Base lower part of the stamen area with Cad Yellow Pale and fluff upward to break up color.

Leaves/Stems: Base the dark values with Black + Sap Green. Base light values with Sap Green + Raw Sienna + White.

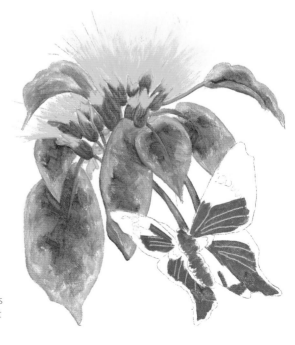

STEP TWO

Butterfly: With tip of no. 1 round, apply White + Phthalo Turquoise + French Ultramarine on outer third of blue sections on all wings. Base brownish areas of hindwings with Raw Umber + White. Base yellow band at base of hindwings with Cad Yellow Pale. Tap Cad Yellow Pale stippling color on red spots using no. 1 round. Base rest of body with Black + Raw Umber. Blend between values.

Flower/Buds: Blend calyxes where values meet. Highlight with red mix + White. Shade base of stamens with Cad Yellow Pale. Soften ends of stamens with cheesecloth to fade more subtly to the background.

Leaves/Stems: Where values meet, blend with growth direction. Set in central vein light with light green. Add a few highlight areas with light green mix + more White.

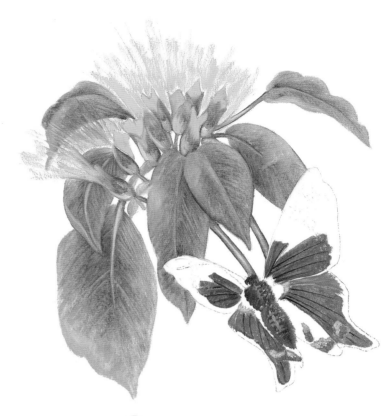

STEP THREE

Butterfly: Using no. 1 round, stipple the turquoise highlights on both fore- and hindwings, creating a value gradation between blue basecoat and iridescent turquoise. Lay in section lines with Black + Raw Umber using chisel edge of no. 4 bright. Using the flattened tip of the round, stipple the Cad Yellow Pale applied to red sections to soften. Lead a little White from the white spots on forewing down along the outer edges of the blue sections to suggest faint white markings. Fill in remainder of forewings and outer edges of hindwings with Black + Raw Umber. Edge into white spots on forewing and outer edges of blue sections. Body: With a little White + Phthalo Turquoise, create bits of stippled highlight on and behind head and on abdomen. Add a few lines of Black to indicate segmented abdomen. Add tiny white dots to the side of the mid-thorax. With slightly thinned Black + Raw Umber + White, base antennae using no. 0 round.

Flower/Buds: Blend highlight on calyxes to soften. Make a very thin mix of Cad Yellow Pale + Winsor Red and apply with no. 0 round to the stamen area, pulling from tips of stamens into the yellow area and letting all red lines fade out about midway. Add loose dots of the same mix at outer tips and a few within the cluster. Add pollen dots with straight Cad Yellow Pale, thinned for better control.

Leaves/Stems: Soften highlights, blending with growth direction. Add more highlights with light green mix + White if needed. Reblend. Then apply central vein structure using same mix. Accent in dark areas of a few leaves with Raw Umber and reblend.

Julia Longwing & Passion Vine

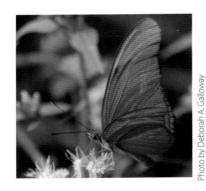

Photo by Deborah A. Galloway

IN THE NEXT 18 DEMOS, we will look at the huge butterfly family known as Brushfoots (*Nymphalidae*), named for their short, fuzzy front "legs." Our first Brushfoot is the beautiful female Julia Longwing (*Dryas julia*), shown here. She is larger than the male, and is found within the U.S. only in Texas and Florida. You can see why this family is called "Longwings": the graceful wing shape, large size and dramatic color catch the eye. Here it's shown with the caterpillar host plant, Passion Vine.

OIL COLOR MIXES

Alizarin Crimson + Winsor Red + Cadmium Yellow Pale

Black + Raw Umber

Winsor Red + Cadmium Yellow Pale

Cadmium Yellow Pale + Winsor Red

Previous mix + Cadmium Yellow Pale

Burnt Sienna + Raw Sienna

Burnt Sienna + Raw Sienna + White

Black + Sap Green

Sap Green + Raw Sienna + White

Previous mix + White

White + Cadmium Yellow Pale

Raw Sienna + Raw Umber

Cadmium Yellow Pale + Raw Sienna + tad of Winsor Red

White + Raw Sienna

Alizarin Crimson + Winsor Red

Alizarin Crimson + Raw Umber

Alizarin Crimson + Winsor Red + White

Sap Green + Raw Sienna

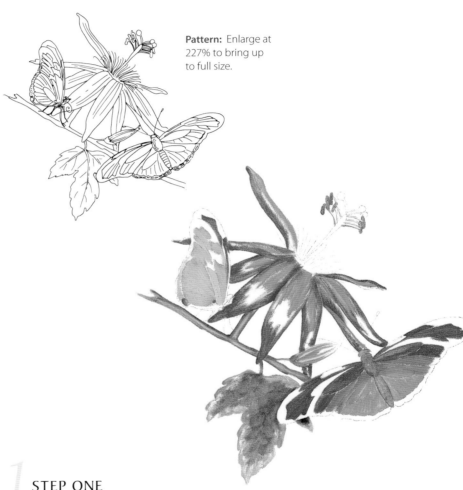

Pattern: Enlarge at 227% to bring up to full size.

STEP ONE

Butterfly, wings spread: Use a no. 2 or 4 bright for all steps unless otherwise noted. Base red sections with Alizarin Crimson + Winsor Red + Cad Yellow Pale. Base orange sections with Winsor Red + Cad Yellow Pale. Base yellow-orange sections on hindwing with Cad Yellow Pale + bit of Winsor Red. Body: Base with Burnt Sienna + Raw Sienna.

Butterfly, closed wings: Base red sections as described above. Base yellow section with Cad Yellow Pale. Base yellow-orange sections with Cad Yellow Pale + Raw Sienna + tad of Winsor Red.

Flower/Bud: Base dark values on petals with Winsor Red + Alizarin Crimson. Base light orange areas at petal bases with Cad Yellow Pale + Winsor Red. Base anthers and part of filaments with Sap Green + Raw Sienna. Bud: Base orange areas with Winsor Red + Cad Yellow Pale, and narrow yellow bands with Cad Yellow Pale.

Stems/Leaf/Calyx: Base the dark values with Black + Sap Green. Base light value with Sap Green + Raw Sienna + White.

STEP TWO

Butterfly, wings spread: Blend between values. Base margin of hindwing with Black + Raw Umber. With dirty brush, add dark veining in red sections. Shade body with Raw Umber. Highlight with Burnt Sienna + Raw Sienna + White. Place eyes with Black. Thin a little Black + Raw Umber and apply antennae.

Butterfly, closed wings: Base brown apex and hindwing margins with Raw Umber + Raw Sienna. Base black areas with Black + Raw Umber. Shade within yellow-orange sections with Burnt Sienna. Base dark value on body with Black + Raw Umber. Base top of head and stripes with Raw Umber. Fill in rest of body with White and add legs with Cad Yellow Pale + Winsor Red.

Flower/Bud: Base medium value with Winsor Red + Alizarin Crimson + Cad Yellow Pale. Blend between values with the growth direction of the petals. Place shading with Alizarin Crimson + Raw Umber. Flower center: Chisel lines of fuzzy, sparse Winsor Red + Alizarin Crimson on corona. Fill in anther filaments with Raw Sienna. Base stigma filaments with Alizarin Crimson + Winsor Red. Base round tips of the stigma with White. Base the style with Alizarin Crimson + Winsor Red on the bottom half and White on the top half. Base rest of bud with White + Cad Yellow Pale and blend between values. Shade yellows with green mix from the calyx.

Stems/Leaf/Calyx: Blend where values meet, following growth direction. Add a few highlights with light green mix + more White.

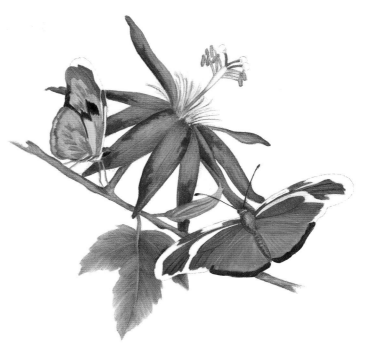

STEP THREE

Butterfly, wings spread: Base rest of Black + Raw Umber on forewings. Use same mix to divide sections with lightly-applied lines using chisel edge. Highlight with Cad Yellow Pale on hindwing, blending to soften. Use Cad Yellow Pale to place section lines and to highlight in a few of the outer red-orange sections. Add detail markings on hindwing margins using no. 0 round and Cad Yellow Pale + Winsor Red. Tip antennae with dirty Cad Yellow Pale.

Butterfly, closed wings: Blend shading color within yellow areas with chisel edge, following growth direction. Soften Raw Umber mix into yellow sections with chisel. Break up edge where Black + Raw Umber meets the rest of the wing. Highlight hindwing sections and along hindwing margin with White + Raw Sienna. Highlight hindwing margin and darkest margin on forewing with a little White detail. Body: With no. 0 round, add White highlights. Highlight legs with White + Raw Sienna. Thin Black + Raw Umber and apply antennae. Tip with dirty Cad Yellow Pale.

Flower/Bud: Highlight petals with White + Cad Yellow Pale, blend to soften into base mix. Add faint chisel lines of Cad Yellow Pale following the shape of each petal. Flower center: With slightly-thinned White on a no. 0 round brush, add white lines in corona. Highlight stigma filaments with a bit of White. Highlight round tips of stigma with stippled White. Shade underside of anthers with Black + Sap Green. Stipple pure White in center of top of style. Blend values within style where they meet.

Stems/Leaf/Calyx: Blend highlights softly into leaves and stems. Add vein structure with light value green mix. Accent with Burnt Sienna along stem and on leaf.

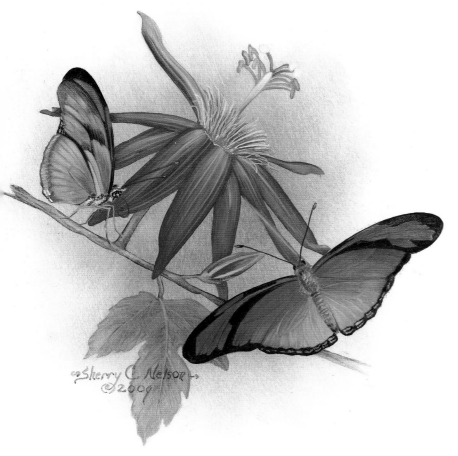

Zebra Longwing & Sea Hibiscus

OUR NEXT BRUSHFOOT BUTTERFLY DEMO is the Zebra Longwing (*Heliconius charithonia*), the State butterfly of Florida. It's also found occasionally in SE Arizona, and in the lower Rio Grande Valley of South Texas to South America. It is unusually long-lived, surviving as long as several months. Adults may collect at a communal roost, returning to the same location each evening. When in South Texas collecting reference photos for this book, we watched a Zebra perusing a Sea Hibiscus tree, and I decided to use it for the flower in this painting. Sea Hibiscus flowers open yellow, turn color as they age and drop off the tree a deep, rich red.

OIL COLOR MIXES

White + Cadmium
Yellow Pale

Black + Raw Umber

Raw Sienna + Sap
Green

Winsor Red + Alizarin
Crimson

Black + Sap Green

Black + more Sap
Green

Sap Green + Raw
Umber + White

Previous mix + White

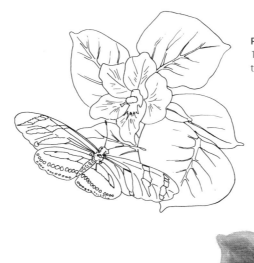

Pattern: Enlarge at 152% to bring up to full size.

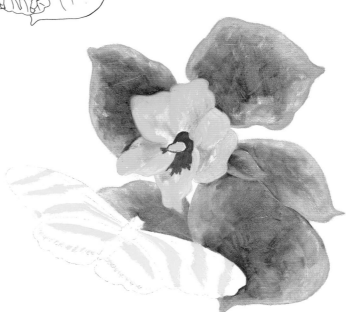

1 STEP ONE

Butterfly: Use a no. 2 or 4 bright for all steps unless otherwise noted. Base the yellow sections with Cadmium Yellow Pale + White.

Flower petals: Base dark value with Sap Green + Raw Sienna or in a place or two, just Raw Sienna. Light value is based with Cad Yellow Pale. Flower center: Base darkest area around style with Alizarin Crimson. Base remainder with Alizarin Crimson + Winsor Red. Outline tip of style with Alizarin Crimson mix and fill in with Cad Yellow Pale.

Leaves: Base the dark values on darkest leaves with Black + Sap Green. Base light values with Sap Green + a bit of Raw Umber + White. Base dark values on lighter leaves with Black + more Sap Green. Base lighter areas of light leaves with the previous mix + more White.

STEP TWO

Butterfly: Highlight yellow sections with White + Cad Yellow Pale. Base all dark areas, including body, with Black + Raw Umber. Blend with chisel edge to connect into edges of yellow sections, following the growth direction.

Flower petals: Blend where values meet. Highlight with White + Cad Yellow Pale. Flower center: Stipple White into center of style with a no. 1 round. Shade inside upper portion of red area with a bit of Black.

Leaves: Blend where values meet, following growth direction. Add a few highlight areas with light green mix + White.

STEP THREE

Butterfly: Using a no. 4 bright, smooth the dark base color, then apply section lines with dirty dark brush within yellow sections. Apply section lines in dark areas with a bit of dirty White. Add a row of tiny White + Cad Yellow Pale spots at margins of hindwings. With a no. 0 round, add the tiny red dots with Winsor Red + Alizarin Crimson on thorax. Highlight body with a little dirty White, stippling color on and behind head and a few lines to indicate segmented abdomen. Thin a little puddle of Black + Raw Umber and apply antennae using the round brush.

Flower petals: Blend where values meet. Highlight if needed with more White. Blend bottom edge of red throat into bottom yellow petal using chisel edge of bright to create fine lines.

Leaves: Soften highlights. Pat out any excess paint with cheesecloth pad, then apply central vein structure with light green mix + more White.

Sherry C. Nelson
(c) 2008

Pachinus Longwing & Orchid

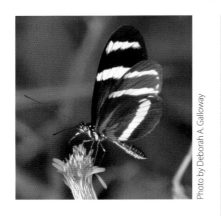

Photo by Deborah A. Galloway

GETTING GOOD PHOTOS of new species of butterflies in the wild is never easy. So I was especially pleased when Deb got a whole raft of great shots of these Costa Rican Longwings nectaring in the rain forest near La Cangreja. Pachinus Longwing (*Heliconius cydno pachinus*) can be a difficult identification. Much appreciation to Kim Garwood, expert on butterflies of the neotropics, who taught me how to sort them out. Pachinus is painted here with Phalaenopsis Orchid.

Pattern: Enlarge at 172% to bring up to full size.

OIL COLOR MIXES

Black + Sap Green

Sap Green + Raw Sienna + White

Previous mix + White

Raw Sienna + Sap Green + White

Raw Sienna + Burnt Sienna

Black + Raw Umber

Alizarin Crimson + Winsor Red

Winsor Red + Cadmium Yellow Pale

Raw Umber + Raw Sienna + Black

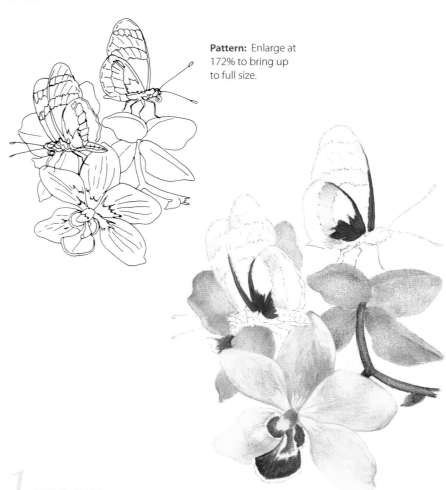

1 STEP ONE

Butterflies: Use a no. 2 or 4 bright for all steps unless otherwise noted. Both views of the butterfly are painted much the same. Base red sections with Alizarin Crimson + Winsor Red. Base light sections on all wings with White, shading at wing edges and in natural shadows with a little bit of Raw Sienna.

Orchids: Far petals: Base green areas of petals and sepals with Raw Sienna + Sap Green + White. Shade in darkest value areas with Black + Sap Green. Base pinkish areas with sparse Alizarin Crimson + a bit of White. Lift out excess paint by patting with cheesecloth to give a sparse appearance to the paint. Near orchid petals: Base the dark value with Raw Sienna + Sap Green + White. Base lighter value areas with the same mix + more White. Lip: Base dark areas with Alizarin Crimson. Base lighter value with Raw Sienna + Burnt Sienna.

Stems: Base the dark values with Black + Sap Green. Base light values with Sap Green + a bit of Raw Sienna + White.

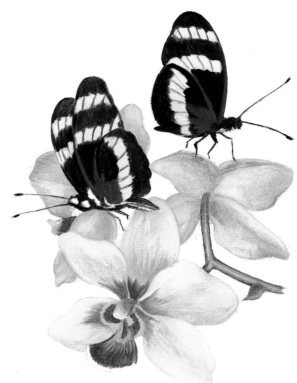

STEP TWO

Butterflies: Highlight red areas along wing margins with Winsor Red + Cad Yellow Pale. Base dark areas with Black + Raw Umber. Blend with chisel edge to connect to edges of red and white sections, with growth direction. Use dark mix on chisel edge to touch in section lines within the white sections. Body: Base dark areas with Black + Raw Umber. Base rest with White. Thin Black + Raw Umber and apply antennae using the no. 0 round brush.

Orchid: Far orchid petals: Blend where values meet. Highlight with White on both pinkish areas and green. Near orchid petals and sepals: Blend where values meet, following growth direction of petals. Shade with dirty brush + Alizarin Crimson at base of petals and sepals. Highlight with White. Lip: Base remainder of inner area lip with Cad Yellow Pale. Base bottom edge with White. Stipple yellow detail with no. 1 round for texture. Highlight central column with White.

Stems: Add a few highlight areas with light green mix + White.

STEP THREE

Butterflies: Blend highlights in red sections. Reblend the dark values on forewings with Raw Umber + Raw Sienna + Black with the chisel, leaving some directional lines showing to give dimension to the wings. Add dirty White highlight where needed and blend in same manner. Add a few dirty White spots at margins of hindwings with no. 0 round. Place a bit of red detail with Alizarin Crimson + Winsor Red where hindwings join body. Body: Highlight with a little dirty White, stippling on thorax and adding a few lines to indicate segmented abdomen. Antennae and proboscis: Add White dots on tips of antennae using the round brush. Draw the spiral proboscis with Black.

Orchid: Far orchid petals: Blend where values meet. Re-highlight if needed with more White. Enhance pink areas with dirty brush + Alizarin Crimson texture. Near orchid petals and sepals: Blend highlights, following petal growth direction. Blend with chisel edge where pink shading meets petal. Walk a little of the pink color out into the petal, tapping and dragging a bit to create irregular detail lines and dabs of color. You can add sparky White highlights when painting is dry. Lip: Blend bottom edge of red lip into yellow detail. Soften white edge into pink.

Stems: Soften and blend highlights.

Agnosia Clearwing & Thunbergia

Photo by Deborah A. Galloway

OIL COLOR MIXES

Black + Raw Umber

Previous mix + White

Black + Winsor Red

Winsor Red + Raw Sienna

Previous mix + White

Winsor Red + Cadmium Yellow Pale + a tad Raw Sienna

White + Cadmium Yellow Pale

Black + Sap Green

Previous mix + Sap Green + White

Previous mix + more White

French Ultramarine + Alizarin Crimson + White

White + French Ultramarine + Alizarin Crimson

Cadmium Yellow Pale + Winsor Red

AGNOSIA CLEARWINGS, IN THE FAMILY *Ithominae,* are only one of the many species of transparent or translucent-winged butterflies. Some are so "see-through" that you can see the details of the plant it rests on through the wings. Also called Glasswings, these lovely creatures are found largely in South America. This Agnosia (*Ithomia agnosia*) was photographed in Trinidad, off the coast of Venezuela.

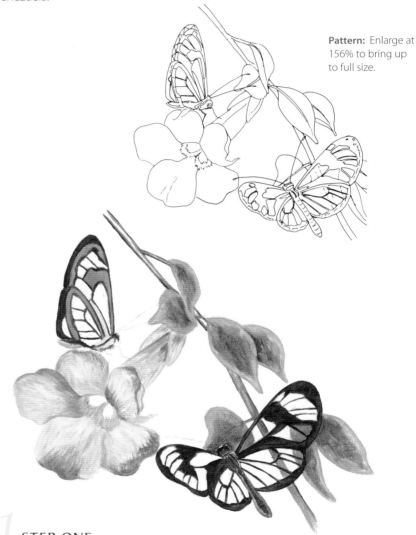

Pattern: Enlarge at 156% to bring up to full size.

1 STEP ONE

Butterfly, wings spread: Use a no. 2 or 4 bright for all steps unless otherwise noted. Base all dark areas with Black acrylic except those on body. Body: Base dark areas with Black + Raw Umber. Base reddish areas with Raw Sienna + Winsor Red.

Butterfly, closed wings: Base all dark areas with Black acrylic, including the body detail. Base orange spots and sections with Winsor Red + Cad Yellow Pale + a tad of Raw Sienna. Base yellow sections on wing and body with White + Cadmium Yellow Pale. Body: Base underside of abdomen with Cadmium Yellow Pale + Winsor Red.

Flower: Base dark values with Alizarin Crimson + French Ultramarine + White. Base light value with previous mix + White. Flower center: Base lobes of center with Raw Sienna.

Leaves/Stems: Base the dark values with Black + Sap Green. Base light values with previous mix + Sap Green + White. Don't forget to base leaf sections inside wings.

STEP TWO

Butterfly, wings spread: Haze inside sections with White + French Ultramarine + Alizarin Crimson. Use cheesecloth to remove excess paint so it looks truly translucent. Body: Blend crosswise on abdomen to suggest segments.

Butterfly, closed wings: Haze inside sections with White + French Ultramarine + Alizarin Crimson. Use cheesecloth to remove excess paint so it looks translucent. Stipple orange sections with Cad Yellow Pale, softening to an iridescent look with the flattened tip of a no. 1 round. Add the gray details on the wing margins with Black + Raw Umber + White mix. Stipple White + Cad Yellow Pale on the upper abdomen.

Flower: Blend between values with the natural growth direction of the petals. Add White highlights. Fill in remainder of center with Cad Yellow Pale + Winsor Red.

Leaves/Stems: Blend between values with growth direction. Apply needed highlights using light value green mix + more White.

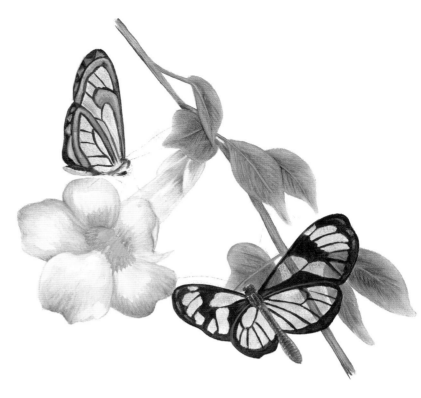

STEP THREE

Butterfly, wings spread: Add detail markings on hindwing margins using no. 0 round brush and dirty Winsor Red. Add dirty White markings with same brush. When violet glazing is dry, highlght sections with White, and again soften into wing surface for translucent appearance. Add a few lines of dirty White across abdomen to indicate segments. Accent behind head with Winsor Red. Thin Black + Raw Umber and apply antennae using no. 0 round.

Butterfly, closed wings: When violet glazing is dry, highlight sections with White, and again soften into wing surface to appear translucent. Soften yellow highlights on orange sections if needed. Shade upper portion of body with a little Black + Raw Umber. Thin Black + Raw Umber and apply antennae using no. 0 round.

Flower: Blend highlights on petals. Add faint chisel lines of White to indicate the shape and growth of each petal. Flower center: Blend with chisel between the two values. With dry brush, connect in an uneven blend to the bases of the petals.

Leaves/Stems: Blend highlights softly into leaves and stems, following growth direction. Add vein structure with light value green mix.

73

Monarch & Butterfly Bush

Photo by Deborah A. Galloway

OUR MOST FAMOUS, WIDESPREAD and best loved of all North American butterflies, the Monarch is perhaps most known for the incredible migration that takes them to wintering roost sites in California and Mexico where millions of these beautiful butterflies gather. They head north in the spring to mate, lay eggs, and raise two more generations before the final brood of the summer turns toward Mexico once again. Isn't it remarkable that the ones who return to the exact location do so by some sort of genetic instinct, never having been there before? The Monarch will willingly come to gardens to nectar on a wide variety of blooms. But they need milkweeds as the host plant for their eggs. Plant some and encourage this beautiful butterfly to hang out in your yard.

OIL COLOR MIXES

Cadmium Yellow Pale + Winsor Red + Raw Sienna	White + Cadmium Yellow Pale + Raw Sienna
Winsor Red + Cadmium Yellow Pale + Raw Sienna	Black + Raw Umber
Alizarin Crimson + Raw Sienna + White	Previous mix + White
Previous mix + more White	Cadmium Yellow Pale + Winsor Red
Black + Sap Green	Sap Green + Raw Sienna + White
Previous mix + White	

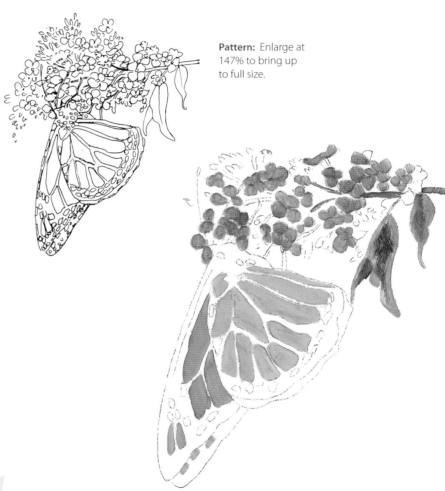

Pattern: Enlarge at 147% to bring up to full size.

1 STEP ONE

Butterfly: Use a no. 2 or 4 bright for all steps unless otherwise noted. Base orange sections on forewing with Cadmium Yellow Pale + Winsor Red + Raw Sienna. Base rusty orange sections on hindwing with Cadmium Yellow Pale + Raw Sienna + tad of Winsor Red.

Flower: Base with Alizarin Crimson + White + Raw Sienna.

Leaves/Large stems: Base the dark values with Black + Sap Green. Base light value with Sap Green + Raw Sienna + White.

STEP TWO

Butterfly: Apply White + Cad Yellow Pale + Raw Sienna on outer third of orange and yellow sections. Flatten tip of no. 1 round brush and use as a stippling brush, walking dabs of light value into basecoat color until a gradation of value is achieved in each section. Base remaining areas of wings and body with Black + Raw Umber. Center tracing of butterfly carefully on top of wet paint. Using ballpoint pen, draw all the little margin markings and body spots into the wet paint (see page 21). Thin a little Black + Raw Umber and apply antennae and legs.

Flower: Highlight individual petals, two or three on each flower, with the flower base mix + White. Base flower centers with Raw Sienna.

Leaves/Large stems: Where values meet, blend with growth direction. Then apply highlights using light value green mix + more White. Tiny stems and tiny green leaflets within flower spike: Base with Black + Sap Green and some Sap Green + Raw Sienna + White as well.

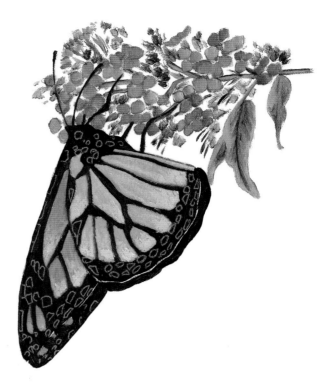

STEP THREE

Butterfly: Stipple Cad Yellow Pale + Winsor Red at base of yellow sections on hindwing for shading. Use no. 1 round and pat with flattened tip to blend. Stipple orange sections with a bit of Winsor Red. Add margin markings and spots on hindwings using no. 0 round brush and White. With a little White on chisel edge, tap on outlines of dirty White around edges of wings to separate wings and define wing shapes. Detail more dirty White markings along margins. With no. 0 round, add a few light highlight dots in eye area and on thorax. Tip antennae with a bit of dirty Cad Yellow Pale + Winsor Red.

Flower: Blend highlights to soften into base mix. Highlight on a few main petals once more using White. Place flower center dots with Cad Yellow Pale + Winsor Red.

Leaves/Large stems: Blend highlights, following growth direction. Add vein structure with light value green mix. Add some stippled bits of the Black + Sap Green mix in green areas within the flower spike for interest.

75

Monarch Caterpillar & Showy Milkweed

Photo by Deborah A. Galloway

THE CATERPILLARS OF THE MONARCH are dependent on milkweeds, which contain a chemical that cause the caterpillars and even the adult butterflies that develop from them to be bitter and distasteful. Thus they gain protection from predators, for once a bird has discovered the unpalatable taste, they will never again attempt to eat a monarch—or any other butterfly with similar coloration. This painting also shows a chrysalis attached to one of the leaves. The word *chrysalis*, by the way, comes from the Greek for "gold," referring to its beautiful iridescent gold detail.

OIL COLOR MIXES

White + Cadmium Yellow Pale

White + Black

Burnt sienna + Winsor Red + Raw Umber

Previous mix + White

White + Raw Umber

Black + Sap Green

Sap Green + Raw Sienna + White

Previous mix + White

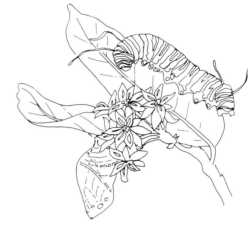

Pattern: Enlarge at 156% to bring up to full size.

STEP ONE

Caterpillar: Use a no. 2 or 4 bright for all steps unless otherwise noted. Base yellow bands with Cadmium Yellow Pale.

Chrysalis: Base with Sap Green + Raw Sienna + White.

Flowers: Base red calyxes with Burnt Sienna + Winsor Red + Raw Umber. Base petals with White. Shade centers of petals with Raw Umber + White.

Stems/Leaves/Green calyx: Base the dark values with Black + Sap Green. Base light value with Sap Green + Raw Sienna + White.

STEP TWO

Caterpillar: Base all dark areas with Black, including false antennae. Black acrylic can be used for faster drying time if desired. Highlight yellow stripes with Cad Yellow Pale + White. Using a no. 1 round with flattened tip, pat to walk color down into stripes to blend.

Chrysalis: Shade with Black + Sap Green. Highlight with the light green base mix + White. Add faint "section lines" (which are visible through the translucent covering as the adult monarch develops inside) with Black. Paint the "stem" where it attaches to the underside of the leaf with Black also. Touch on the "gold" detail with Cadmium Yellow Pale.

Flowers: Highlight red calyxes with White at base of each. Blend petals slightly where values meet. Highlight with White. Place two round spots of Raw Umber on each flower center.

Stems/Leaves/Green calyx: Blend where values meet. Apply highlights and central vein using light value green mix + more White. Add a bit of Cad Yellow Pale to warm the green mix.

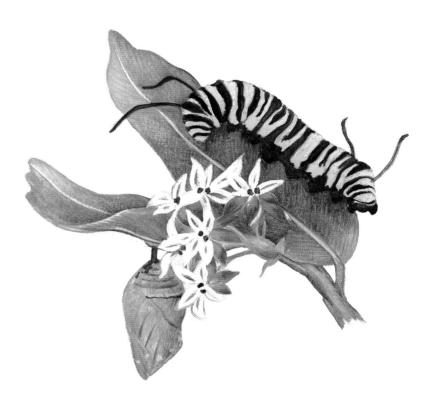

STEP THREE

Caterpillar: Stipple top of most yellow stripes with pure White. Use a no. 1 round and pat with flattened tip to walk a bit of the White to blend. Add dirty White markings on pro-legs and on false antennae.

Chrysalis: Soften section lines by patting with cheesecloth. Add final highlights with pure White on green areas and also on Cad Yellow Pale detail using a no. 0 round.

Flowers: Blend highlights on red calyxes to soften into base mix. Outline each petal with slightly-thinned White, using the no. 0 round. On the petals, accent a bit on the Raw Umber centers with a little of the red mix. Do final highlights with pure White, using a no. 0 bright. Flower centers: With a no. 0 round, place a star-shaped outline of slightly thinned White within the centers, enclosing the Raw Umber round dots.

Stems/Leaves/Green calyx: Blend highlights, following growth direction. Add central vein structure and any additional light highlights on calyx and stems with light value green mix + White, using a bright brush.

Sherry C.
Nelson
© 2009

77

Bordered Patch & Common Sunflower

THE BORDERED PATCH IS SO inconsistent in the size of markings and coloration that at times you have to look more than twice to be sure of a solid identification. The yellow-to-orange hindwing band may be narrower than that in the painting—or totally absent. The wing pattern may consist of almost entirely white spots as in the photo shown here. A better name for this Brushfoot might be Variable Patch!

OIL COLOR MIXES

Raw Sienna + White

Cadmium Yellow Pale + Winsor Red

White + Cadmium Yellow Pale

Black + Sap Green

Sap Green + Raw Sienna + White

Previous mix + White

Black + Raw Umber

Raw Umber + Raw Sienna

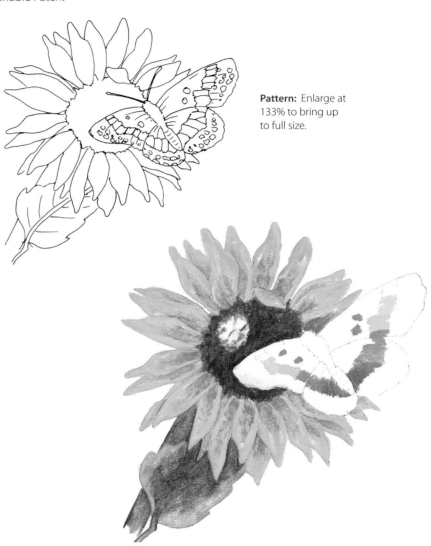

Pattern: Enlarge at 133% to bring up to full size.

STEP ONE

Butterfly: Use a no. 2 or 4 bright for all steps unless otherwise noted. Base lightest sections at forewing margin with White. Base several adjacent sections with Cad Yellow Pale. Base the orange sections and forewing spots with Cad Yellow Pale + Winsor Red. Base rusty orange sections on hindwing with Burnt Sienna.

Flower: Base the dark values on the sunflower petals with Raw Sienna + just a tad of White. Base light values with Cad Yellow Pale + Winsor Red. Flower center: Chop in dark value with a no. 2 bright using Raw Umber.

Leaf/Stem: Base dark values on stem and leaf with Black + Sap Green. Base light value with Sap Green + Raw Sienna + White.

STEP TWO

Butterfly: Blend with growth direction between values to create a gradation of color across the sections. Base rest of wing with an equal mix of Black + Raw Umber. With dirty brush, tap in dark section lines between red sections. With tracing paper pattern, transfer all markings on wing margins onto wet paint (see page 21). Base the dark side of the body with Raw Umber + Raw Sienna. Base the light side with Raw Sienna. Thin Black + Raw Umber and apply the antennae.

Flower: Blend between values with the lengthwise growth direction of the petals. Highlight with mix of White + Cadmium Yellow Pale. Base balance of center with Raw Sienna and blend where values meet, using a choppy stroke of a no. 2 bright.

Leaf/Stem: Blend where values meet with growth direction of leaf and stem. Apply highlights using light value green mix + more White.

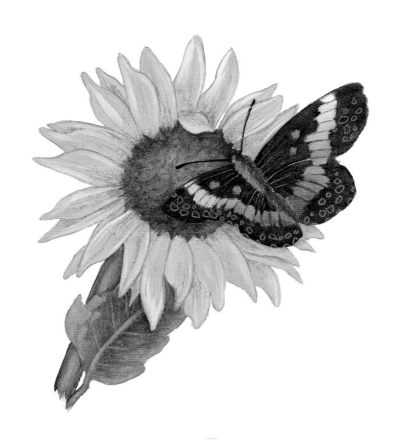

STEP THREE

Butterfly: Create sections in dark areas with lightly applied, tapped-in lines of dirty White using the chisel edge. Add dirty White for highlights on the leading edge of the wing and where the wings meet the body. Blend a bit. Add detail on margins and spots on hindwings using a no. 0 round brush and White. Body: Blend crosswise between values. Highlight with dirty brush + White. With a no. 0 round, draw faint dirty White lines across abdomen to suggest segments. Antennae: Tip with dirty Cadmium Yellow Pale + Winsor Red. With thinned White, create white dots the length of the antennae using a no. 0 round.

Flower: Blend highlights on petals. Once more, highlight a few main petals using White. When blending is complete, add faint chisel lines of Raw Sienna following the shape and growth of each petal. Connect petal bases to center edges using chisel edge. Flower center: Highlight with White + Raw Sienna, chopping with chisel of small bright for texture.

Leaf/Stem: Blend highlights into leaves and stems, following growth direction. Add vein structure with light value green mix using chisel. Accent leaf with Raw Sienna.

Sherry C. Nelson
© 2009

California Tortoiseshell & Blue Blossom

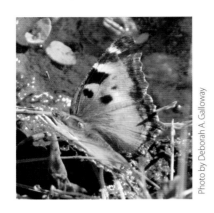

Photo by Deborah A. Galloway

ON VACATION IN OREGON, WE happened upon a lovely little wild spot in a marshy creek bottom. Approaching for a closer look, the air filled with California Tortoiseshells (*Nymphalis californica*). They'd been mud-puddling in the wet areas by the hundreds. We were thrilled with this spectacle, thanks to our friends Terry and Kay Steele who took us there. I've painted this butterfly, another of the Brush-foot family, here with Coastal Blue Blossom.

OIL COLOR MIXES

Alizarin Crimson + French Ultramarine + Raw Sienna

French Ultramarine + White

Previous mix + White

Winsor Red + Cadmium Yellow Pale

Cadmium Yellow Pale + Winsor Red

Cadmium Yellow Pale + White

Black + Raw Umber

Burnt Sienna + Raw Umber

Black + Sap Green

Sap Green + Raw Sienna + White

Previous mix + White

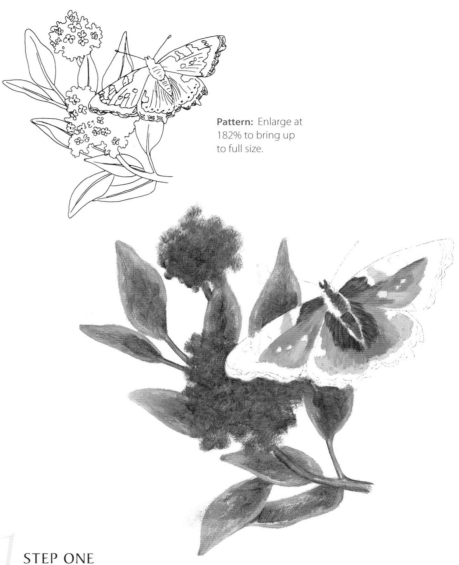

Pattern: Enlarge at 182% to bring up to full size.

1 STEP ONE

Butterfly: Use a no. 2 or 4 bright for all steps unless otherwise noted. Base white sections with White. Base yellow sections with Cad Yellow Pale + White. Base the orange sections with Cad Yellow Pale + Winsor Red. Base reddest sections with Winsor Red + Cad Yellow Pale. Base inner dark sections with Burnt Sienna + Raw Umber. Base dark value on body with Burnt Sienna + Raw Umber.

Flowers: Base with a dry scruffy mix of Alizarin Crimson + French Ultramarine + Raw Sienna, leaving edges fuzzy.

Leaves/Stems: Base the dark values with Black + Sap Green. Base light values with Sap Green + Raw Sienna + White.

STEP TWO

Butterfly: Blend with growth direction between colors on sections to gradate values. Leave white isolated from other colors. Base rest of wing with an equal mix of Black + Raw Umber. Carefully center tracing of butterfly on top of wet paint. Using ballpoint pen, draw the marginal markings into the painted surface (see page 21). Base rest of body with dirty brush + White. Blend between values to soften. Thin a little Raw Umber and apply antennae with no. 0 round brush.

Flowers: Using a no. 0 bright with French Ultramarine + White, lay in the tiny petal strokes in the darkest shadow areas. Then using the previous mix + White, lay in the petals in the outer, more obviously light value areas of the cluster. Let the background darks show through and between lighter petals for depth.

Leaves/Stems: Where values meet, blend with the growth direction. Apply highlights with light green mix + White.

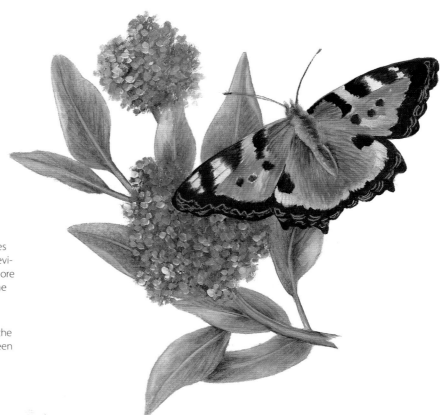

STEP THREE

Butterfly: Accent at base of hindwings with White + Raw Umber, blending toward trailing edge and leaving chisel lines showing. Use Raw Umber to divide red and orange areas, tapping in lines with the chisel edge to create sections. Add margin markings and spots on hindwings using no. 0 round brush and White. Body: Shade if needed with a bit of Black. With a no. 0 round, draw faint dirty White lines across abdomen to suggest segments. Tip antennae with a bit of dirty Cad Yellow Pale + Winsor Red.

Flowers: Add White highlight strokes with no. 0 bright where needed. Add center dots of Cad Yellow Pale + White to connect some of the petals.

Leaves/Stems: Blend highlights softly into leaves and stems, following growth direction. Add central vein with light value green mix using chisel edge. Accent leaves with a bit of the flower basecoat mix + more Raw Sienna.

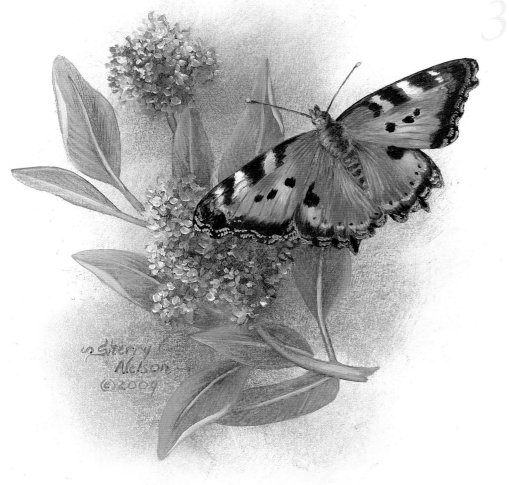

Red Peacock & Mandevilla

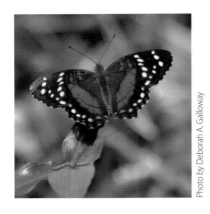

WE WERE WAITING FOR OUR FLIGHT in a small airport in Corrientes in northern Argentina when we saw a butterfly on the terminal window. Certainly this attractive creature was worth the trouble to pull out camera gear and leave the terminal building for the shot. After all, we might never see it again! We've now photographed the Red Peacock (*Anartia amathea*) in several tropical countries and it's become a favorite just for the memory value.

Pattern: Enlarge at 152% to bring up to full size.

OIL COLOR MIXES

White + Winsor Red + Cadmium Yellow Pale

Alizarin Crimson + French Ultramarine + a tad of White

Previous mix + White

Raw Sienna + Burnt Sienna

White + Raw Sienna

Black + Raw Umber

Cadmium Yellow Pale + Winsor Red + Raw Sienna

White + Cadmium Yellow Pale

Alizarin Crimson + Winsor Red + Raw Sienna

Previous mix + White

Black + Sap Green + French Ultramarine

Sap Green + Cadmium Yellow Pale + White

Previous mix + White

Sap Green + Cadmium Yellow Pale

Previous mix + White

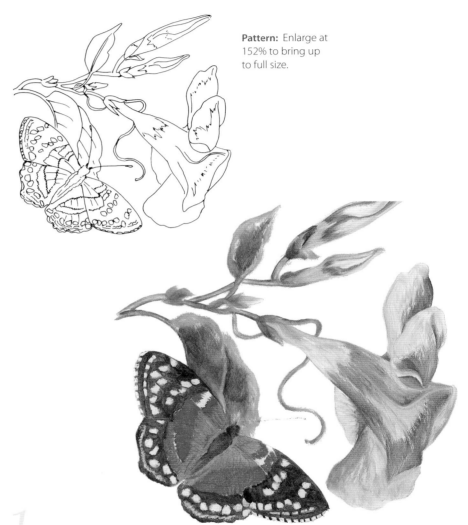

1 STEP ONE

Butterfly: Use a no. 2 or 4 bright for all steps unless otherwise noted. Base red sections with Winsor Red. Base rusty sections with Raw Sienna + Burnt Sienna. Base dark areas of the wings with Black + Raw Umber. Base dark value on body with Raw Umber and the light value with Raw Sienna + Burnt Sienna.

Flower/Buds: Base dark values with a sparse mix of Alizarin Crimson + Winsor Red + Raw Sienna, leaving edges broken where values will meet. Base light values with the previous mix + White. Base a little light value green mix at base of flower trumpets where they meet the calyxes.

Stems/Leaves/Calyxes: Base dark values with Black + Sap Green + French Ultramarine. Base light value with Sap Green + Cad Yellow Pale + White. Add Raw Sienna to the mix if needed to control intensity.

STEP TWO

Butterfly: Base violet bands on forewing with Alizarin Crimson + French Ultramarine. Shade wings next to body with Raw Umber. Lay red-orange bands on wings and hindwing spots with Winsor Red + Cadmium Yellow Pale. Shade wing basecoat at margins and next to red midwing sections with Black + Raw Umber. Base fringes of wing with White and lay on lines of Raw Umber with chisel to divide them. Base all white spots with White. With slightly thinned Raw Umber, place irregular division lines between red sections using no. 0 round. Place section lines in red bands with Raw Umber using the chisel edge. Highlight red sections with White + Winsor Red + Cad Yellow Pale. On body, blend between values to soften. Thin a little Raw Umber and apply antennae.

Flower/Buds: Blend with growth direction of each petal *only* where values meet in order to keep the red mix from "growing." Use chisel edge of a no. 4 bright for the larger petals and the no. 2 for the smaller petals. Highlight with White.

Stems/Leaves/Calyxes: Blend between values with growth direction of leaves. Highlight using light value green mix + more White. Add dirty brush + Alizarin Crimson + Winsor Red + Raw Sienna on the edges of the calyxes.

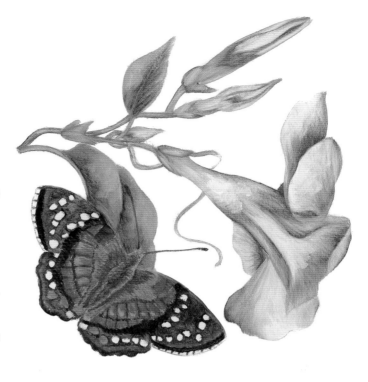

STEP THREE

Butterfly: Highlight violet band with violet base mix + White. Highlight red hindwing spots with White + Cad Yellow Pale. Blend highlights on red sections with growth direction. Complete all irregular division lines with slightly-thinned Raw Umber using round brush. Add white detail at wing edges with White, which will become gray as the brush picks up wet paint from underneath. Shade body with Black. With no. 0 bright, highlight around the edges and on the head with White + Raw Sienna. Tip antennae with a bit of dirty Cad Yellow Pale.

Flower/Buds: Blend where highlights meet basecoat areas. When painting is dry, come back with more highlight if needed.

Stems/Leaves/Calyxes: Blend highlights softly into leaves and stems, following growth direction. Add vein structure with light value green mix using chisel edge. Accent leaves and stems with a bit of the flower basecoat mix + more Raw Sienna.

Sherry C. Nelson
© 2009

Mourning Cloak & Milkweed

Photo by Deborah A. Galloway

"CAMBERWELL BEAUTY" IS THE EUROPEAN name for this well-known, early spring arrival in gardens and woodlands throughout Europe and almost all of North America including Alaska. Mourning Cloak (*Nymphalis antiopa*) is a large, easily-identified butterfly that is long-lived, hibernates over the winter, then flies with the first spring melt. Folks who have been snow-bound for months can't help but be cheered at the welcome sight of the year's first Mourning Cloak. Caterpillar host plants include willow, elm, birch and hackberry trees.

OIL COLOR MIXES

Burnt Sienna + Raw Umber

White + Raw Sienna

Black + Raw Umber

French Ultramarine + White

White + French Ultramarine

Cadmium Yellow Pale + Raw Sienna

White + Cadmium Yellow Pale

Alizarin Crimson + Raw Umber

Winsor Red + Cadmium Yellow Pale

White + Alizarin Crimson + tad of Cad Yellow Pale

Winsor Red + Cadmium Yellow Pale + Burnt Sienna

Black + Sap Green

Sap Green + Raw Sienna + White

Previous mix + White

Pattern: Enlarge at 169% to bring up to full size.

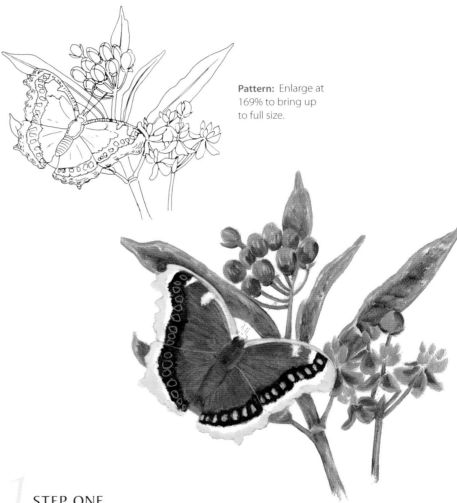

1 STEP ONE

Butterfly: Use a no. 2 or 4 bright for all steps unless otherwise noted. Base the rusty areas with Burnt Sienna + Raw Umber. Base the dark bands with Black + Raw Umber. Draw spots into the wet paint (as shown on left wing above) using tracing paper (see page 21). Lift out spots with the corner of a no. 8 bright dampened with odorless thinner (as shown on right wing). Base the outer half of the wing margins with Cad Yellow Pale + Raw Sienna. Body: Base dark value on thorax with Burnt Sienna + Raw Umber. Base lighter value with Burnt Sienna.

Flower petals/Buds: Base dark value on red petals and buds with Alizarin Crimson + a bit of Raw Umber. Base light value with Winsor Red + Cad Yellow Pale. Base orange petals with Winsor Red + Cadmium Yellow Pale + Burnt Sienna.

Leaves/Stems/Calyxes: Base dark values with Black + Sap Green. Base light value with Sap Green + Raw Sienna + White.

STEP TWO

Butterfly: Shade the rust wing areas with Black. Draw in wing divisions and fore-wing cells with dry chisel. Fill in blue spots with French Ultramarine + a little White. Base remainder of yellow wing margins with White + Cad Yellow Pale and blend where the yellow values meet. Base head with Cad Yellow Pale + Raw Sienna. Shade with Black on thorax and abdomen. Thin a little Raw Umber and apply antennae using no. 0 round brush.

Flower petals/Bud: Blend between values on red petals and buds with chisel edge of bright. Highlight with White + Alizarin Crimson + a bit of Cad Yellow Pale. Highlight orange petals with White + Cad Yellow Pale.

Leaves/Stems/Calyx: Where values meet, blend with growth direction. Highlight with light green mix + more White. Add a Raw Sienna accent color on some leaves.

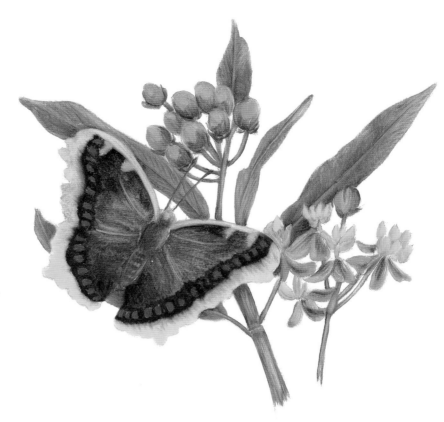

STEP THREE

Butterfly: Blend Black shading, then accent wings with Winsor Red to enrich. Add faint section lines with Black. Highlight blue spots with fine lines of White + French Ultramarine using round brush. With thinned Raw Umber and round brush, lay in all the fine, irregular detail lines on the yellow margins. Use Burnt Sienna to make cross markings on yellow leading edge of fore-wing; use Black in the same manner to do markings across the leading margin of the forewing. Body: Highlight palps and head with White + Raw Sienna. Blend crosswise between values on abdomen. Highlight thorax and abdomen with White + Raw Sienna. With a no. 0 round, draw faint dirty White lines across abdomen to suggest segments. Tip antennae with a bit of White. With slightly-thinned White, create evenly spaced white dots down the length of the antennae.

Flower petals/Bud: Blend highlights on flowers to soften. Re-highlight with pink mix + more White if desired. Add a few division lines with a small bright brush to indicate edges of unopened petals using Alizarin Crimson mix. Blend highlights on orange petals, then highlight again using White if needed.

Leaves/Stems/Calyx: Blend highlights and accents softly into leaves and stems, following growth direction. Add central vein structure with light value green mix using chisel edge.

85

Red Rim & Abelia

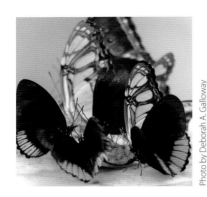

Photo by Deborah A. Galloway

BUTTERFLY GARDENS OFFER A WONDERFUL opportunity to observe butterflies in a setting where they can be readily photographed and enjoyed with little effort. But did you ever wonder where all those gorgeous butterflies come from? This photo was shot at the Sacha Lodge Butterfly Farm in Ecuador, on the Rio Napo, a tributary of the Amazon. This is not a butterfly garden open to the public, but rather a true farm, where the necessary host plants are grown to feed the caterpillars. When they reach the chrysalis stage they are ready to be shipped to butterfly gardens all over the world. The photo shows three Red Rims in the company of some Malachites and a Morpho, all feeding on a soft banana.

OIL COLOR MIXES

Winsor Red + Alizarin Crimson

Black + Raw Umber

Raw Sienna + White

Alizarin Crimson + Raw Sienna

White + Cadmium Yellow Pale

Previous mix + White

Black + Sap Green

Sap Green + White

Previous mix + White

Sap Green + Cadmium Yellow Pale + White

Pattern: Enlarge at 154% to bring up to full size.

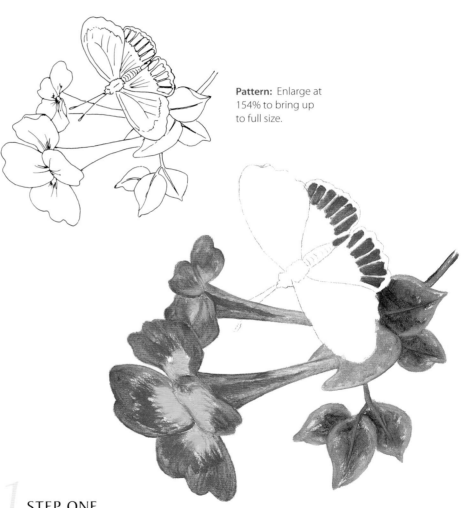

STEP ONE

Butterfly: Use a no. 2 or 4 bright for all steps unless otherwise noted. Base the red sections of the hindwings with Winsor Red + Alizarin Crimson.

Flower trumpet/Calyx: Base lighter yellow values with Cad Yellow Pale and a few darker areas with straight Raw Sienna. Base green inner section of calyx with Sap Green + Cad Yellow Pale + White. Petals and red on trumpet: Base dark value reds with Alizarin Crimson + Raw Sienna. Base lighter values with Winsor Red. Base yellow at flower center with Cad Yellow Pale.

Stems/Leaves: Base the dark values with Black + Sap Green. Base some light edges with pale green mix of Sap Green + White.

STEP TWO

Butterfly: Base dark areas of the wings and body with Black + Raw Umber. Use tracing paper pattern to draw the section lines back into the wet paint (see page 21). Stipple inner half of red markings with Winsor Red.

Flower trumpet/Calyx: Blend where values meet within the calyx. Add a little highlight with light green value + White. Blend between yellow values on the trumpets. Blend petals a bit where values meet, following the growth direction. Highlight with White + Cad Yellow Pale.

Stems/Leaves: Blend where values meet, following growth direction. On leaves, highlight with light value leaf mix + more White.

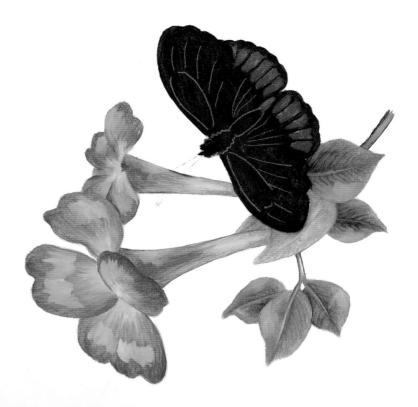

STEP THREE

Butterfly: Apply section lines on forewings with White + Raw Sienna using chisel. With the same brush, blend White into the tips of the forewings and along the trailing edge of the forewings to separate them from the hindwings. Add a few barely visible section lines in dark values on hindwings. Using the flattened tip of a no. 1 round brush, stipple red sections with Cad Yellow Pale. Body: Add details with slightly thinned White for dots on head, down middle of thorax, a band across the junction of thorax and abdomen, and segment lines across the abdomen. Thin a little Black + Raw Umber and apply antennae.

Flower trumpet/Calyx: Blend highlights on calyx with growth direction. Add veining with light green mix. Blend base of trumpet into red upper part. Blend the highlights on the petals following growth direction. Add Alizarin Crimson detail lines using small bright brush from center of each petal outward.

Stems/Leaves: Blend highlights softly into leaves, following growth direction, using no. 4 bright. Add vein structure with light value green mix.

Sherry C. Nelson
(c) 2009

Common Mestra & Betony Mist Flower

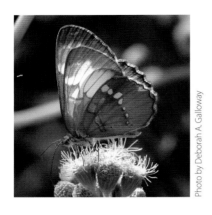

Photo by Deborah A. Galloway

IN THE FALL OF 2007, WE FLEW TO south Texas to shoot more reference photos for this book. We had been in the NABA gardens hardly five minutes when we saw our first Common Mestra (*Mestra amymone*). It was feeding, as you see here, on a betony mist flower. As the days passed, we saw many of these gold beauties and they continued to draw me in. This little tropical brushfoot is not as flashy as some, but it's a lovely little butterfly and has become one of my favorites.

Pattern: Enlarge at 123% to bring up to full size.

OIL COLOR MIXES

Black and White

Cadmium Yellow Pale + Winsor Red + Raw Sienna

Black + Raw Umber

Alizarin Crimson + French Ultramarine + White

White + Cadmium Yellow Pale + Winsor Red + Raw Sienna

Raw Sienna + Burnt Sienna

Alizarin Crimson + French Ultramarine

Black + Sap Green + Raw Sienna

Sap Green + Raw Sienna + White

White + Cadmium Yellow Pale + Sap Green

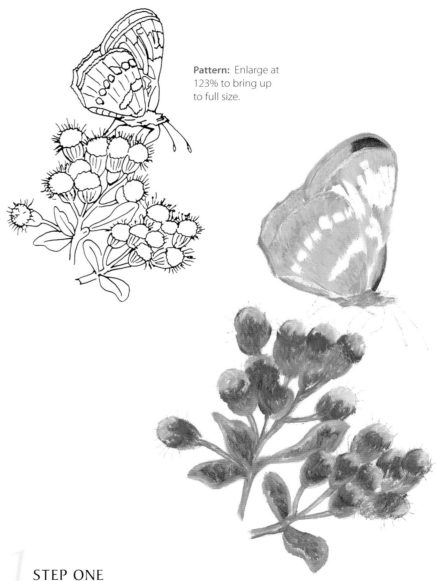

1 STEP ONE

Butterfly: Use a no. 2 or 4 bright for all steps unless otherwise noted. Outline wings with Black + White. Base warm yellow sections with Cad Yellow Pale + Winsor Red + Raw Sienna. Place the two small sections of Black + Raw Umber on the forewing. Base the dark on body with Black + White.

Flowers: Base dark value with French Ultramarine + Alizarin Crimson, leaving edges broken. Base light value with previous mix + White.

Stems/Leaves/Calyxes: Base the dark values with Black + Sap Green + a bit of Raw Sienna. Base light value with Sap Green + Raw Sienna + White.

2 STEP TWO

Butterfly: Shade the yellow areas with Burnt Sienna. Blend to basecoat but don't overwork. Soften Black on forewing apex into adjacent value. Highlight gray wing margins with White. Base gray hindwing section with Black + White + a bit of Raw Sienna. Base all white sections and spots with White. Body: Base rest of body with Cad Yellow Pale + Winsor Red + Raw Sienna. Thin a little Raw Sienna + Burnt Sienna and apply antennae with a no. 0 round.

Flowers: Blend where values meet with choppy strokes of a no. 2 bright. Stipple with White on top of each blossom to highlight.

Stems/Leaves/Calyxes: Blend where values meet, following growth direction. Then apply highlights using White + Cad Yellow Pale + Sap Green. On calyxes, etch lines with the chisel edge as you apply the highlight. Highlight leaves and blend with chisel.

3 STEP THREE

Butterfly: Stipple all white spots with pure White. With slightly thinned Black + Raw Umber, make an irregular row of dots to create the dark detail inside wing margins. Use the no. 4 bright to do section lines with Black + White. Shade body with a bit of Black. With a no. 0 round, draw faint dirty dark lines across abdomen to suggest segments. Add a few White details on head and palps. Base legs with slightly thinned Black + White using a no. 0 round. Tip antennae with a bit of White. Thin a puddle of White and with a no. 0 round add a row of spaced dots down the length of the antennae.

Flowers: Stipple highlights with flattened tip of no. 1 round to soften. Thin a little puddle of Alizarin Crimson + French Ultramarine and apply the stamens that stick out all over each little blossom. They are quite ragged so don't make them too neat.

Stems/Leaves/Calyxes: Soften highlights into leaves and stems following growth direction. Add vein structure with White + Cad Yellow Pale + Sap Green using chisel edge. Accent leaves with Raw Sienna + Burnt Sienna.

Blue-frosted Banner & Shrimp Plant

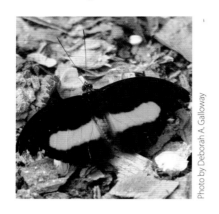

Photo by Deborah A. Galloway

THE STRIKING GENUS OF TROPICAL Brushfooted butterflies have another interesting characteristic aside from their generally flashy and colorful patterns. They are sexually dimorphic, which means that the males and females are dramatically different in appearance. The male *Acontius Catone* shown in the photo is a close cousin to the Blue-frosted Banner male in the painting, which we photographed in Costa Rica.

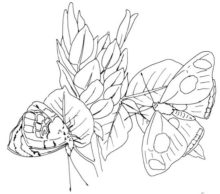

Pattern: Enlarge at 196% to bring up to full size.

OIL COLOR MIXES

Black + Raw Umber

Cadmium Yellow Pale + Winsor Red

French Ultramarine + White

White + French Ultramarine

Cadmium Yellow Pale + Raw Sienna

White + Raw Sienna + Winsor Red

White + Raw Umber

Raw Sienna + Winsor Red

White + Raw Sienna

Black + White

Black + Sap Green

Sap Green + Raw Sienna + White

Previous mix + White

1 STEP ONE

Butterfly, wings spread: Use a no. 2 or 4 bright for all steps unless otherwise noted. Base orange sections with Cad Yellow Pale + Winsor Red.

Butterfly, closed wings: Base yellow sections with Cad Yellow Pale + Raw Sienna. Base pinkish sections on wing and thorax with White + Raw Sienna + a tad of Winsor Red. Base dark on hindwing with sparse Raw Umber. Base dark on forewing with Black + Raw Umber, and gray patch with White + Raw Umber. Base a small patch of Cad Yellow Pale + Raw Sienna next to pink mix on thorax.

Flower sepals: Base dark values on sepals with Raw Sienna + Winsor Red. Base light value with White + Raw Sienna. White flowers: Apply sparse shading with Black + White. Base rest of flowers with White.

Leaves/Stems: Base the dark values with Black + Sap Green. Base light value with Sap Green + Raw Sienna + White.

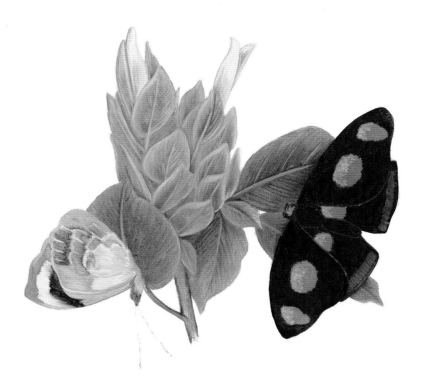

STEP TWO

Butterfly, wings spread: Apply Cad Yellow Pale on inner half of orange sections with no. 1 round. Base blue margin with French Ultramarine. Base dark on wings and body with Black + Raw Umber. Draw in wing separation lines with stylus. Base head with Cad Yellow Pale + Winsor Red.

Butterfly, closed wings: Blend yellow sections into adjacent Raw Umber. Outline Raw Umber sections with White. Base rest of hindwing with White. Accent near body with Cad Yellow Pale + Raw Sienna. Highlight pinkish sections with White. Accent margin on forewing with Cad Yellow Pale + Winsor Red. Base white band with White and blend to soften into edge of dark mix. Shade leading edge of forewing with Raw Umber. Base dark area on body with Raw Umber. Blend a bit into adjacent colors.

Flower sepals: Blend between values on sepals with the growth direction. Accent with Winsor Red if needed. Use light value mix for central veining. Place Raw Umber in the shadow areas between individual sepals at the bottom of the flower spike. White flowers: Blend between values with chisel leaving faint lines in surface. Accent with Raw Sienna + Winsor Red.

Leaves/Stems: Blend between dark and light values with growth direction. Apply highlights using light value green mix + more White.

STEP THREE

Butterfly, wings spread: Stipple Cad Yellow Pale highlighting with flattened tip of no. 1 round brush. Add white stippling on the blue sections on hindwing. Soften with flattened tip of brush. Separate blue sections with tapped-in lines of dark mix applied with no. 2 bright. With White + Raw Sienna, set in a few sparse and indistinct section lines to define dark wing areas. Highlight a little along margins of forewing to separate from hindwing. Body: Shade top of head with a bit of Raw Umber. Using small bright and White + Raw Sienna, touch in bits of light value along edges of thorax for a fuzzy look, and faint lines on abdomen to indicate segments. Thin a little Black + Raw Umber and apply antennae.

Butterfly, closed wings: Blend accent color on white areas to soften. Blend light edges of Raw Umber sections into adjacent Raw Umber to soften. Accent margin of hindwing with White + Raw Sienna + Winsor Red. On both fore- and hindwing, add detail markings with slightly-thinned Raw Umber applied with tip of no. 0 round. Thin a little Black + Raw Umber and apply legs and antennae using no. 0 round. Tip antennae with a bit of dirty Cad Yellow Pale.

Flower sepals: Soften pinkish highlights on sepals with growth direction. Add more if needed and reblend. Accent far sepals and flowers with Raw Sienna if desired.

Leaves/Stems: Blend highlights softly into leaves and stems, following growth direction. Add central vein with light value green mix using chisel edge. Accent with Raw Sienna + Winsor Red at vein on some leaves. Blend to soften.

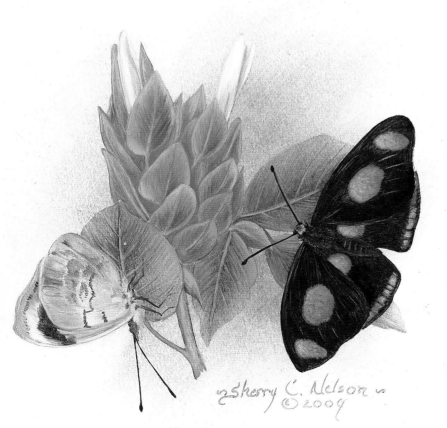

Clymena 88 & Bomarea

THE 88'S ARE UNIQUE BUTTERFLIES, and are as familiar to folks who live in the tropics as the Monarchs are to us. Some species don't have the perfect "88" on the wing—the pattern looks more like "80" or "86." But this sharp-looking Clymena 88 (*Diaethria clymena*), photographed at Iguaçu Falls, really lives up to its name. The caterpillar host for the 88's are the woody lianas. The rain forests are full of interesting members of this vining family. The one painted here, *Bomarea hirsuta*, is pollinated by hummingbirds.

OIL COLOR MIXES

White + Raw Sienna

Winsor Red + Alizarin Crimson

White + Raw Sienna + Cadmium Yellow Pale

Previous mix + White

Alizarin Crimson + Winsor Red + Raw Sienna

White + Cadmium Yellow Pale

Black + Sap Green

Sap Green + Raw Sienna + White

Previous mix + White

Pattern: Enlarge at 143% to bring up to full size.

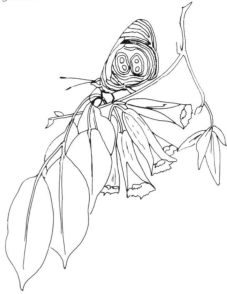

1 STEP ONE

Butterfly: Use a no. 2 or 4 bright for all steps unless otherwise noted. Base red section with Winsor Red + Alizarin Crimson. Base all dark stripes with Black acrylic, using a no. 0 red sable round brush. Work across the stripes so the edges are just a bit broken or fuzzy. That helps the wings look scaled rather than smooth. When finished, clean the acrylic paint out of the brush well before using it again with oils. Thin a little Black + Raw Umber and apply legs and antennae with a no. 0 round brush.

Flower: Base dark values with Alizarin Crimson + Winsor Red + Raw Sienna. Base lighter values with White + Raw Sienna + a bit of Cad Yellow Pale.

Leaves/Stems: Base the dark values with Black + Sap Green. Base light areas with Sap Green + Raw Sienna + White.

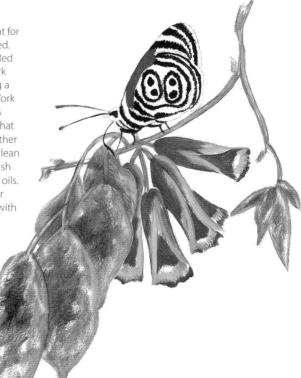

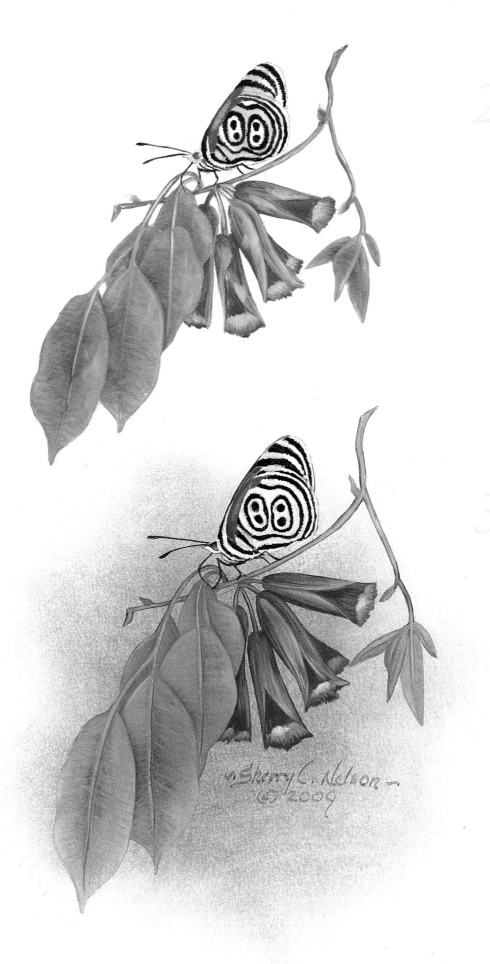

STEP TWO

Butterfly: Fill in white sections with White oil paint in the central part of the wing, and White + Raw Sienna in the more shadowed areas of the wings, using a no. 0 bright. Highlight with Winsor Red + White in the red section, using a no. 1 round. Fill in light areas of the body with White + Raw Sienna.

Flower: Blend between values with growth direction. Highlight with White + Raw Sienna + Cad Yellow Pale + more White. Fill in the throat of each trumpet with White + Cad Yellow Pale.

Leaves/Stems: Blend between dark and light values with a growth direction that's perpendicular to the center vein. Apply highlights using the light value green mix + more white.

STEP THREE

Butterfly: Stipple on highlights in white sections with pure White to strengthen, using no. 1 round. Soften the highlight in the red section by tapping with flattened tip of the no. 1 round. Body: Highlight with a little stippled White where needed.

Flower: Blend highlights to soften, following the growth direction. Soften bottom edge of yellow throat into the adjacent red mix. Highlight center of yellow throat with White.

Leaves/Stems: Blend highlights softly into leaves, following perpendicular growth direction, using no. 4 bright. Add central vein with light value green mix using chisel edge. Accent with Raw Sienna and reblend.

Mexican Bluewing & Vasey's Wild Lime

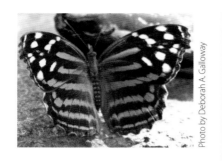

Photo by Deborah A. Galloway

THE SPECTACULAR BLUEWING IS a butterfly of woodland areas, and feeds readily on over-ripe fruit. Thus this rare south-of-the-border specialty was lured in to soft bananas at the NABA gardens in South Texas. Mexican Bluewings (*Myscelia ethusa*) are found from the very tip of Texas southward into Mexico. A unique behavior: this butterfly prefers perching on tree trunks facing downward. It is painted here with Vasey's Wild Lime tree (*Adelia vaseyi*), its host plant, painted to show the blossoms as well as the young fruit.

OIL COLOR MIXES

French Ultramarine + Alizarin Crimson + White

White + French Ultramarine

Previous mix + White

Black + Raw Umber

Raw Sienna + Raw Umber

Previous mix + White

Previous mix + more White

Black + Sap Green

Sap Green + Cadmium Yellow Pale + White

Previous mix + White

White + Cadmium Yellow Pale

Pattern: Enlarge at 189% to bring up to full size.

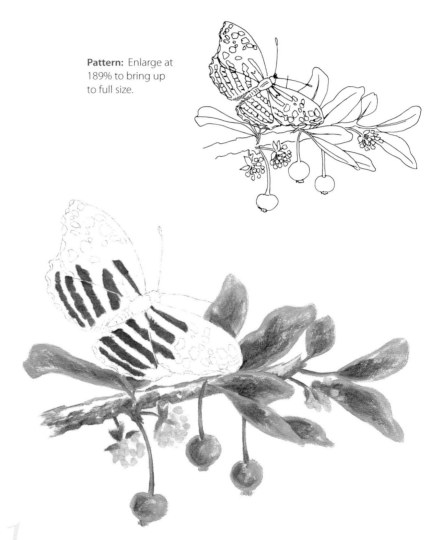

1 STEP ONE

Butterfly: Use a no. 2 or 4 bright for all steps unless otherwise noted. Base blue sections with French Ultramarine + a tiny bit of Alizarin Crimson + a tad of White.

Blossoms: Base with White + Cad Yellow Pale.

Lime Fruit: Base the dark values with Black + Sap Green. Base light values with Sap Green+ Cad Yellow Pale + White. Base blossom ends with Raw Sienna.

Branch: Base dark value with Raw Sienna + Raw Umber.

Leaves/Stems/Calyxes: Base the dark values with Black + Sap Green. Base light values with Sap Green + White.

2 STEP TWO

Butterfly: Apply light blue mix + White to upper edge of all blue sections with no. 1 round. Base all dark areas with Black + Raw Umber. Blend just a bit with chisel edge to connect to blue sections. Clean out any messy dark mix from spots using damp brush. Fill in white spots with White. Body: Base with Black + Raw Umber except in very center. Base center with White. Thin a little Black + Raw Umber and apply antennae using the round brush.

Blossoms: Shade at base of some with a bit of Sap Green.

Lime Fruit: Soften colors in a multi-directional blend where values meet using a no. 2 bright. Highlight with a little light blue mix + White.

Branch: Base rest of branch with Raw Sienna + Raw Umber + White. Blend roughly where values meet with choppy strokes of the chisel edge parallel with the growth direction.

Leaves/Stems/Calyxes: Blend where values meet, following growth direction. Add a few highlight areas with light green mix + White and a few with light blue mix + White.

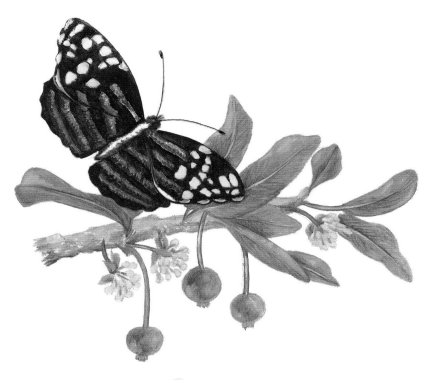

3 STEP THREE

Butterfly: Stipple the light blue with flattened tip of no. 1 round brush to create a value gradation. Highlight at margins, next to body on forewings, and on apex of forewings on top of dark basecoat, using White on a chisel edge of no. 4. With a little gray mix, fray the inner edges of the hindwings to create a soft, hairy edge. Using the flattened tip of the round brush, stipple highlights on white spots with pure White to give some texture. Add white detail markings at margins of wings with the round brush. Body: Blend a bit between values to connect. Highlight with a little dirty White, creating bits of stippled white on and behind head and a few lines to indicate segmented abdomen. HIghlight in very center of thorax and on tips of antennae with a bit of White.

Blossoms: Blend to soften green values. Highlight by stippling White on tips of each little bud with a no. 1 round brush

Lime Fruit: Soften blue highlights. Add final highlights with dabs of pure White. Soften by tapping around edges of white with flattened tip of no. 1 round brush.

Branch: Highlight upper third of branch with White and again, chop with the chisel to get surface texture that looks like bark.

Leaves/Stems/Calyxes: Soften blue highlights by blending with growth direction. Re-highlight with light green mix + more White and reblend. Apply central vein line using Sap Green + White.

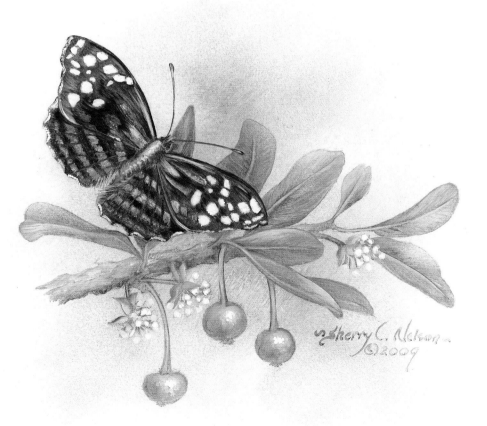

Sherry C. Nelson
©2009

Puddle Party

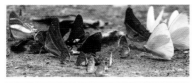

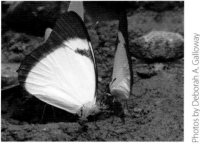

Photos by Deborah A. Galloway

A BIG PUDDLE PARTY IS ONE of the most exciting experiences in the world of butterflies. We've taken some photos at amazing puddling sites in South America that, when we get home to our references, sometimes takes hours to identify every butterfly that crashed the party. This painting includes three species of tropical brushfoots: Orsilochus Daggerwing, Amphiro Redring, and a Lycimnia White, shown in the lower reference photo.

Pattern: Enlarge at 185% to bring up to full size.

OIL COLOR MIXES

Black + Raw Umber

Raw Sienna + Raw Umber

White + Raw Umber

Cadmium Yellow Pale + Winsor Red + Raw Sienna

White + Black + Raw Umber

Cadmium Yellow Pale + Winsor Red + White

Cadmium Yellow Pale + Winsor Red

White + Raw Sienna

Winsor Red + Alizarin Crimson

White + Raw Sienna + Cadmium Yellow Pale

Black + Sap Green

Sap Green + Raw Sienna + White

Previous mix + more White

Raw Umber + Sap Green + White

White + Sap Green + Raw Umber

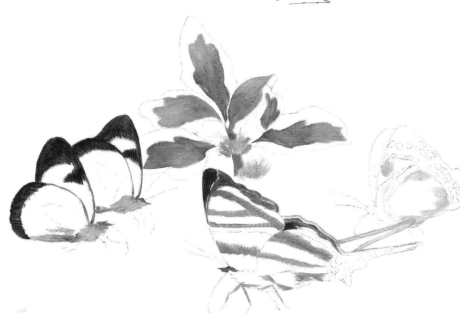

1 STEP ONE

Butterflies: Daggerwing (center): Base orange sections on near wings with Cad Yellow Pale + Winsor Red + Raw Sienna. Base gray bands and patch on underside hindwing with Raw Umber + White. Base dark values on far wings with Black + Raw Umber. Base dark brown section with Raw Umber and marginal band with White + Raw Umber. Base tail margin with White + Raw Sienna. Body: Base legs with Cad Yellow Pale + Winsor Red + Raw Sienna. Base top of head with Raw Umber. Base gray on body with White + Raw Umber. Lycimnia White (left): Base dark areas with Black + Raw Umber. Base underside of hindwing with sparse Raw Umber. Body: Base top of head with Raw Umber. Base orange on body with Cad Yellow Pale + Winsor Red. Amphiro Redring (right): Base wings with White in light values and Raw Sienna in the darker values.

Flower/Leaves/Stem: Scruff in Raw Sienna at bottom of cluster of flower spike. Base dark values with Black + Sap Green. Base light areas with Sap Green + Raw Sienna + White.

STEP TWO

Butterflies: Daggerwing: Base tail markings with Black acrylic on a no. 0 round. Base around the acrylic with White oil paint. Base inside tail with Raw Umber. Base wide hindwing and forewing bands with White. Connect to adjacent colors with chisel. Base hindwing margin with White + Raw Sienna. Base near forewing margin with Raw Sienna + Raw Umber. Base dark values on forewing with Raw Umber. Shade orange on forewing with Raw Umber + White. Add red spot with Winsor Red. Draw pattern lines on far wings with a stylus. Highlight forewing with White + Raw Umber. Body: Place orange mix of Cad Yellow Pale + Winsor Red in eye. Fill in rest of body with White. Lycimnia White: Blend underwings. Walk White into edges of dark margins to connect. Use dirty White for section lines on the dark wing margins. Highlight with White in whitest part of wing. Body: Highlight thorax with a little Cad Yellow Pale. Antennae on all butterflies: Thin a puddle of Raw Umber and apply antennae with a no. 0 round. Amphiro Redring: Blend hindwings where values meet. Shade with a little Raw Umber on hindwing. Base red margins with Winsor Red + Alizarin Crimson. Base all dark values with Black + Raw Umber. Go around spots as you base. Body: Base top of head with Raw Umber. Base behind Daggerwing's tail with Raw Sienna. Base rest of body with White.

Flower/Leaves/Stem: Base rest of flower spike with White. Blend dark green areas of leaves with growth. Highlight with light green mix + White. Base rest of leaves using White + Raw Sienna. Highlight stem with White.

Foreground detail: When dry, scruff a little Raw Sienna and a little White + Raw Umber using a dry brush.

STEP THREE

Butterflies: Daggerwing: Shade white bands and add section lines with White + Raw Umber. Highlight gray bands using White. Add Black + Raw Umber detail markings on hindwings and far tail. Highlight far wings and tail with White along margins and add a small white spot on forewing. Body: Blend between values on body. Add antennae and proboscis and all legs on all butterflies with slightly-thinned Raw Umber or Raw Sienna on a no. 0 round brush. Lycimnia White: Highlight white sections with clean White. Lay in section lines with White + Raw Umber on chisel edge of brush. Body: Highlight with White + Cad Yellow Pale. Add White dots on head. Amphiro Redring: Lay in section lines in wings with White and with Raw Umber. Add bands of red markings using Winsor Red + Alizarin Crimson. Highlight major markings with Winsor Red. On forewing, highlight a few red spots with dirty White. Base white spots with White. Add White detail at wing margins. Highlight forewing with Raw Sienna + White. Body: Blend values where they meet. Add a red eye with Winsor Red.

Flower/Leaves/Stem: Highlight flowers with White, then blend. Blend highlights into leaves. Add vein structure with light value green mix using chisel. Blend light margins with growth direction and connect slightly to the green inner sections. Highlight light edges in places with pure White and reblend.

Foreground detail: Soften shadow color under butterflies in a horizontal direction using a cheesecloth pad.

Sherry C. Nelson
©2009

Silver Emperor & Mexican Wild Olive

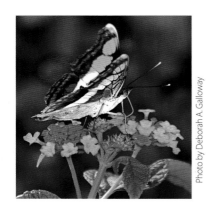

Photo by Deborah A. Galloway

THIS IS A BUTTERFLY OF THE subtropical lowland forest. It ranges from extreme southern Texas to Mexico and Brazil. The photo shows the silvery underside from which this butterfly gets its name, and if you look close, some of the iridescent blue is refracting on the upper wing. It's painted here with the Mexican olive tree, which is not a true olive, but is rather in the Borage family. Adults also visit overripe fruit and sap as well as various garden flowers, while the larvae feed on the foliage of hackberries and sugarberries.

Pattern: Enlarge at 169% to bring up to full size.

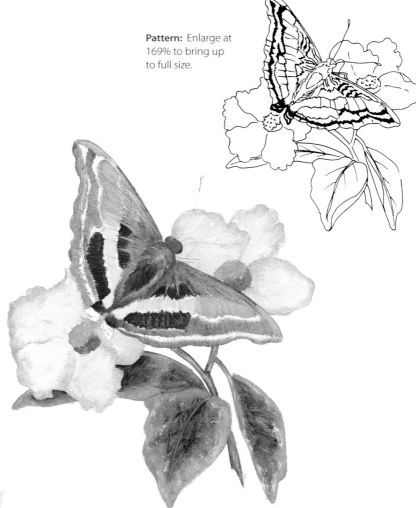

OIL COLOR MIXES

Cadmium Yellow Pale + Raw Sienna

Raw Sienna + Raw Umber

Alizarin Crimson + French Ultramarine + a tad of White

Raw Umber + Black

Raw Sienna + Burnt Sienna

White + Black + Sap Green

Black + Sap Green

Sap Green + Raw Sienna + White

Previous mix + White

STEP ONE

Butterfly: Use a no. 2 or 4 bright for all steps unless otherwise noted. Base yellow sections with Cad Yellow Pale + Raw Sienna. Base white sections between blue bands with White. Base blue sections with French Ultramarine. Base light brown sections with Raw Sienna + Raw Umber. Base dark patches on hindwings and on body with Raw Umber + Black. Base the rest of the abdomen with Raw Sienna. Base thorax with Raw Sienna + Burnt Sienna.

Flowers: Base gray areas of petals with White + Black + a tad of Sap Green, leaving edges broken where values meet. Base light values with White. Flower centers: Base dark value with Raw Sienna + Burnt Sienna. Base light value with Cad Yellow Pale + Raw Sienna.

Leaves/Stems: Base the dark values with Black + Sap Green. Base light value with Sap Green + Raw Sienna + White.

STEP TWO

Butterfly: Apply Raw Sienna + Raw Umber around "tails" on hindwings. Apply White between the bands of the dark mix on tails. Blend white patches below abdomen and the Raw Umber + Black patches so that the appearance is a bit hairy. Apply clean Alizarin Crimson + French Ultramarine on the outer half of the blue patches that occur in the outer hindwings only. Shade the yellow sections with Burnt Sienna and blend until it fades. Use Burnt Sienna to apply the section lines in the yellow section. Use gray to apply section lines in the white bands. Lay pattern onto wet butterfly and draw the detail markings in the forewings for a guide. Body: Blend between values to soften. Shade thorax with Raw Umber + Black. Thin a little Raw Umber and apply antennae.

Flowers: Blend with growth direction of each petal where values meet. Add gray flower mix for the central shadow that defines the vein. Highlight with White. Flower centers: Blend between values with choppy brushstrokes. Shade at base of center with Raw Umber.

Leaves/Stems: Blend between values following growth direction. Apply highlights using light value green mix + more White.

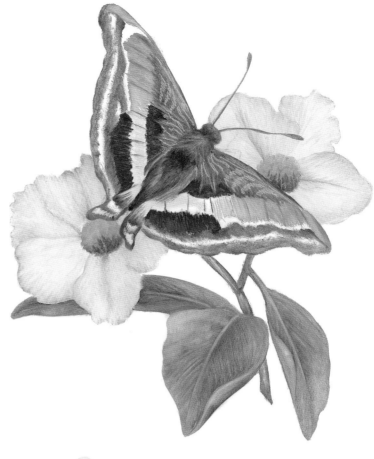

STEP THREE

Butterfly: Highlight violet iridescence with violet mix + White by stippling with flattened tip of no. 1 round brush. Place the irregular, zig-zaggy division lines with slightly-thinned Raw Umber + Black using a round brush. Work across the bands so the edges become irregular, which enhances the realism of the scaled wing. Use the same mix to add the short section lines in the dark wing margins. Apply squiggly detail on inner forewing with same mix. Stipple pure White on white sections to re-highlight. With a no. 2 bright, fluff a bit of the dark mix on end of abdomen into the "hairy" sections so the inside edges of the hindwings appear fluffy and a bit feathered. Body: With no. 0 bright, highlight around the edges of thorax and on the head with dirty White. Accent on mid-abdomen with a bit of dirty Winsor Red. Add the one visible leg with a bit of thinned gray using round brush. Tip antennae with dirty Cad Yellow Pale. Proboscis: Base with Cad Yellow Pale + Raw Sienna. Shade under leg and antennae with Raw Umber.

Flowers: Blend highlights. When painting is dry, come back with additional highlights if needed. Centers: Stipple White for highlights into lightest parts of flower centers using round brush. Pull a bit of the yellow base color out onto the petals where the center meets the petals.

Leaves/Stems: Blend highlights softly into leaves and stems, following growth direction. Add vein structure with light value green mix using chisel edge.

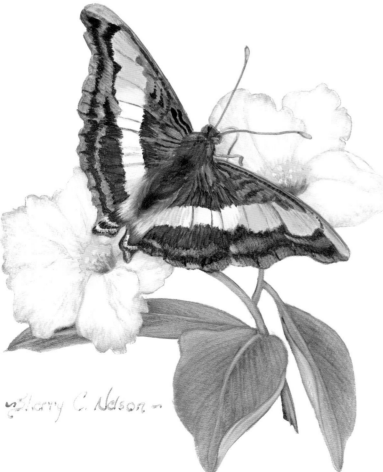

Sherry C. Nelson

Costa Rican Satyr & Thorn Apple

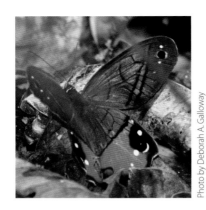

Photo by Deborah A. Galloway

SATYRS ARE THE FINAL SUBFAMILY of Brushfoots that we'll paint. Most satyrs are dressed in brown tones but are not boring by any means. Many have dramatic patterns of eyespots and subtle color variation to enhance their more neutral garb. The lovely Costa Rican Satyr (*Pierella helvetia*) in the photo has bright red hindwings, which it tends to hide in the more common closed-wing posture. Caterpillar host plants include nightshades, madder and arrowroot.

OIL COLOR MIXES

Raw Sienna + Cadmium Yellow Pale

Raw Sienna + Raw Umber

French Ultramarine + Alizarin Crimson + Raw Umber + White

White + Raw Sienna

Raw Sienna + Alizarin Crimson

Violet mix + White

French Ultramarine + Alizarin Crimson + Raw Umber

Black + Raw Umber

Black + Sap Green

Sap Green + Raw Sienna + White

Previous mix + White

Black + White

White + Cadmium Yellow Pale

White + French Ultramarine

Pattern: Enlarge at 179% to bring up to full size.

1 STEP ONE

Butterfly: Use a no. 2 or 4 bright for all steps unless otherwise noted. Base dark yellow sections with Cad Yellow Pale + Raw Sienna; lighter yellow sections with White + Raw Sienna. Base violet sections with French Ultramarine + Alizarin Crimson + Raw Umber + White. Base body and legs with White + Raw Sienna.

Flowers: Base dark value on open petals with very sparse Black + White leaving edges broken. Base some warm areas with Raw Sienna and a few with Raw Sienna + Cad Yellow Pale. Base remainder of flower with White + a tad of Cad Yellow Pale. The base of the pistil is based with Raw Sienna. Bud: Base dark values with Raw Sienna + Raw Umber. Base the gray value with sparse Black + White and the rest with dirty White.

Leaves/Stems/Calyxes: Base the dark values with Black + Sap Green. Base light value with Sap Green + Raw Sienna + White.

STEP TWO

Butterfly: Shade the warm yellow wing areas with a bit of the violet mix, especially at base of large eyespot. Blend gently to basecoat but don't overwork. Lift out light patch and white spots with a brush dampened with thinner. Shade wing margins with violet mix. Highlight light value band with White. Highlight violet sections here and there with a bit of Violet mix + White. Add a little Raw Sienna or Raw Sienna + Cad Yellow Pale accent color in leading edge of both wings. Fill in eyespots with Black acrylic. Then outline eyespots with Cad Yellow Pale + a little White. Body and legs: Blend just a bit of the violet wing color down into the upper part of the body to connect the areas. Highlight body with a bit of white. Shade underside of legs with Raw Sienna or Raw Umber.

Flowers: Blend between values with chisel edge, following growth direction of the individual petals. Pat petals with cheesecloth pad to remove excess paint and to give more of a translucent effect. Add a little White + French Ultramarine shading. Add strong highlights with White. Base rest of pistil with White + Cad Yellow Pale and blend where values meet. Bud: Blend between values on bud, but blend across the petals to suggest the way the petals wrap around the bud before they begin to open. Highlight with White.

Leaves/Stems/Calyxes: Blend between values with growth direction. Apply highlights using light green mix or White + French Ultramarine.

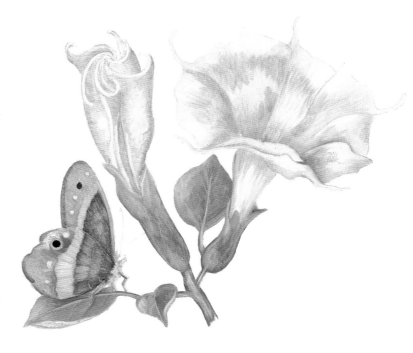

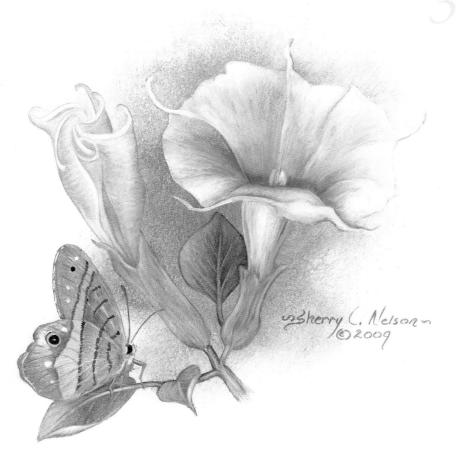

Sherry C. Nelson
© 2009

STEP THREE

Butterfly: Highlight white section and spots on wings with pure White. Use round brush for white fringe along wing margin on fore-wing. Use slightly thinned Raw Umber + a little Black to create the irregular row of dots, short lines and dark detail that divide wing sections. Work across the line, not with it, so the line appears broken and irregular. Use a no. 2 bright to tap in the section lines with White, or with Raw Sienna + Raw Umber. With a no. 0 round, add a few white details on head. Place black eye with Black. Detail the legs with more Raw Umber if needed using a no. 0 round. Thin a little Raw Umber and apply antennae.

Flowers: Blend both shading and highlights with chisel edge of brush following growth direction carefully to get correct shape of flower. Wait until it's dry and then re-highlight for more drama. Highlight pistil with White. Bud: Blend highlights with chisel edge to keep the wrap-around look with the brush marks. The bud is more colorful than the open, older flower.

Leaves/Stem/Calyxes: Soften highlights into leaves and stems and calyx. Add vein structure with light green mix + White.

Guava Skipper & Guava Tree

Photo by Deborah A. Galloway

IN THESE NEXT FIVE DEMOS WE'LL LOOK AT the family of butterflies called Skippers (*Hesperiidae*). The gorgeous iridescent Guava Skipper (*Phocides polybius palemon*) is so-called because it uses only the Guava tree—the floral element in this painting—as its host plant. The excellent reference photo at left shows the shape and structure of the unusual antennae characteristic of skippers. Note the angle of the club at the end and the *apiculus* extending from it; note also the bright white trailing edges of the wings.

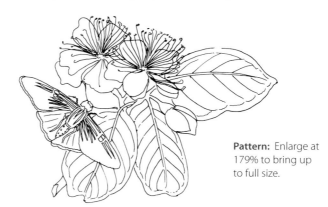

Pattern: Enlarge at 179% to bring up to full size.

OIL COLOR MIXES

French Ultramarine + Sap Green

Previous mix + White

Phthalo Turquoise + White

Sap Green + Black + White

Previous mix + Cadmium Yellow Pale

Raw Sienna + White

Cadmium Yellow Pale + White

Black + Sap Green

Sap Green + Raw Sienna + White

Previous mix + White

French Ultramarine + White

STEP ONE

Butterfly: Use a no. 2 or 4 bright for all steps unless otherwise noted. Base the wings with a mix of French Ultramarine + Sap Green. Base wing margins with White. **Body:** Base the thorax and abdomen with French Ultramarine + Sap Green. Base red cap on the head with Winsor Red. Base band behind red cap with Raw Umber.

Flowers/Bud: Base dark value with sparse Sap Green + Black + White. Base light values with White.

Leaves/Stems/Calyx: Base the dark values with Black + Sap Green. Base light values with Sap Green + Raw Sienna + White.

STEP TWO

Butterfly: Using tracing paper pattern, draw the lines indicating the iridescent markings into the wet paint (see page 21). Lift dark green basecoat color out of iridescent markings using a no. 8 bright dampened in odorless thinner. Remove paint in body also. Base red spots with Winsor Red. Shade wings and body with Black.

Flowers/Bud: Blend where values meet. Accent with green mix at base of petals, then apply sparse Cad Yellow Pale. With cheesecloth, soften yellow into flowers, and lift out excess yellow and shading color to give flowers a translucent appearance.

Leaves/Stems/Calyx: Blend where values meet, following growth direction. Establish vein structure with the light green leaf mix. Add highlight areas with light green leaf mix + White.

STEP THREE

Butterfly: With French Ultramarine + Sap Green + White on a no. 4 bright, highlight outer third of all wings and soften into basecoat with growth direction. Stipple strong White along white margins with a round brush. Base iridescent lines on both body and wings with Phthalo Turquoise + White on a small bright. Then load a slightly lighter value of the same mix on the tip of a no. 1 round and, starting on each line next to the body, tap down the line, allowing the brush to run out of paint as you come to the end of the line. Add a few section lines in outer wings with same mix. Thin a little Black + Raw Umber and apply legs and antennae using a no. 0 round.

Flowers/Bud: Apply strong White highlights in central area of most petals. Blend and re-highlight. Thin some White very, very thin, and with a no. 0 round brush, lay in the dozens of long graceful stamens. Dab on ends with Raw Sienna + White first, then a bit of Cad Yellow Pale + White.

Leaves/Stems/Calyx: Blend highlights. Add additional highlights with light value green mix + White if needed. Reblend. Add French Ultramarine + White accents and blend. Apply central vein using same mix. Accent calyx with a bit of Mix + Cad Yellow Pale. Shade tip of calyx with Raw Umber.

103

White-Striped Longtail & Trailing Bean

Photo by Deborah A. Galloway

NOT A COMMON RESIDENT IN the Southwest but still found quite regularly, the White-striped Longtail (*Chioides catillus*) is a dramatic addition to the *Hesperiidae* family. Many of the longtails, including this one, depend on various species of legumes for their host plant. For that reason, I chose the Trailing Bean as the floral element for this painting. The reference photo at left shows a Long-tailed Skipper (*Urbanus proteus*). Check out the antennae clubs with the apiculus easily visible at the ends. And note how the light is shining through the wing windows. They truly are as translucent as thin film.

OIL COLOR MIXES

Black + Raw Umber

White + Black + Raw Umber

Black + Sap Green + French Ultramarine

White + Sap Green + French Ultramarine

Previous mix + White

Raw Sienna + White

Sap Green + Raw Sienna + White

Alizarin Crimson + French Ultramarine

Cadmium Yellow Pale + Raw Sienna

White + Raw Sienna

Pattern: Enlarge at 149% to bring up to full size.

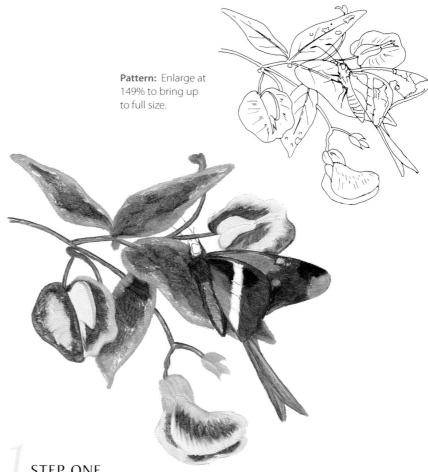

1 STEP ONE

Butterfly: Use a no. 2 or 4 bright for all steps unless otherwise noted. Base white sections with White. Base gold sections with Raw Sienna. Base darkest sections with Black + Raw Umber. Base remainder of dark on wings with Raw Umber. Tail: Base dark value with Raw Umber and light value with Raw Sienna. Body: Base dark on body with Raw Umber and light with Raw Sienna.

Blossoms: Base the dark values with a dry mix of Alizarin Crimson + French Ultramarine + Raw Sienna, leaving edges fuzzy. Base rest of blossom with White + Raw Sienna. Bottom blossom has a yellow section based with Raw Sienna + Cad Yellow Pale.

Leaves/Stems/Calyxes: Base dark values on leaves with Black + Sap Green + French Ultramarine. Base light value with White + French Ultramarine + Sap Green. Stems: Base one side of stem with dark value of Black + Sap Green + French Ultramarine. Base other side with Burnt Sienna. Calyxes: Base with Sap Green + Raw Sienna + White.

STEP TWO

Butterfly: Blend with growth direction between colors on individual sections to gradate values. Leave white area clean but connect edges slightly to surrounding colors using chisel. With dirty brush, add section lines within White sections. Highlight Raw Sienna basecoat areas with White + Raw Sienna. Shade on tail with additional Raw Umber + Black to define dark edges. With dirty White on a round brush, apply the fuzzy white detail paint on wing margins, a few spots on forewing, and one larger one on hindwing. Body: Blend between values. Base head with White (except for eye). Blend White a bit into thorax below. Add a few White lines curving across abdomen to suggest segments. Thin a little Raw Umber and apply legs using a no. 0 round.

Blossoms: Blend where values meet with no. 2 bright. Study petal shapes and growth direction and blend one at a time, carefully noting how petal is formed in order to develop the proper shape in each blossom. Allow chisel lines to remain to give a realistic look.

Leaves/Stems/Calyxes: Blend between values with growth direction of leaf and stem. Apply highlights using light value green mix + more White. Fill in remainder of stems with Sap Green + Raw Sienna + White. Shade calyxes with dark green, then add a bit of Burnt Sienna accent color. Highlight with light green mix + more White.

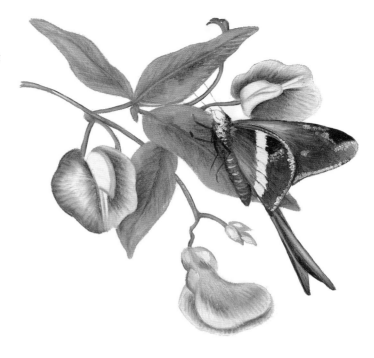

STEP THREE

Butterfly: Blend highlights on Raw Sienna sections. With flattened tip of a round brush, tap the fuzzy white areas to achieve a value gradation from wing edges inward toward body. Wing should gradually become grayed and a bit hazy looking. Stipple white sections with pure White. Blend on tail at a lateral angle. Body: Shade if needed with a bit of Black. With a no. 0 bright, blend dirty White lines across abdomen to soften. Add eye with Black. Highlight legs with a bit of White. Thin a little Raw Umber and apply antennae.

Blossoms: Re-highlight with White in lightest value areas. Reblend. Add a little Alizarin Crimson accent at bottom center line of blossoms.

Leaves/Stems/Calyxes: Blend highlights into leaves and stems, following growth direction. Add vein structure with light value green mix using chisel edge. Accent leaves with a bit of the dark value flower mix. With White + Raw Sienna, add a few spots of caterpillar damage. Blend on stems where values meet. Accent with a little Burnt Sienna. Blend on calyxes where values meet. Highlight with more White if desired.

Two-barred Flasher & White Plumbago

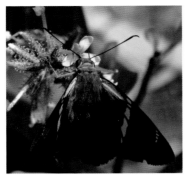

Photo by Deborah A. Galloway

ONE OF A SPREAD-WING SKIPPER genus, the beautiful, iridescent Two-barred Flasher (*Astraptes fulgerator*) ranges from Argentina north to the Lower Rio Grande Valley of Texas. Iridescence in both butterflies and birds is created by the structure of the feather or the scale, in the case of this beautiful Flasher. The light must hit the structural blue scales at a particular angle to allow these scales to break up the light into the spectrum, which reflects back the rich turquoise color you see here. Look back at the Silver Emperor demo (pages 98-99). When the wing of that butterfly turns just slightly away from the direct angle of the light, the brilliant blue wing sections become uniformly brown.

OIL COLOR MIXES

Phthalo Turquoise + Sap Green

Cadmium Yellow Pale + Raw Sienna

Raw Sienna + Burnt Sienna

Black + Raw Umber

White + Raw Sienna

Raw Sienna + Sap Green

White + Raw Sienna + Sap Green

Black + Sap Green

Sap Green + Raw Sienna + White

Previous mix + White

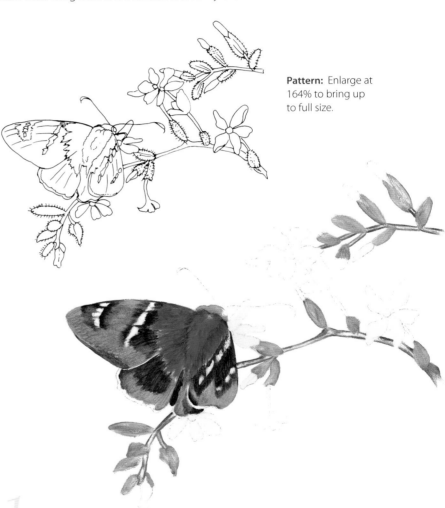

Pattern: Enlarge at 164% to bring up to full size.

STEP ONE

Butterfly: Use a no. 2 or 4 bright for all steps unless otherwise noted. Base light brown value on wings with Raw Sienna + Burnt Sienna. Base dark values with Black + Raw Umber. Base white sections and hindwing margins with White. Base turquoise sections with pure Phthalo Turquoise. Base the body with Phthalo Turquoise + Sap Green. Base the head with Cadmium Yellow Pale + Raw Sienna.

Flowers: Base with White.

Stems/Calyxes: Base calyxes with Raw Sienna + Sap Green. Base dark values on stems with Black + Sap Green.

STEP TWO

Butterfly: Blend between values on the wings, following growth direction. Apply highlights with a no. 2 bright at base of wings with White. Apply highlights on the body with White. Stipple White on the yellow head using a round brush.

Flowers: Shade with Raw Sienna + Sap Green and blend where values meet. Highlight with White. Place centers with small doughnuts of Raw Umber.

Stems/Calyxes: Shade calyxes with Raw Umber streaks that grow from the point where the calyx attaches to the stem. Base light values on the stems with Sap Green + Raw Sienna + White.

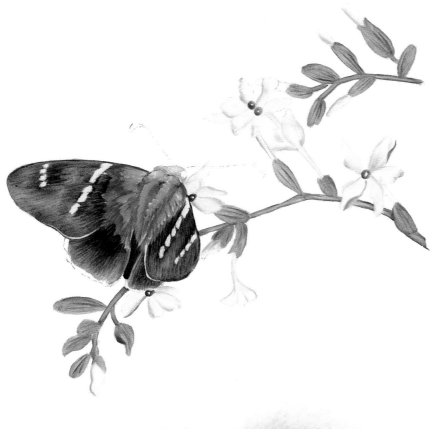

STEP THREE

Butterfly: Blend highlights on turquoise with a no. 2 bright, using tapping or choppy strokes. With more White, stipple the whitest areas with flattened tip of no. 1 round brush. Stipple pure White on white spots and sections on wing to re-highlight. Separate some of the white wing bars with the dark base mix using chisel edge. Soften white wing margins into wing by blending just a little. With dirty White on brush, add a few faint, barely visible light section lines within wings. Blend a bit to connect brown wing color into edges of turquoise. Body: With flattened tip of the no. 1 round, stipple and blend the highlights on the turquoise areas. Add more White if needed and re-stipple. With no. 0 round, tap a little Black + Raw Umber at base of head to divide head and thorax, and add eye with same color. Outline eye with a narrow band of White. Thin a little Black + Raw Umber and apply antennae and proboscis using a no. 0 round.

Flowers: Blend highlights. When painting is dry, do additional highlights if needed. Place a few dots of White in center of Raw Umber flower centers using round brush.

Stems/Calyxes: Highlight tips of calyxes with White + Raw Sienna + Sap Green. Add "stickers" with slightly thinned base mix or base mix + White, depending on value of background in that area. Blend between dark and light values on stems with natural growth direction. Then apply highlights using light value green mix + more White.

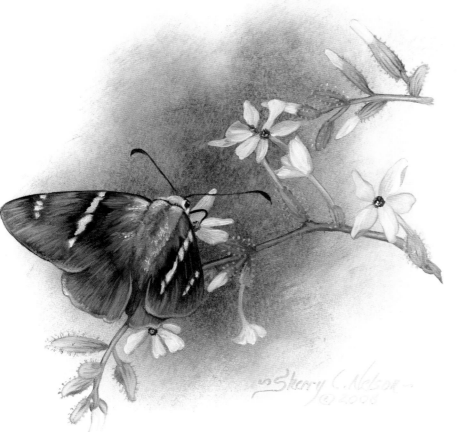

Common Checkered Skipper & Mallow

Photo by Deborah A. Galloway

THE COMMON CHECKERED SKIPPER is perhaps the most common and most widespread of the skippers in North America. It can be found in any of the lower 48 states and in almost any habitat. Here it is painted with one of its caterpillar food plants, the Checker Mallow, a lovely wildflower that we photographed in the Sierra Nevada mountains of California. Often the Common Checkered Skippers (*Pyrgus communis*) gather at damp mud or gravel, puddling for minerals and other nutrients.

OIL COLOR MIXES

White + Raw Umber

Black + Raw Umber

White + Raw Umber + more White

White + French Ultramarine

Alizarin Crimson + Raw Sienna

Previous mix + White

Black + French Ultramarine + Sap Green

Previous mix + White

Previous mix + more White

Pattern: Enlarge at 145% to bring up to full size.

1 STEP ONE

Butterfly: Use a no. 2 or 4 bright for all steps unless otherwise noted. On forewings, base darkest sections with Black + Raw Umber. Base medium values with White + Raw Umber. Add a fine line of Black + Raw Umber in the middle of the wing along the top of the gray, using the chisel. Near hindwing: Base darkest sections and medium values the same as on the forewings. Add a fine line of Black + Raw Umber in the middle of the wing around some of the white spots. Add a dark spot at base of wing near body. Base a little Black + Raw Umber behind the eye and where the wings connect to the body. Base blue on the head with French Ultramarine + White + a bit of Raw Umber. Base rest of body (except eye) with White.

Petals/Open Buds: Base dark value within petals and pink buds using Alizarin Crimson + Raw Sienna. Fill in rest of each petal and bud with the previous mix + White. Flower centers: Base column with Alizarin Crimson + Raw Sienna.

Stems/Unopened Buds: Base the dark values with Black + French Ultramarine + Sap Green. Base light values with previous mix + White.

STEP TWO

Butterfly: Far forewing and hindwing: Base wing margins with White. Near forewing and hindwing: Base rest with White. Body: Blend a little where the dark and light values meet. Highlight top of blue head with a little White. Add eye with Black. Thin a little White + Raw Umber and apply antennae using no. 0 round.

Petals/Open Buds: Blend where values meet on petals and open buds, following the growth direction of the petal in each area. As you blend, allow the chisel edge to create a few streaks in each petal with the Alizarin Crimson mix. Apply highlight with White. Flower centers: Shade column with a bit of Raw Umber. Highlight column with White. Base rest of center with White.

Stems/Unopened Buds: Blend where values meet following growth direction. Highlight with light green mix + more White.

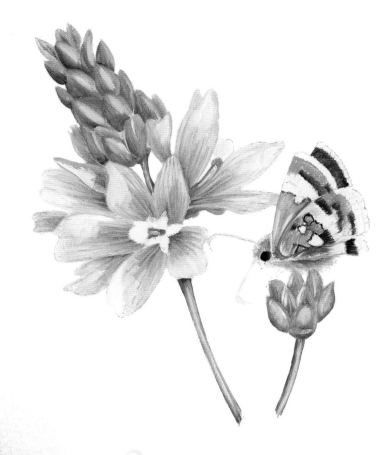

Sherry C. Nelson
©2009

STEP THREE

Butterfly: Divide all white margins on all wings with Black section lines using no. 0 bright. Far forewing: With no. 0 round, add dots of White in two rows on dark basecoat. Near forewing and near hindwing: Highlight gray areas with a bit of White. Divide white areas into individual spots (square) with lines of Black + Raw Umber, using the chisel edge of a no. 0 bright. Stipple a little White on the whitest sections or spots for highlighting. Highlight white on margins with White. Use slightly-thinned White to draw in legs. Highlight legs with more White. Highlight over eye with White. Using a no. 0 round, tip antennae with White. Add row of tiny spaced dots of thinned Black + Raw Umber down length of each antenna.

Petals/Open Buds: Blend highlights. Soften streaks by patting with cheesecloth if desired. Flower centers: Shade within star-shaped center and within cluster of pollen at end of column with a bit of White + French Ultramarine. With round brush, add White dots of pollen.

Stems/Unopened Buds: Blend highlights with growth direction. Detail with a few division lines of light mix + White on unopened buds.

Sachem Skipper & American Marigold

Photo by Deborah A. Galloway

THE GRASS SKIPPERS ARE PROBABLY the group that most cause butterfly folks to tear their hair and rend their garments. They are indeed small, brown and incredibly confusing. At present count, 114 species of them reside in the lower 48 states and as a group use a wide variety of grasses as the caterpillar host plants. The photo shows a tiny close cousin of the Sachem, the Fiery Skipper, perched on betony mist flower. This group rests with their wings in a "jet plane" position, perhaps to be ready for one of their instant take-offs.

OIL COLOR MIXES

Raw Sienna + Raw Umber

Cadmium Yellow Pale + Raw Sienna

Cadmium Yellow Pale + White

Cadmium Yellow Pale + Winsor Red

White + Raw Umber

Burnt Sienna + Winsor Red

Winsor Red + Burnt Sienna

Black + Sap Green

Sap Green + Raw Sienna + White

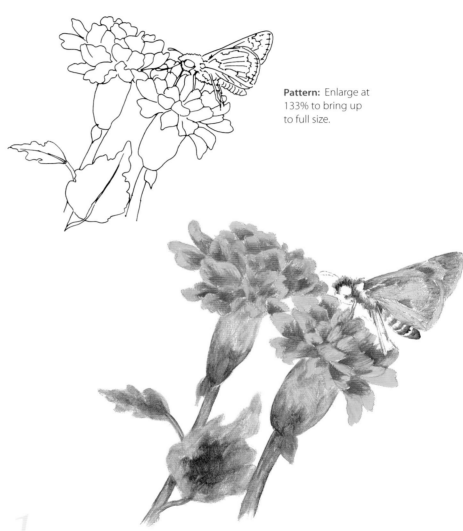

Pattern: Enlarge at 133% to bring up to full size.

STEP ONE

Butterfly: Use a no. 2 or 4 bright for all steps unless otherwise noted. Hindwing and forewing: Base dark values with Raw Umber + Raw Sienna. Base light values with Cad Yellow Pale + Raw Sienna. Body: Base dark values with Raw Umber. Thin a mix of Raw Sienna + Raw Umber and place legs with a no. 0 round brush.

Flowers: Base dark values on far petals with Burnt Sienna + Winsor Red. Base dark values on near petals with Winsor Red and just a bit of Burnt Sienna. Base rest of each petal with Cad Yellow Pale + a tad of Winsor Red.

Stems/Leaves/Calyxes: Base the dark values with Black + Sap Green. Base light value with Sap Green + Raw Sienna + White.

STEP TWO

Butterfly: Hindwing: Define sections a little to separate dark and light values and shade at base of wings with Raw Umber. Accent light value areas with a little Cad Yellow Pale + Winsor Red. Define hindwing margin with dirty White. Highlight outer edge of yellow basecoat with White + a bit of Cad Yellow Pale. Forewing: Highlight small sections at apex of wing and next to hindwing with White + a bit of Cad Yellow Pale. Base rest of body (except eye) with White + Raw Umber. Shade behind eye with a bit stronger Raw Umber. Thin a little Raw Umber and apply antennae and proboscis using a no. 0 round. Shade legs a little if needed with same mix, and accent legs with a little Cad Yellow Pale.

Flowers: Blend between values with the lengthwise growth direction of the petals. Place highlight mix of White + Cad Yellow Pale.

Stems/Leaves/Calyxes: Blend between values with growth direction. Apply highlights using dirty brush + White.

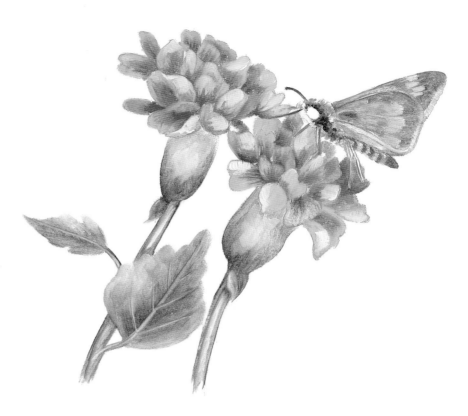

STEP THREE

Butterfly: Soften accents and shading to give smoother appearance. Retouch with a bit more Raw Umber shading next to body if needed. On both wings, use slightly-thinned Raw Umber to detail wing margins and lay in fine section lines at edge of wing. Body: Base eye with Black. Highlight in thorax and abdomen with dirty brush + Cad Yellow Pale + White. Outline underside of eye with a bit of White and add a white dot at base of hindwing. Tip antennae with a bit of dirty Cad Yellow Pale + White. With slightly-thinned White, highlight legs and proboscis using a no. 0 round.

Flowers: Blend highlights to soften into base mix. Highlight on a few main petals once again, if needed, using White.

Stems/Leaves/Calyxes: Blend highlights into leaves and stems, following growth direction. Add vein structure with light value green mix using chisel edge. Accent with Winsor Red under flowers and with Burnt Sienna on leaves.

Moths

OF THE 127 RECOGNIZED FAMILIES of "Leps" in the world, most are moths. A general rule of thumb: for every 10 butterfly species there are at least 100 moth species. That's almost three hundred thousand species around the world, an almost unbelievable figure. A sizable percentage of them are the little drab, fluttery micro-leps you see at your screen at night in the summer. But that's just the tip of the moth-y iceberg. Right in your yard, there may reside some of the most spectacular creatures that ever took wing.

Many ask how you can tell a moth from a butterfly. Look at the antennae for starters. We know that moths have feathery antennae and butterflies have thin ones with clubs on the ends. However, many female moths have skinny antennae that can make it difficult to tell that they are not a butterfly. And don't moths always fly at night? The beautiful Snowberry Clearwings look like bumblebees and feed at flowers in the heat of the day, right along with White-lined Sphinx, who may choose an afternoon snack at a hummingbird feeder. The Urania Swallowtailed Moth features gorgeous iridescence, and it's a day-flier too. In summary, moths are not always what you think they are!

Unless otherwise noted, all photos by Deborah A. Galloway.

Saturniidae

Giant silkmoths are perhaps the most notable of all the moths. The large size, gorgeous eye spots, spectacular patterned markings and the ornately armed caterpillars, often decorated with various spines and tubercles, are much admired. In addition, their namesake role in silk production in the Orient adds to their mystery.

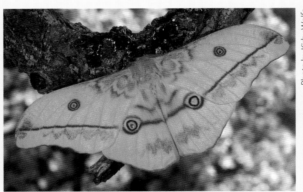

Photo by Kirby Wolfe

Dione Silkmoth (*Imbrasia dione*). This beautifully-marked Silkmoth comes from Cameroon. A commonly used food plant for the caterpillars is willow. Kirby Wolfe obtained the cocoons, then photographed this freshly-hatched, beautiful male.

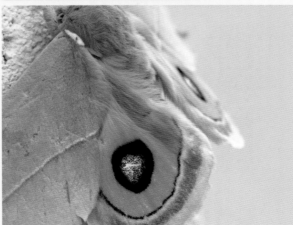

Cecrops Eyed Silkmoth (*Automeris cecrops pamina*). Silkmoth adults have no mouth parts. When they "eclose" or emerge from their cocoons, they have only one goal: sex. They live a few days, hopefully long enough to find a mate, and then die without ever having eaten. This pink beauty shows off the incredible eyespots that, when flashed at a predator, hopefully startles it so that the moth can live another night.

Apotolype brevicrista, a member of the *Lasiocampidae* family. Photographed at the black light in our front yard last summer, this unusual moth appears to have a fur coat. Each "hair" is a modified scale that helps maintain body temperature so they can fly in cooler nighttime temperatures. If this one weren't a night-flier, one could believe he was sunbathing.

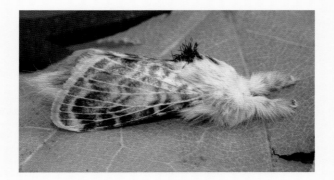

Lasiocampidae

This moth family includes the tent caterpillars and lappet moths, and total 1500 species worldwide. The caterpillars are usually brightly colored and dense with hairs. When resting, many of these moths hold their wings like a roof over their bodies.

Photographed in Costa Rica, this lovely creature had a wing span of only perhaps 2 inches (51mm), but in the light the wings were entirely iridescent silver. Look at the amazingly realistic "eyes"!

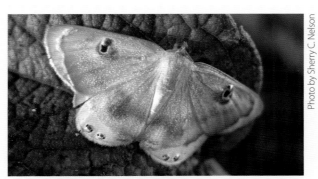

Photo by Sherry C. Nelson

Geometridae

The members of this moth family are sometimes called the "inchworm" moths because of the way the caterpillars walk. Emeralds and Waves are just two groups in this world's second-largest family. Geometrids can have fabulous wing shapes and patterns, and many of them lay absolutely flat, with wings spread, making them a bit easier to identify.

Oospila albicoma, another Costa Rican *Geometrid* family member. The cryptic coloration gives it great protection as it blends perfectly into its surroundings. The adjacent leaf even has a similar brown spot!

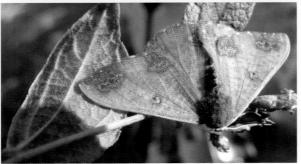

This clear-winged Wasp-moth, *Cosmosoma teuthra*, is a member of the family *Arctiidae*. Note the fine antennae. If you found it in the daytime, would you think "butterfly" or "wasp"?

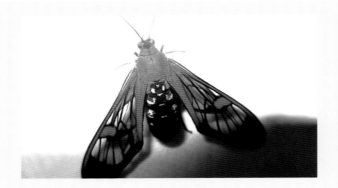

Arctiidae

Tiger moths are small to medium sized, are at their most colorful and numerous in the tropics, and often sport dramatic markings. Some adults are day-fliers while others are nocturnal. Some tiger moth caterpillars are called "woolly bears" and they feed on lichens and woody plants. Lichen Moths are also part of this family.

Aptly named, the Hierogylphic Moth, *Dipthera festiva*, gets its common name from the markings' similarity to ancient Egyptian pictographs, an early form of written language.

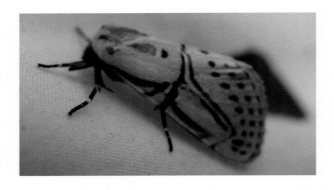

Noctuidae

The Noctuids are the largest superfamily of moths in the world, with perhaps as many as 35,000 known species. They exhibit great diversity in size and pattern, and are represented by at least 10 different subfamilies. Some *Noctuidae* species have tiny organs in their ears that respond to bat's sonar, aiding the moths in evading the bats.

White-lined Sphinx & Cereus

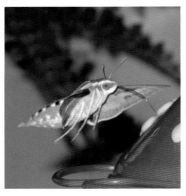

Photo by Sherry C. Nelson

HERE'S A WHITE-LINED SPHINX MOTH at my hummingbird feeder! Normally seen nectaring at flowers at dusk or late afternoon, this medium-sized moth (*Hyles lineata*) hovers while feeding, and is often mistaken for a tiny hummingbird. The lovely night-blooming Cereus I painted was photographed by Marilyn Kerr and shared with me for this demo. A perfect match—I've seen these moths nectaring at these very blooms.

Pattern: Enlarge at 179% to bring up to full size.

OIL COLOR MIXES

Black + Raw Umber

Raw Sienna + a tad of Alizarin Crimson

Raw Sienna + Raw Umber

Dirty brush (Raw Sienna + Raw Umber) + White

Alizarin Crimson + Raw Sienna

White + Raw Sienna

Sap Green + Black + Raw Sienna

Previous mix + White

White + French Ultramarine

Burnt Sienna + Raw Sienna

White + Black

Black + Sap Green

Sap Green + Raw Sienna + Cadmium Yellow Pale

White + Cadmium Yellow Pale

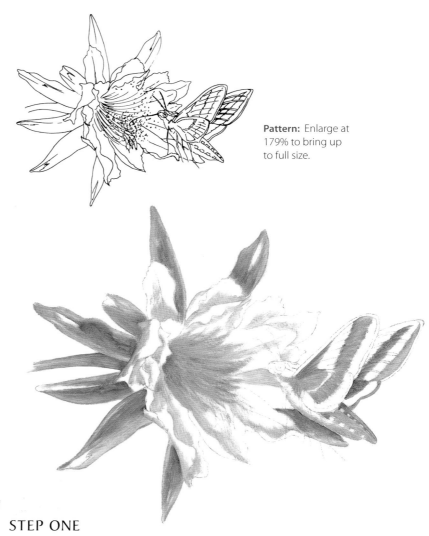

STEP ONE

Moth: Use a no. 2 or 4 bright for all steps unless otherwise noted. Forewings: Base dark value with Raw Sienna + tad of Alizarin Crimson. Base lighter value with Raw Sienna. Far hindwing: Base reddish areas with Raw Sienna + tad of Alizarin Crimson. Near hindwing: Base as shown with Raw Sienna. Body: Base pinkish color on abdomen with sparse Raw Sienna + Alizarin Crimson. Base underside of abdomen with the same mix + a little more Raw Sienna. Base top of abdomen with Raw Umber. Base rust area on thorax with Raw Sienna.

Flower Petals/Center: Base the shadow color in the petals with White + Black. Base the flower center with Sap Green + Black + Raw Sienna.

Stem/Sepals: Base the dark values with Black + Sap Green + Raw Sienna. Base light value with White + French Ultramarine.

2 STEP TWO

Moth: Far forewing: Base darkest section with Black + Raw Umber. Base dark brown band with Raw Umber. Draw lines with stylus to indicate the white lines on the wing. Outline wing with a little Raw Sienna. Fill in margin with White. Far hindwing: Accent the pink section with Alizarin Crimson. Base adjacent dark band with Raw Umber + a little Black. Highlight pink margin with a bit of dirty White. Near forewing: Base dark bands with Raw Sienna + Raw Umber. Use mix to shade pinkish section. Connect dark bands into edges of previous Raw Sienna + Alizarin bands. Outline wing with Raw Sienna. Fill in margin with White. Use dirty White to place subtle section lines, dividing the mid fore-wing bands. Near hindwing: Base dark band with Raw Sienna + Raw Umber. Shade at base of wing with same mix. Base wider margin of wing with White and blend into the edge of the dark band. Highlight on leading edge of forewing with White + Raw Sienna. Add dark band of slightly-thinned Raw Umber + Black in midwing with no. 0 round brush. Base dark areas on head with Raw Umber. Base light head stripe and eye ring with White. Base eye with Black + Raw Umber.

Flower Petals/Center: Base rest of petals with White. Blend between values with chisel edge, following growth direction of the individual petals. Pat petals with cheesecloth to remove excess paint for a translucent effect. Add strong highlights with White. Add a little Black + Sap Green shading at deepest part of flower center. Base yellow stigma with Cad Yellow Pale + Raw Sienna + a tad of Sap Green.

Stem/Sepals: Blend between values following growth direction. Apply highlights using light green mix + White. Accent with Raw Sienna + Burnt Sienna.

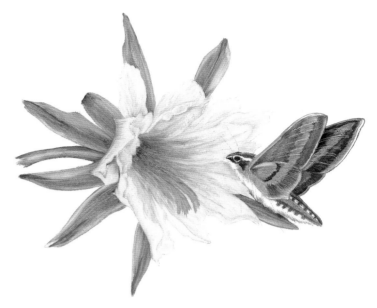

3 STEP THREE

Moth: Far forewing: Lay in section lines using White, curving them slightly and keeping them clean. Far hindwing: Highlight at outer part of pinkish sec-tion with White. Near forewing: Shade at base of wing with Raw Umber. Let Raw Sienna band in apex soften into surrounding colors. Near hindwing: Soften overall look of wing by patting with cheese-cloth. Shade with Black + Raw Umber in outer bottom corner of wing. Add section lines and final highlight on leading edge of wing with dirty White. With a no. 0 round, add a few White details on head, highlighting in eye, on stripe on head and under eye on throat. Shade under wing edge with a bit of Raw Umber. Highlight on abdomen with White on a no. 0 round, placing tiny square dots. Highlight with a bit of White the length of the pink mix. Base legs with White + Raw Sienna. Detail base of legs with more Raw Umber using a no. 0 round. Thin a little Raw Umber and apply antennae with a no. 0 round.

Flower Petals/Center: Blend highlights on petals with chisel edge, creating final growth direction. Add additional White on rolled petal edges and strongest white folds. Center: Thin a bit of the light green center base mix very thin, using odorless thinner. Place many fine stamen filaments with the no. 0 round, observing the direction and how the ends tip up on many of them. Add White to the mix, re-thin, and do some more. Add a few with White + French Ultramarine toward the bottom left of the flower opening. With slightly thinned Burnt Sienna + Raw Sienna as well as Raw Sienna + Raw Umber, tip stamens with tiny dots, using the no. 0 round. Highlight stigma with White + Cad Yellow Pale.

Stem/Sepals: Soften highlights and blend accent color in sepals. Re-highlight with White + French Ultramarine.

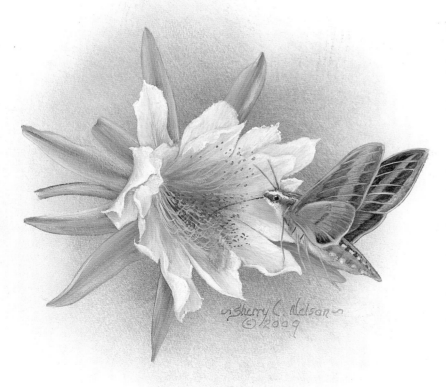

Walter's Silkmoth & Lemonberry

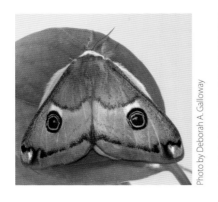

Photo by Deborah A. Galloway

OIL COLOR MIXES

White + Raw Umber

Winsor Red + Cadmium Yellow Pale

Previous mix + White

Black + Raw Umber

Winsor Red + Burnt Sienna

Cadmium Yellow Pale + Winsor Red

Burnt Sienna + White + a tad of Winsor Red

White + French Ultramarine

Alizarin Crimson + Winsor Red

Black + Raw Umber + White

Black + Sap Green + French Ultramarine + a tad of White

Sap Green + Raw Sienna + White

Previous mix + White

Alizarin Crimson + Raw Umber

White + Raw Sienna + Alizarin Crimson + Winsor Red

THE WALTER'S SILKMOTH HAS ONLY a limited range in California. Our friend Kirby Wolfe gave us several cocoons of this silky, along with instructions on how to care for them (weekly rain shower, temperatures not too extreme). Would they eclose when we could be here to photograph them? We got lucky—here's Deb's photo of the first female to emerge. Our moths could not be released here so we sent the eggs back to Kirby for him to raise another generation and release our moth's progeny back into their natural habitat.

Pattern: Enlarge at 172% to bring up to full size.

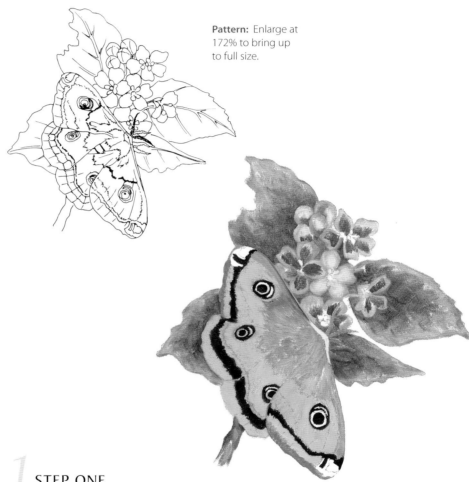

1 STEP ONE

Moth: Use a no. 2 or 4 bright for all steps unless otherwise noted. Base the black bands and eyespot patterns with Black acrylic on a no. 0 round brush. Forewings: Base gray areas with White + Raw Umber. Base gray wing margins with a slightly darker gray mix. Base orange areas with Winsor Red + Cad Yellow Pale. Base lighter value yellow-orange areas with Cad Yellow Pale + Winsor Red. Hindwings: Base gray areas with White + Raw Umber. Base lighter value yellow-orange areas same as on forewing. Body: Base orange areas with Cad Yellow Pale + Winsor Red. Base gray with White + Raw Umber. Base antennae and legs with Cad Yellow Pale + Winsor Red.

Flowers: Outline all petals and tops of buds with red centers using White + Raw Sienna. Fill in the blossom with no red in middle of cluster with same mix. Base red portions of petals and buds with Alizarin Crimson + Winsor Red.

Stem/Leaves: Base dark values with Black + Sap Green + French Ultramarine + a tad of White. Base light value with Sap Green + Raw Sienna + White.

STEP TWO

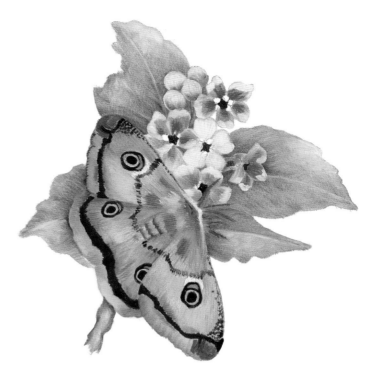

Moth: Forewings: Blend orange and gray areas where they meet. Highlight wings next to body and near eyespots with Cad Yellow Pale + White. Accent with Winsor Red + Cad Yellow Pale. Blend gray margins where they meet the yellow, following growth direction. Accent with the same red-orange. Base blue spots with White + French Ultramarine. Base red apex spots with Winsor Red + Alizarin Crimson. Eyespots: Base yellow with Cad Yellow Pale + a bit of Winsor Red. Base upper band of eyespot with gray mix. Base above eyespots with White, then blend into wing. Dark markings: With slightly-thinned Black + Raw Umber on a no. 0 round, touch in the irregular band of dark in the midwing. Stipple Black + Raw Umber, unthinned, along leading edge of wing. Hindwings: Shade under forewings with Raw Umber. Accent yellow areas with Winsor Red + Cad Yellow Pale. Body and head: Shade behind white head with Raw Umber. Shade upper body with Winsor Red + Burnt Sienna. Detail abdomen with several narrow bands of Black + Raw Umber. Shade antennae and legs with Alizarin Crimson.

Flowers: Blend between values on petals following growth direction. Highlight with White. Do star-shaped centers with Alizarin Crimson + Raw Umber.

Stem/Leaves: Blend between dark and light values with growth direction. Apply highlights using light green mix + White.

STEP THREE

Moth: Forewings: Blend accent colors where values meet. Blend dark midwing band with the chisel to soften it above into the gray, and below into yellow areas of wings. Stipple with Raw Umber where needed in forewings for shading. Stipple White on blue apex markings. Stipple red markings with Cad Yellow Pale + Winsor Red. Hindwings: With slightly thinned Burnt Sienna, detail irregular band. Body: Soften the edges of the dark red mix into the basecoat above. Base head with White, and lead stippled paint along leading edge of wing until it fades away. Add dark gray shading behind head. Blend bands on abdomen. Highlight antennae and legs with Cad Yellow Pale + White. Allow moth to dry.

With Burnt Sienna + White + a tad of Winsor Red, use chisel edge to highlight and accent sparsely over all the bright yellow areas, toning them down and making them a warm rusty pink. Shade in darkest areas with more Burnt Sienna. Soften with cheesecloth to remove excess paint. The dry yellows underneath allow a "glow" of yellow through the pink tones for a more luminous look. Use White + Burnt Sienna for sparse section lines in all wings.

Flowers: Blend highlights with growth direction. Add more light if needed and reblend. With red base mix, indicate edges of unopened petals. Around each star-shaped center, lay five short, thick strokes of Cad Yellow Pale.

Stem/Leaves: Blend highlights. Establish center vein with light green mix. Accent caterpillar-chewed leaf edges with Burnt Sienna. Accent leaf edges with red flower mix.

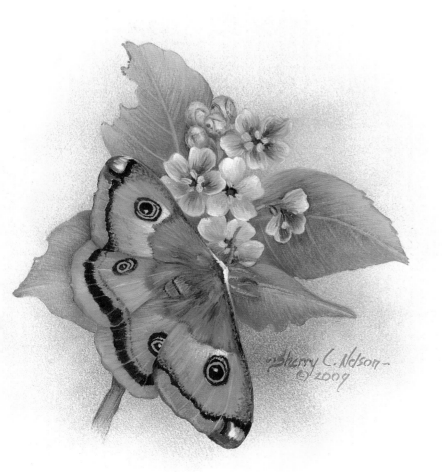

117

Elegant Sheep Moth & Wild Rose

THE ELEGANT SHEEP MOTH IS SO NAMED because of its association with the high mountain meadows and pastures in which sheep graze. A member of the *Saturniidae* family, adults fly during the day, usually very fast and close to the ground. Truly elegant, *Hemileuca eglanterina* is shown in the painting with a caterpillar host plant—a wild rose—with a cluster of her pink eggs on one of the stems.

OIL COLOR MIXES

Cadmium Yellow Pale + Raw Sienna + Winsor Red

Previous mix + White

Alizarin Crimson + Raw Sienna + Winsor Red + White

Alizarin Crimson + Raw Sienna

Black + Raw Umber

Burnt Sienna + Winsor Red + Cadmium Yellow Pale

Alizarin Crimson + Winsor Red + Raw Sienna

Raw Umber + Burnt Sienna

White + Cadmium Yellow Pale + Raw Sienna

Cadmium Yellow Pale + Raw Sienna

Black + Sap Green

Previous mix + White

Raw Sienna + Raw Umber

Sap Green + Raw Sienna + White

Pattern: Enlarge at 147% to bring up to full size.

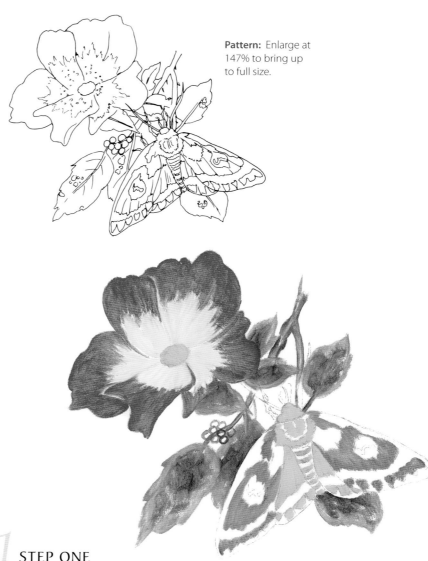

1 STEP ONE

Moth: Use a no. 2 or 4 bright for all steps unless otherwise noted. Forewings: Base pinkish areas with Alizarin Crimson + Raw Sienna + Winsor Red + White. Hindwings and Body: Base yellow-orange areas with Cad Yellow Pale + Raw Sienna + Winsor Red.

Flower: Base dark values on petals with Alizarin Crimson + Winsor Red + Raw Sienna. Fill in rest of the petals with White + a tad of Cad Yellow Pale + Raw Sienna. Base center with Cad Yellow Pale + Raw Sienna.

Stems/Leaves: Base dark values with Black + Sap Green. Base light value with Sap Green + Raw Sienna + White.

Egg Cluster: Outline with Raw Umber + Burnt Sienna.

2 STEP TWO

Moth: Base all black bands and eyespot patterns on the wings and markings on the body with Black acrylic, using a no. 0 round. Do not do the fine section lines on the hindwings; those will be done with oil paint. Forewings: Stipple White highlights onto wing with no. 1 round. Accent on margins and on pink inside wing using Cad Yellow Pale + Winsor Red + Raw Sienna. Hindwings: Highlight yellow areas with the previous mix + White. Shade where wing connects to body with Black + Raw Umber. Dark section lines: Tap in with Black + Raw Umber using a small bright. Body and head: Accent upper body with Burnt Sienna + Winsor Red + Cad Yellow Pale. Base antennae with Burnt Sienna + Winsor Red + Cad Yellow Pale. Base legs with Cad Yellow Pale + Raw Sienna.

Flower: Blend between values on petals following growth direction. Highlight with White in petal bases near center. Separate petals by highlighting with White on overlapping edges. Place shadow areas with Raw Umber + Burnt Sienna to tone down bright petals. Shade center with a little Black + Sap Green. Stipple a little White in upper portion of center.

Stems/Leaves: Blend between values following growth direction. Apply highlights using light green mix + White.

Egg Cluster: Fill in with Alizarin Crimson + Raw Sienna + Winsor Red + White.

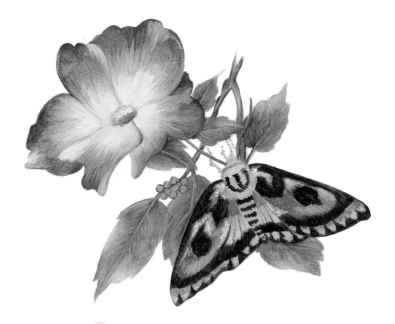

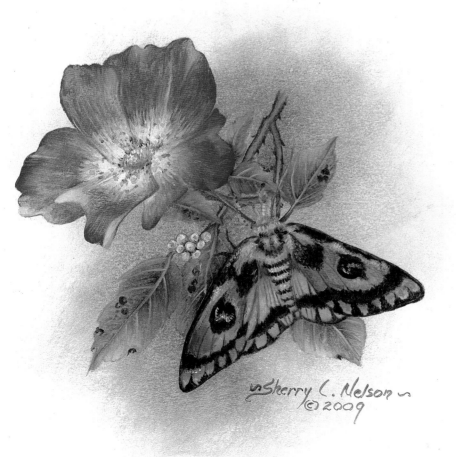

Sherry C. Nelson
© 2009

3 STEP THREE

Moth: Forewings: Soften White highlights into basecoat by tapping with flattened tip of no. 1 round brush. Let a little bit extend over onto dark wing margins to gray a bit. Blend yellow accents in same manner. Accent apex of wings and in pink sections where wing overlaps the hindwings with Alizarin Crimson + Raw Sienna. Hindwings: With dry flattened tip of no. 1 round brush, soften highlights and accents. Highlight within eyespots with zig-zag of White. On all wings, using a no. 4 bright, tap in the section lines with Black + Raw Umber. Allow some to be faint, barely there. Do not blend the dark into the yellow basecoat. Highlight yellow bands on abdomen and on head with Cad Yellow Pale + Raw Sienna + Winsor Red + White. Highlight with same mix on thorax, softening into the black bands. Highlight antennae with Cad Yellow Pale. Add Raw Sienna + Raw Umber to "dirty" bottom portions of legs.

Flower: Blend petals where values meet, shaping petals by working with the growth direction of each one. Blend highlights with growth direction using chisel. Control growth of light values. Let chisel lines remain for realism. Accent with Cad Yellow Pale within White petal base. Center: Blend shading where values meet. Soften White by tapping edges with flattened tip of round brush. When petals are complete, add pollen dots with Raw Umber and with Raw Sienna. If they seem a bit heavy, pat with cheesecloth to soften.

Stems/Leaves: Blend highlights with growth direction. Establish vein structure with light green mix. Accent leaves with caterpillar-chewed leaf spots using round brush and Raw Sienna + Raw Umber.

Egg Cluster: Highlight with White + Cad Yellow Pale + Raw Sienna. Blend, then touch with a dot of White.

Ailanthus Silkmoth & Tulip Tree

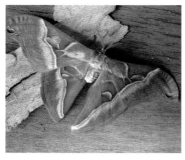

Photo by Deborah A. Galloway

THE AILANTHUS SILKMOTH IS ORIGINALLY from China and was imported to the U.S. in 1784 to begin a silk production operation. The effort failed, and the moths were released. The Tree of Heaven that is the caterpillar host plant used in China is not found here, but the moth adapted to our Tulip Tree and other plants and a small resident population still exists in the Atlantic seaboard region around New Jersey, where it was originally introduced. The photo shows a fresh Ailanthus Silk, brought to us by John Cody, with its 5-inch (13cm) wingspan and beautiful lavender wing bars.

OIL COLOR MIXES

White + Raw Umber + Alizarin Crimson

French Ultramarine + Alizarin Crimson + White + bit of Black

Cadmium Yellow Pale + Winsor Red + Raw Sienna

French Ultramarine + Alizarin Crimson + White + more Black

Raw Sienna + Raw Umber

Raw Umber + Raw Sienna

Cad Yellow Pale + Winsor Red + Raw Sienna + Raw Umber

Black + White + French Ultramarine

White + Raw Sienna

Sap Green + Raw Sienna + Cadmium Yellow Pale

White + Cadmium Yellow Pale + Raw Sienna

Winsor Red + Cadmium Yellow Pale + Raw Sienna

Cadmium Yellow Pale + Raw Sienna

Black + Sap Green

White + Sap Green + Cadmium Yellow Pale

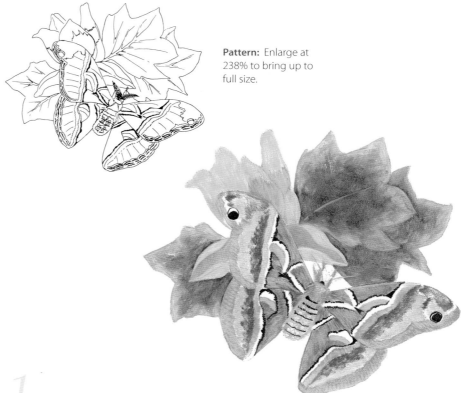

Pattern: Enlarge at 238% to bring up to full size.

1 STEP ONE

Moth: Use a no. 2 or 4 bright for all steps unless otherwise noted. Wings: Base black bands and eyespot patterns with Black acrylic on a no. 0 round. Base pink around eyespots with White + Raw Umber + Alizarin Crimson. Use same mix to base the wing bar across fore- and hindwing. Base dull violet wing bar adjacent to pink and apex patch using French Ultramarine + Alizarin Crimson + White + a bit of Black. Base yellow-orange markings on inner wings with Cad Yellow Pale + Winsor Red + Raw Sienna. Base inner wings with Raw Sienna + Raw Umber. Base wing margins with Cad Yellow Pale + Winsor Red + Raw Sienna + Raw Umber. Base with a lighter value of same mix, the long wing bars adjacent to the margins.

Body: Base thorax with Raw Sienna + Raw Umber. Base abdomen, around Black, with Cad Yellow Pale + Winsor Red + Raw Sienna. Dab in White markings in middle of abdomen. Antennae: Base shaft line with dull violet mix. Legs: Base with Raw Sienna + Raw Umber.

Petals/Sepals: Base orange bands on petals with Cad Yellow Pale + Winsor Red + Raw Sienna. Base remaining petals with Cad Yellow Pale + Raw Sienna. Base dark value on sepals with Sap Green + Raw Sienna + Cad Yellow Pale; base light value with White + Cad Yellow Pale + Sap Green.

Leaves: Base dark values with Black + Sap Green. Base light value with White + Sap Green + Cad Yellow Pale.

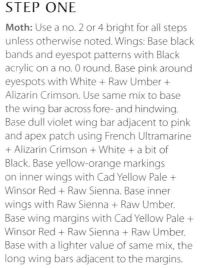

STEP TWO

Moth: Left wings show these steps: Blend between pinkish and dull violet. Shade apex and on pink band with violet mix of French Ultramarine + Alizarin Crimson + White + more Black. Highlight on apex with White. Blend where the violet value meets the inner yellow wing margin. Smooth inner wing brown basecoat to follow growth direction, and shade with Raw Umber or Raw Umber + a bit of Raw Sienna. Highlight with Cad Yellow Pale + Winsor Red + Raw Sienna + Raw Umber. Base white bands and markings with White. Right wings show these steps: Blend highlights on apex, then re-highlight with White. Stipple with White down the length of the violet wing bar, letting color ease onto pink wing bar but controlling its spread. With existing violet paint from the wingbar, stipple violet sparsely into outer wing areas over the yellow sections. Yellow should show through a bit; do not overwork. Blend the top of the yellow inner wing markings into edges of white bands. Blend the shading on the inner wing, retaining growth direction with faint chisel lines. Blend the highlights where values meet on inner wing. Detail margin markings with slightly-thinned paint on a no. 0 round: outer markings with Burnt Sienna; middle markings (hindwing only) with Black + White + French Ultramarine; an inner line of tiny markings with Raw Umber. Highlight thorax with White. Divide abdomen markings by outlining the white spots with a bit of slightly-thinned Black + a bit of Raw Umber. Make feathery strokes on the antennae using slightly-thinned violet mix on a no. 0 round.

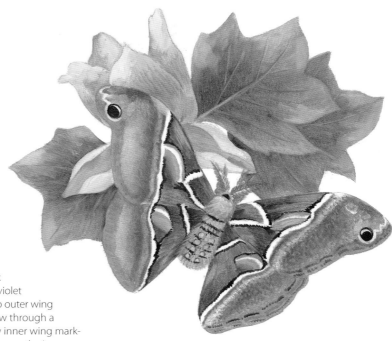

Petals/Sepals: Using a no. 4 bright, blend between values on petals just enough to connect colors. Shade with Sap Green + Raw Sienna + Cad Yellow Pale. Highlight with White. Accent sepals with Cad Yellow Pale + Winsor Red + Raw Sienna. Highlight on rolled edges with White.

Leaves: Blend between values with growth direction. Apply vein structure and highlights with light green mix + White.

STEP THREE

Moth: Add a White + Raw Sienna irregular detail marking inside wing margins on forewing only, using slightly-thinned paint and a no. 0 round. Stipple pure White on the white markings and bands to clean them up and add texture. Highlight inner wing areas with Black + White + French Ultramarine to cool. Add white crescent inside of eyespot at top and a little dirty White below it. Accent abdomen with Burnt Sienna. Highlight "waist" where abdomen meets thorax with White. Shade thorax with Raw Umber; accent with Burnt Sienna. Shade legs with Raw Umber. Highlight legs and antennae with White + Raw Sienna.

Petals/Sepals: Blend highlights on petals. Add more light if needed. Blend the shading color, softening into basecoat. Coax a little greenish shading color into the orange band on each petal and add sparse White on orange band on central petal. Blend sepals where values meet. Add faint center vein with light value.

Leaves: Blend highlights with growth direction. Re-establish center vein structure with light green mix.

Many-windowed Silkmoth & Bomarea

Photo by Kirby Wolfe

OIL COLOR MIXES

Cadmium Yellow Pale + Winsor Red

Cadmium Yellow Pale + Raw Sienna

White + Cadmium Yellow Pale

Raw Sienna + Raw Umber

Black + Raw Umber + White

Black + French Ultramarine + a tad of White

White + French Ultramarine

Black + French Ultramarine

Black + Raw Umber

Alizarin Crimson + Raw Umber + White + a tad of Black

Alizarin Crimson + Raw Umber + White

Alizarin Crimson + Raw Sienna

Previous mix + White

Alizarin Crimson + Burnt Sienna

Black + Sap Green

Sap Green + Raw Sienna + White

Previous mix + White

THE SPECTACULAR MUELLER'S SILKMOTH shown in the photo at left (taken by Kirby Wolfe) is a kissing cousin from the same Central American habitats as the Many-windowed Silkmoth (*Copaxa multifenestrata*) we're painting in this demo. Look closely—does it remind you of a Navaho rug? The floral element in my painting is *Bomarea pardina*, a member of the *Alstroemeria* family.

Pattern: Enlarge at 200% to bring up to full size.

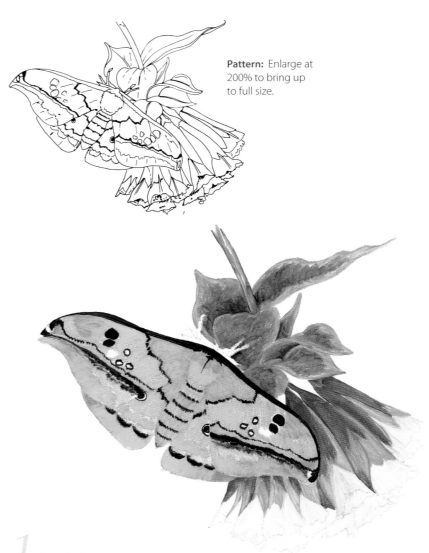

1 STEP ONE

Moth: Wings: Use a no. 2 or 4 bright for all steps unless otherwise noted. Base the black bands, leading edge of wings and larger "windows" with Black acrylic on a no. 0 round. Base orange values with Cad Yellow Pale + Winsor Red. Base palest value yellow areas with Cad Yellow Pale. Base dark in forewings next to body with Cad Yellow Pale + Raw Sienna. Body: Base orange with Cadmium Yellow Pale + Winsor Red and bottom of thorax with Cad Yellow Pale. Base abdomen with Cad Yellow Pale + Raw Sienna.

Flower: Base blossom stems with Raw Umber. Base dark values on trumpets with Alizarin Crimson + Raw Sienna. Base light values with mix + White. Base white petals with White.

Stem/Leaves: Base dark values with Black + Sap Green. Base light value with Sap Green + Raw Sienna + White.

STEP TWO

Moth: Blend where values meet on all basecoated areas of the wings. Highlight with White + Cad Yellow Pale. Shade at apex of forewings and next to body with Raw Sienna + Raw Umber. Shade on hindwings next to abdomen with Black + Raw Umber + a bit of White. With no. 1 round, stipple Black + French Ultramarine onto the forewings next to the black acrylic band. Wipe brush dry, flatten the tip, then tap and walk the color outward. If it seems too dark, add White to the mix and continue. Don't overwork. Repeat, working upward from the scallop shapes in the hindwing. Windows: Fill in small outlined windows and the single larger window with Alizarin Crimson + Raw Umber + White + a tad of Black. Forewing apex: Insert narrow band of White to divide acrylic base. Accent with a little Cad Yellow Pale + Winsor Red. Base the moth's head with Cad Yellow Pale + Winsor Red. Shade head and thorax with Raw Umber. Blend where values meet on thorax and abdomen. Highlight center of abdomen with White. Base antennae with Cad Yellow Pale + Raw Sienna. Base legs with Alizarin Crimson + Raw Umber + White.

Flowers: Accent blossom stems with Alizarin Crimson. Blend between values on trumpets, following growth direction. Shade with Alizarin Crimson + Raw Umber + a tad of White in darker areas, and Alizarin Crimson + Burnt Sienna in more intense dark areas. Highlight with White. With Cad Yellow Pale + Raw Sienna, accent in

a few places. White petals: Shade in trumpet opening with Black or Black + Raw Umber. Accent with Cad Yellow Pale + Raw Sienna.

Stems/Leaves: Blend between values. Allow veining to remain, following the growth directions of the leaves. Apply highlights using light green mix + White.

STEP THREE

Moth: Blend where values meet within the highlights on the wings. Shade along hindwing margins with Raw Sienna and on forewing margins with Raw Sienna + Raw Umber. Shade next to body with same mix. Use the darker mix for section lines on margins. Continue to stipple, softening with the flattened tip of the round, to get nice value gradations. Add stipping around and between the windows in the wing, a little along the forewing margins and on the underside of the forewing apex. Highlight Black-based windows (two) with stippled White + French Ultramarine. Highlight small pink windows with a bit of White applied with a few stipples. Shade larger pink window with a bit of Black + French Ultramarine + a tad of White. Highlight with White. Forewing apex: Stipple tips of forewings with a White + French Ultramarine. Body: Shade on thorax and abdomen with Raw Sienna + Raw Umber + a tiny bit of Winsor Red. Blend into basecoat where values meet. Highlight thorax and abdomen and on the black acrylic band between head and thorax with dirty white. Highlight antennae with Cad Yellow Pale + White. Highlight legs with White + French Ultramarine.

Flowers: Stipple highlights on blossom stems with White. On trumpets, blend shading areas and highlights with growth direction. Add more light if needed and reblend. Stipple white petals with same dark mix. Tap to blend, leaving a good bit of texture. When finished, add lots of random, loose dots of slightly-thinned dark mix.

Stems/Leaves: Blend highlights. Establish center vein structure with light green mix. Enhance some rolled edges and flips with White.

Metz's Silkmoth & Crepe Ginger

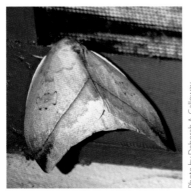

Photo by Deborah A. Galloway

OIL COLOR MIXES

Raw Umber + White

White + Raw Umber

Black + Raw Umber

Alizarin Crimson + Raw Umber

White + Raw Sienna

Black + White

Black + Sap Green

Sap Green + Raw Sienna + White

Previous mix + White

White + French Ultramarine

Alizarin Crimson + Raw Sienna

Cadmium Yellow Pale + Winsor Red

A PHOTO OF A PINK AND BROWN Silkmoth in a book on Trinidad caught my eye. When that trip came up, nothing would do but to search it out. We asked the naturalist at our lodge how to find one. His reply: Have never seen it! Undiscouraged, after hours, in our pj's, we took flashlights to check out what might be coming to lights along paths and by windows. This photo is the result. Shown in the painting with the Metz's Silkmoth (*Automeris metzii*) is Crepe Ginger, which was growing on the grounds at our lodge.

Pattern: Enlarge at 250% to bring up to full size.

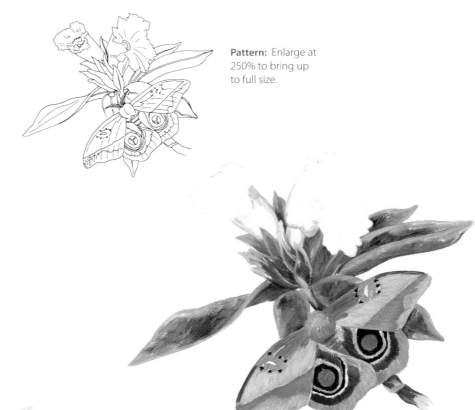

1 STEP ONE

Moth: Use a no. 2 or 4 bright for all steps unless otherwise noted. Base the black parts of the eyespots, the surrounding black band, and the tiny markings on the forewings with Black acrylic, using a no. 0 round. Forewings: Base darkest value on wing margin with Raw Umber. Base dark value in the cell next to thorax with Raw Umber. With Raw Umber + White, base the medium value band on outer forewing and the inside of the oval at the end of the cell surrounded by the tiny black acrylic markings. Base the lightest values with White + Raw Umber. Hindwings: Base outer hindwing margins with White + Raw Umber. Base inside of eyespots and lower half of band outside of eyespot with Black + White. Base upper half of band with White + Raw Umber. Base pink areas with Alizarin Crimson + Raw Umber in shadow areas and with plain Alizarin Crimson in stronger intensity areas. Body: Base dark values with Raw Umber + White. Base rest of body with White + Raw Umber.

Flower Trumpets: Base dark value with White + Raw Sienna. Base rest with White.

Red Stems/Calyxes: Base dark values with Alizarin Crimson + Raw Sienna; light values with White + Raw Sienna.

Leaves/Green Calyxes: Base dark values with Black + Sap Green; light value with Sap Green + Raw Sienna + White.

2 STEP TWO

Moth: Highlight in light value areas with White. Shade midwing with Black + Raw Umber to develop the dark wingbar. Add shading next to thorax with additional Raw Umber. Add White crescent in tip of cell. Right forewing: Blend between values. Soften dark wingbar into basecoat at trailing edge of wing. Outline white crescent with Raw Umber. Stipple apex of wing with Black + Raw Umber. Hindwings: Shade margins with Raw Umber. Highlight with White at edge of left hindwing. Eyespots: Place zig-zaggy lines of White inside eyespot. Blend where values on circular band meet. Highlight wide top of circular band with White. Shade pink bands with Raw Umber. Highlight pink hindwing band with White + Raw Sienna. Body and head: Highlight thorax with White. Shade with Raw Umber. Add two narrow White bands across the visible part of the abdomen. Antennae: Base shaft and feathery side strokes with slightly-thinned Alizarin Crimson + Raw Sienna.

Flower Trumpets: Blend between values and shade in a few places using Sap Green + Raw Sienna. Highlight with White. White blossom: Shade in trumpet opening with White + French Ultramarine. Base rest of petals with White. Base center with Cad Yellow Pale + a tad of Winsor Red. Shade at base of center with Winsor Red. Pink blossom: Lay in detail with Alizarin Crimson + Raw Sienna. Base yellow areas on lip with Cad Yellow Pale. Outline yellow areas with a bit of Sap Green + Raw Sienna + White shading. Base rest of visible lip with White.

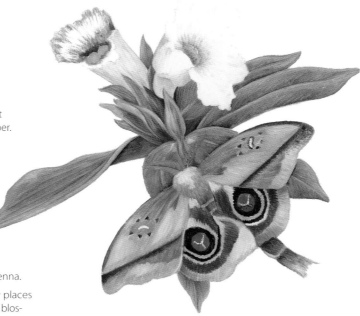

Red Stems/Calyxes: Blend with growth direction. Shade with a bit of Alizarin Crimson + Raw Umber.

Leaves/Green Calyxes: Blend where values meet. Allow some veining to remain. Apply highlights using light green mix + White and White + French Ultramarine.

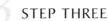

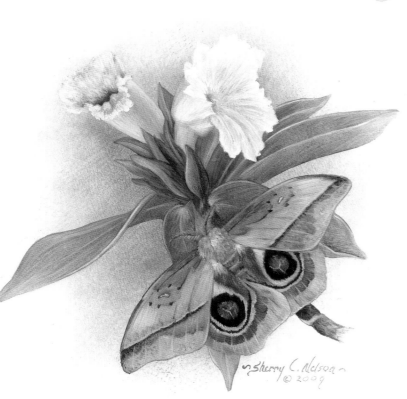

3 STEP THREE

Moth: Forewings: Shade next to thorax with Black + Raw Umber. Add detail lines and a few section lines with Raw Umber, applied sparsely and irregularly. Stipple at apex of wings with Raw Umber. Walk stippling in a value gradation into the adjacent area. Add dirty White section lines on outer forewings and on hindwings. Hindwings: Fluff White at base of wings over pink bands. Outline some of the hindwing edges and most of the forewing edges with a bit of dirty White. Soften to basecoat if it seems too hard. Eyespots: Soften white zag-zags to blend to basecoat a bit. Blend highlights and shadows on pink areas. Blend highlight at top of circular band around eyespot to soften. Body: Soften white highlight with feathery strokes. Soften the light bands across abdomen with tip of round brush. Highlight antennae with slightly thinned White + Raw Sienna.

Flower Trumpets: Blend shading areas and highlights using chisel where values meet. With Alizarin mix on the brush, touch in some very sparse and minor accents and reblend to soften. White blossom: Blend, then highlight with more White. Re-blend. Stipple White on center and soften with flattened tip of a round brush. Pink blossom: Gently blend White + Raw Sienna using no. 2 bright in between the detail. Don't overwork. Blend edge of yellow into green outline on lip. Pull a tiny bit of Alizarin mix with chisel to divide the yellow area. Highlight lip with more White.

Red Stems/Calyxes: Blend where values meet. Accent with a little Sap Green + Raw Sienna + White and re-blend.

Leaves/Green Calyxes: Blend highlights. Establish center vein structure with light green mix. Enhance rolled edges and flips with light green mix + White.

125

Saucy Beauty Tiger Moth & Plumbago

Photo by Deborah A. Galloway

THIS SAUCY BEAUTY IS IN THE Tiger Moth family of *Arctiidae* and is another day-flying moth that could pass as a butterfly! Note the turquoise head that's showing in this camera angle. The Saucy Beauty (*Phaloesia saucia*) in the photo is feeding on betony mist flower; we'll be painting it instead with the beautiful blue Cape Plumbago.

OIL COLOR MIXES

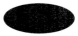

Black + French Ultramarine

White + French Ultramarine

Cadmium Yellow Pale + Alizarin Crimson

Alizarin Crimson + Cadmium Yellow Pale

Black + Sap Green

White + Sap Green

French Ultramarine + White

Alizarin Crimson + French Ultramarine

Alizarin Crimson + White

Pattern: Enlarge at 182% to bring up to full size.

1 STEP ONE

Moth: Use a no. 2 or 4 bright for all steps unless otherwise noted. Base darker, dull blue values with Black + French Ultramarine. Base bright blue areas and around spots with French Ultramarine. Body: Base dark value with Black + French Ultramarine. Base bright blue with French Ultramarine.

Flowers: Base dark values with French Ultramarine. Base light values with White + French Ultramarine.

Leaves/Stems: Base the dark values with Black + Sap Green. Base light values with Sap Green + White.

STEP TWO

Moth: Blend where values meet with the chisel edge of no. 4 bright. When blended, soften all four wings by patting with cheesecloth to lift a little paint, giving a translucent look and obliterating hard brushstrokes. Lift out paint that gets into the white wing spots with a brush dampened with odorless thinner. Base yellow margin with Cad Yellow Pale + a tad of Alizarin Crimson. Base red on margin with Alizarin Crimson + a tad of Cad Yellow Pale. Base red wing spots with same mix. Add white spots with White using a no. 0 bright. Body: Blend where values meet on body. Base head with Cad Yellow Pale + a tad of Alizarin Crimson. Thin a puddle of Black + French Ultramarine and apply antennae with a no. 0 round.

Flowers: Where values meet, blend with the growth direction of the petals. Shade with French Ultramarine + Black. Highlight with White.

Leaves/Stems: Blend where values meet following growth direction. Accent with French Ultramarine + White. Lift out caterpillar bite with odorless thinner on a no. 8 bright.

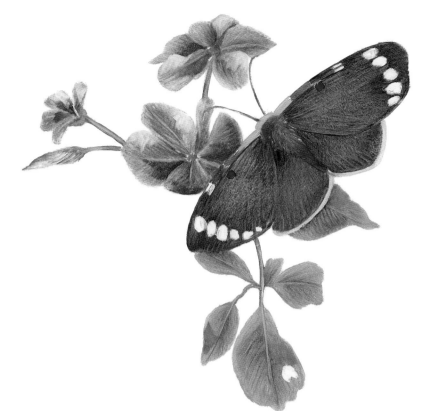

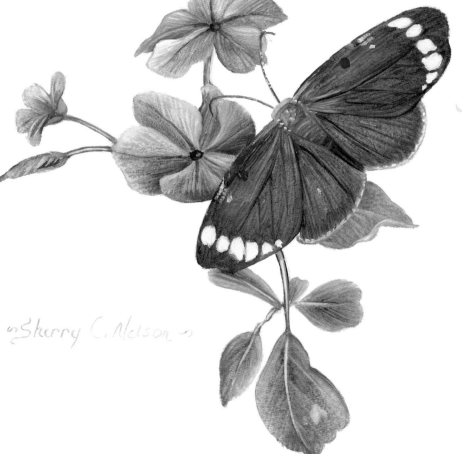

Sherry C. Nelson

STEP THREE

Moth: Apply section lines on wings with Black + French Ultramarine. Use dry chisel edge of brush to lift out some paint to denote fine surface striations on the wing. Wing margin: Tap with chisel edge where the yellow and red meet. White spots: Stipple with pure White for texture. Body: Using no. 1 round brush, highlight with White to indicate markings and eyes. Stipple White into center of thorax and soften with flattened tip of the round brush. Add curving lines of dirty White to indicate segmented abdomen. Using a no. 0 round, tip antennae with White highlight dots.

Flower: Blend again where values meet. Base center with a circle of Alizarin Crimson + French Ultramarine and draw in center vein line within each flower petal with same mix. Accent the bud with the same red-violet mix as well. Re-highlight petals with White in a place or two if needed for variety.

Leaves/Stems: Blend with growth direction. Using chisel edge, lift paint to create light striations. If paint doesn't lift easily, apply lines with light green mix + White.

Urania Swallowtailed Moth & Silky Acacia

Photo by Deborah A. Galloway

OFTEN FOUND IN SHADED SPOTS on the forest floor, these moths can be common but difficult to photograph. The *Urania fulgens* is a day-flying moth and perhaps for that reason, is as beautiful as any butterfly could be with electric green bands across the wings and long, graceful tails. This beauty was photographed in Costa Rica. They're primarily from Central and South America but for no apparent reason they occasionally migrate northward, even into the southern United States, in huge numbers. They may be seen nectaring on many different food sources, including the lovely Silky Acacia shown in our painting.

OIL COLOR MIXES

French Ultramarine + Phthalo Turquoise

Previous mix + Cadmium Yellow Pale + White

Previous mix + more White

Winsor Red + White

Black + Raw Umber

Previous mix + White

Black + Sap Green

Sap Green + Raw Sienna + White

Previous mix + White

Raw Sienna + White

White + Cadmium Yellow Pale

Winsor Red + Cadmium Yellow Pale + White

Previous mix + Alizarin Crimson

Previous mix + White

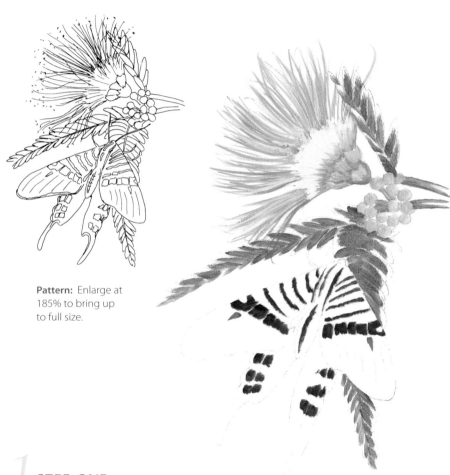

Pattern: Enlarge at 185% to bring up to full size.

1 STEP ONE

Moth: Use a no. 2 or 4 bright for all steps unless otherwise noted. Base all the turquoise lines and wing bars including those on the body with French Ultramarine + Phthalo Turquoise. Base the two red spots with Winsor Red + White.

Flower/Calyx: Base green on base of blossom and in calyx with sparse Black + Sap Green. Base the light value with White. Thin Winsor Red + Cad Yellow Pale + White very thin using odorless thinner. With a no. 0 round, apply the long filaments, pulling from the white area outward. Base light values in calyx with Raw Sienna + White.

Buds: Base with Raw Sienna + White.

Leaves/Stems: Base the dark values with Black + Sap Green.

STEP TWO

Moth: Create initial iridescence on all turquoise sections using a no. 1 round. Load the brush with the French Ultramarine + Phthalo Turquoise mix + Cad Yellow Pale + White and lay on short strokes of the brush across the sections. Check the finished painting frequently. The yellow-green mix varies throughout. Add only what's needed to get the right value. Stipple red spots with a bit of Winsor Red + White. Now base the rest of the moth, including body, with Black + Raw Umber, going carefully up to, but not into, all the turquoise markings. Thin a little puddle of the Black mix and apply antennae and legs using the round brush.

Flower/Calyx: Using thinned mix of Winsor Red + Cad Yellow Pale + White, plus a little Alizarin Crimson, add a few filaments in a darker value to shade within the blossom. Blend where green and white meet, using chisel edge of bright. Wipe brush dry and soften the white into the ends of the pink filaments. Don't let the pink "grow" into the white. Keep brush dry and neutralize it in White to remove pink, then wipe dry to help control the color. On the calyx, blend where values meet.

Buds: Stipple highlights with White plus a smidgen of Cad Yellow Pale using no. 1 round brush.

Leaves/Stems: Base light values with Sap Green + Raw Sienna + White. Blend where values meet, following growth direction. Add a few highlight areas with light green mix + White.

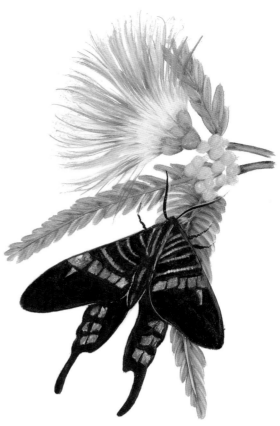

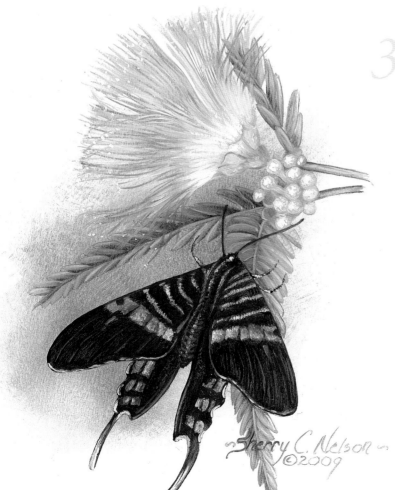

STEP THREE

Moth: Finalize iridescent wing markings and bars. The larger, inner sections are a bit yellower; you might add a bit of Cad Yellow Pale to the Turquoise Mix + White and stipple a bit of that on those areas to enhance the iridescent appearance. A few lines, particularly the narrow ones, have bits of near-white highlighting in a few places. With a little White + Black, apply dirty highlights to create wing separations, and a bit of light value at trailing margins of forewings. Use same mix to suggest a few faint section lines in dark areas. Highlight tails with White, blending upward just a bit. With White on no. 0 round, lay in detail markings at wing edges. Body: Highlight with stippled dirty White on and behind head. With the Turquoise mix + White on a round brush, tap a row of tiny markings down center line of abdomen. Using same mix, drag a few lines across abdomen to indicate segments. Highlight legs with White.

Flower/Calyx: Use the filament mix from Step 2, adding more White to it. Add lighter filaments on top of those which appear too strong or too thick. Blot gently with cheesecloth to soften and subdue. Add dozens of tiny White pollen dots at ends of filaments. With chisel, soften and connect white and base of filaments one more time. Highlight calyx with White.

Buds: Soften highlights with flattened tip of the round brush. Highlight again with pure White and soften edges.

Leaves/Stems: Reblend, defining leaf edges with light green lines. Use same light green for center veins.

Smaller Parasa Moth & Desert Willow

THE SMALLER PARASA IS INDEED smaller—than what, I'm not sure! My fingertip helps you to judge just what a minute creature it is. We have gotten to know these cute critters at the mercury vapor lights when we do summer moth nights. Here I've painted it with its food plant, the Desert Willow. Hard to imagine that across the world, there are thousands of such tiny creatures, each with their unique and extraordinary markings, each so beautiful and so paintable. And the life history of most is a huge unsolved mystery.

Pattern: Enlarge at 196% to bring up to full size.

OIL COLOR MIXES

Sap Green + French Ultramarine + White

Previous mix + White

Sap Green + Cadmium Yellow Pale + Raw Sienna

Previous mix + White

Cadmium Yellow Pale + Winsor Red

White + Raw Sienna

Black + Sap Green

Sap Green + Raw Sienna + White + tad of French Ultramarine

White + French Ultramarine

White + Cadmium Yellow Pale

Alizarin Crimson + Winsor Red + Raw Umber

Alizarin Crimson + Winsor Red + Raw Sienna + White

Previous mix + more White + Alizarin Crimson

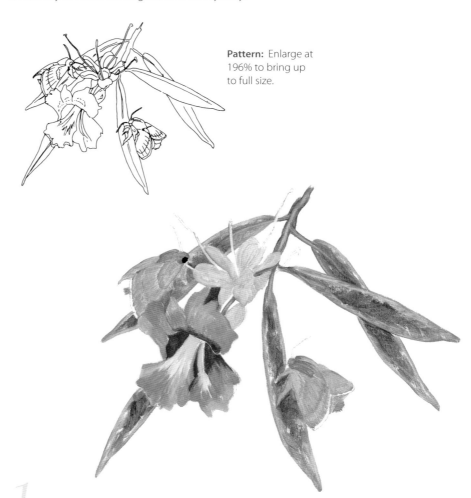

1 STEP ONE

Moths: Use a no. 2 or 4 bright for all steps unless otherwise noted. Wings: Base yellow-green band with Sap Green + Cadmium Yellow Pale + Raw Sienna. Base brownish wing bands with Raw Sienna. At end of wingtip, place a narrow band of Raw Sienna. Base head and upper thorax with Black + Sap Green + a tiny tad of French Ultramarine and a little White. Base tip of abdomen with Cad Yellow Pale + Winsor Red. Add eye with Black. Base legs with Raw Sienna.

Flower Petals/Center/Calyx: Base dark values on petals with Alizarin Crimson + Winsor Red + Raw Umber. Base light values on petals with Alizarin Crimson + Winsor Red + Raw Sienna + White. Center: Base with Cad Yellow Pale in throat, and White + Cad Yellow Pale where throat meets pink of petals. Calyx: Base with White + Raw Sienna.

Leaves/Stems: Base dark values with Black + Sap Green. Base light value with Sap Green + Raw Sienna + White + a tad of French Ultramarine.

STEP TWO

Moth: Wings: Highlight yellow-green band with base mix + White on side of band toward back of wing. Shade Raw Sienna bands with Raw Umber along margins, and with scruffy marks in band near head. Body and head: Highlight head with the green base mix + White. Tip abdomen with a row of Burnt Sienna dots. Antennae and legs: Shade back of leg with tiny dots using Raw Umber. Thin Raw Sienna and do antennae with a no. 0 round brush.

Flower Petals/Center/Calyx: Blend between values on petals, following the growth direction, using chisel edge. Highlight with dirty brush + White + Alizarin Crimson. Add form by highlighting on overlapping edges. Deepen shadow areas with Alizarin Crimson + Winsor Red + Raw Umber. Center: Blend where yellow values meet. Soften light value into pink petal with chisel. Stipple on a little White + Cad Yellow Pale paint in widest portion of center. Calyx: Shade with bits of Black + Sap Green. Lift out paint for stamens using no. 8 bright dampened in odorless thinner. Base stamens with White + Cad Yellow Pale.

Leaves/Stems: Blend between values with growth direction. Apply highlights using White + French Ultramarine.

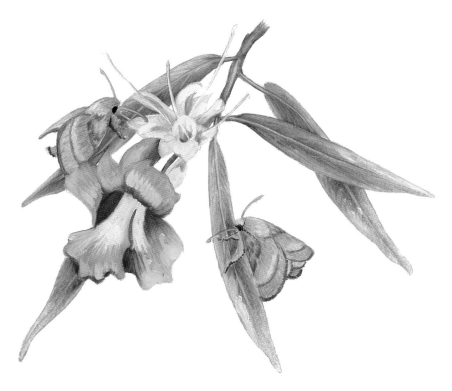

STEP THREE

Moths: Wings: Soften highlights on yellow-green band by stippling with a no. 1 round brush. Accent side of wing with Cad Yellow Pale + Winsor Red. With a no. 0 bright, blend Raw Umber shading on Raw Sienna bands. Highlight with White in band by head. Far wing: Detail with Raw Umber. Shade base of wing with Raw Umber and accent with the orange mix on top. Using a good no. 2 chisel and Raw Umber, set in faint and imperfect section lines to divide wing. Body and head: Stipple highlight on head. Soften Burnt Sienna on abdomen. Shade antennae with Burnt Sienna or Raw Umber near tips, leaving base light. Accent legs with Cad Yellow Pale + Winsor Red.

Flower Petals/Center/Calyx: Blend petals where values meet, shaping petals by working with the growth direction of each petal. Blend highlights with growth direction using chisel, but control growth of light values. Let chisel lines remain to indicate realism. Center: Soften highlights by tapping edges of White with a chisel. Accent base of throat with Winsor Red + Cad Yellow Pale. Calyx: Blend to soften shading color where values meet. Accent with bits of Alizarin mix in places. Highlight rolled edges and turns with White + Cad Yellow Pale, then finally White. Shade base of stamens with dark green mix. Tip with Burnt Sienna.

Leaves/Stems: Blend highlights with growth direction. Establish vein structure with light green mix.

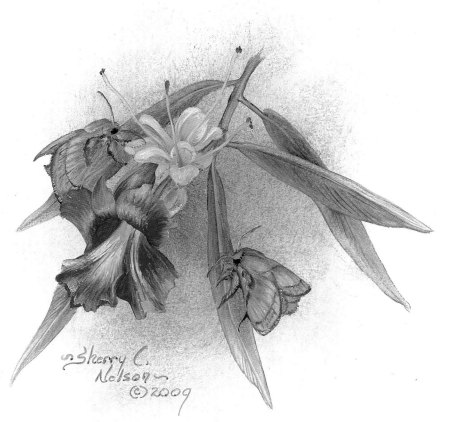

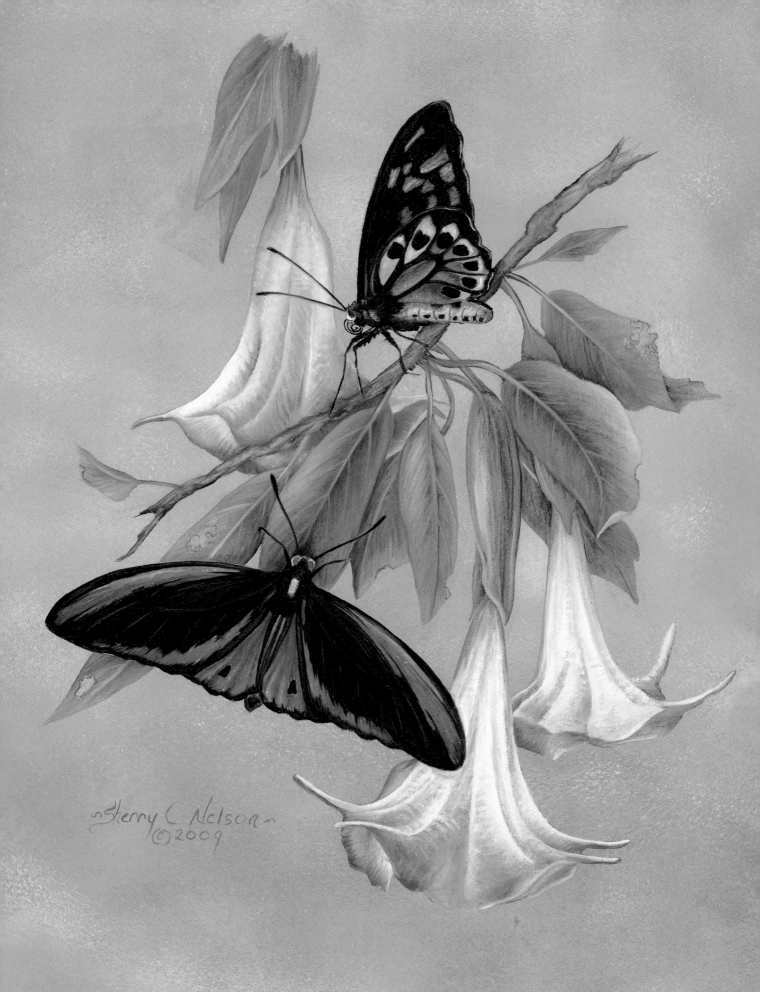

Sherry C Nelson
© 2009

Common Green Birdwing & Angel Trumpet

Photo by Deborah A. Galloway

THE QUEEN ALEXANDRA'S BIRDWING is the world's largest butterfly, with a wingspan up to 12 inches (30.5cm). But since the Queen wouldn't fit here, we'll paint the spectacular Common Green, a butterfly of Australia and New Guinea with a wingspan of "only" 6 inches (15cm) for the female and 5 inches (13cm) for the male. The photo at left is a nice shot of the underwing with its iridescent turquoise and yellow-green sections. The challenge of creating structural iridescent color on butterflies with brush and paint is part of what makes them fascinating subjects. The flower in this painting is commonly called Angel Trumpet (*Brugmansia versicolor*). Note the "crosswise" texture on the trumpets. Getting that look will be your challenge when painting them.

OIL COLOR MIXES

Sap Green + Phthalo Turquoise

Titanium White + Cadmium Yellow Pale

Phthalo Turquoise + Sap Green + a tad of White

White + Sap Green

Black + Raw Umber

Black + White

White + Raw Sienna

White + Burnt Sienna

Cadmium Yellow Pale + Sap Green + Raw Sienna

Previous mix + Black

Burnt Sienna + White

Previous mix + Winsor Red

Black + Sap Green

Sap Green + Raw Sienna + White

Previous mix + White

Black + Sap Green + French Ultramarine

Previous mix + White

Burnt Sienna + White + Black

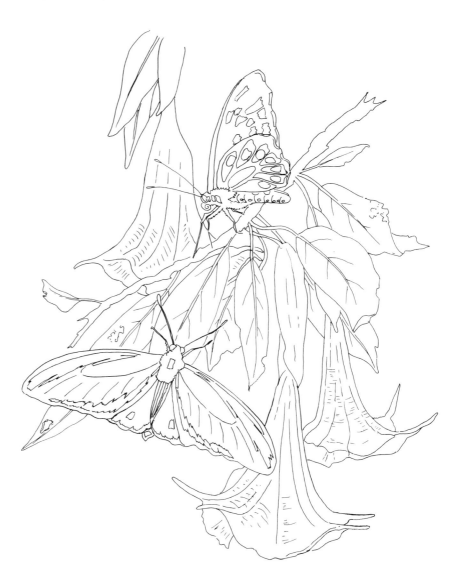

Enlarge at 145% to bring up to full size. Transfer this line drawing to your prepared background, using dark graphite paper.

MATERIALS & BACKGROUND

Surface:
11x14-inch (28cm x 36cm) hardboard panel, 1/8-inch (3mm) thick

Delta Ceramcoat acrylic paints:
Cactus Green
Dark Victorian Teal
Green Tea
Oyster White

Winsor & Newton Artists' Oils:
Ivory Black
Titanium White
Raw Sienna
Raw Umber
Burnt Sienna
Sap Green
Cadmium Yellow Pale
Winsor Red
French Ultramarine
Phthalo Turquoise

Brushes:
nos. 0, 2, 4, 6, 8 red sable brights
nos. 0 and 1 red sable rounds

Background Preparation:
Base the hardboard panel, using a sponge roller, with Cactus Green. Let dry. Sand well. Rebase with Cactus Green, and while wet, drizzle on two 2-inch (51mm) stripes of Dark Victorian Teal on opposite corners on the surface and two 2-inch (51mm) stripes of Green Tea in the other corners. Use the same roller to blend the Green Tea here and there into the basecoat. Then blend the Dark Victorian Teal in the same way, working colors to balance across the surface. Add a little Oyster White in the center of the surface, and with another roller, blend and move color to achieve nice value gradations between the splotches of white and the background. Let dry, sand well, and spray with Krylon Matte Finish, #1311. See page 14 for more information on preparing the surface.

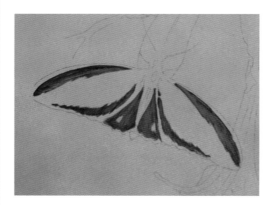

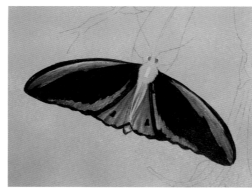

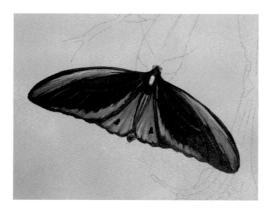

STEP ONE

Butterfly, wings spread: Using a no. 2 bright, base the green bands with Sap Green + Phthalo Turquoise. Base the turquoise bands with Phthalo Turquoise + Sap Green + White.

STEP TWO

Butterfly, wings spread: Using the flattened tip of a no. 1 round brush, stipple White + Cadmium Yellow Pale on the edges of the green bands. Stipple White + Sap Green on the turquoise areas. Colors should be applied a bit thickly to allow enough paint to create texture and iridescence. Base yellow on the thorax with White + Cad Yellow Pale using a no. 0 bright. Base a wide gray line on the abdomen and base the eyes with Black + White using a no. 0 bright. Outline the eyes with White + Cad Yellow Pale. Outline the tip of the abdomen with Raw Umber. Base all dark values with Black + Raw Umber on a no. 4 bright.

STEP THREE

Butterfly, wings spread: Dry the round brush between folds of a paper towel. Flatten tip. Use the flattened tip to blend where values meet, gently tapping and walking the pale yellow mix into the section, creating a value gradation. Walk the White + Phthalo Turquoise mix in the same way with the same brush, walking the color upward from the outer edge of the section into the hindwings. Base the body with Black + Raw Umber using a no. 2 bright. Tap a line of dark to divide the gray abdomen band into two lines of gray. Base the tip of the abdomen with Black. Smooth the dark wings with the natural growth direction. Using a little dry White + Raw Sienna on the chisel of a no. 4 bright, lay in faint section lines, dividing the wing into sections.

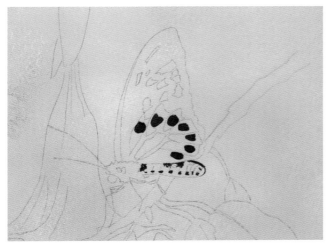

STEP FOUR

Butterfly, closed wings: Base the darkest sections on the underwing, and details on the body, with Black acrylic using a no. 0 round brush. When finished, clean the acrylic paint out of the brush well before using it again with oils.

STEP FIVE

Butterfly, closed wings: Use a no. 0 bright to base in the spots:

On hindwing: Base turquoise spots and sections with Phthalo Turquoise + Sap Green + White. The topmost turquoise spots are more greenish; add a little more Sap Green to the same mix. Base yellow spots with Cad Yellow Pale.

On forewing: Base turquoise spots with the same mix. Base the green spots toward the apex of the wing with Sap Green + Phthalo Turquoise.

On body: Base red spots with Winsor Red. Base abdomen with Cad Yellow Pale + Sap Green + Raw Sienna.

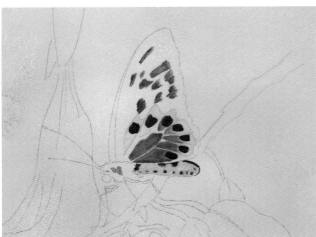

STEP SIX

Butterfly, closed wings: Use a no. 1 round to do all iridescent stippling on spots and sections. Initially apply a thickish bit of the color listed below on one-third of each section or spot where shown. Then dry the round brush, flatten the tip and blend, stippling color where the highlight meets the basecoat, walking and tapping the surface to get an iridescent appearance to the paint. Do not overwork.

On hindwing: Stipple turquoise spots with White + Sap Green. Stipple yellow spots with White + Cadmium Yellow Pale. Stipple between the yellow spots and turquoise spots in between and around the black acrylic spots to achieve a gradation. Stipple White + Burnt Sienna accent on the two yellow spots at the front of the hindwing so they appear a bit peachy.

On forewing: Stipple green spots with White + Sap Green. Stipple turquoise spots with White + Sap Green.

On body: Stipple red spot with Winsor Red. Shade along the edges of the abdomen with the base mix + a little Black.

Base in all remaining wing areas with Black + Raw Umber, blending smoothly with the growth direction. With White + Raw Sienna on chisel edge, add a few section lines to suggest wing detail and outline the hindwing edge to separate it from the forewing. Place White + Raw Sienna detail markings along the edges of the wings.

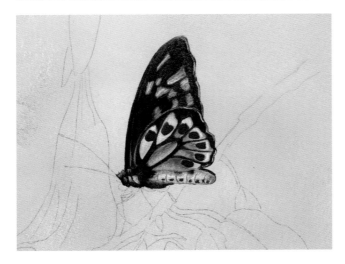

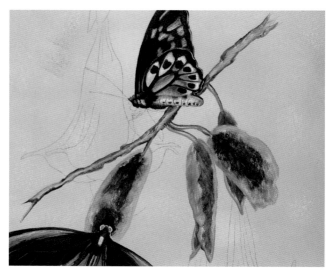

STEP SEVEN

Leaves/Calyxes/Branch: Base the dark values of the leaves and stems with Black + Sap Green + French Ultramarine, using a no. 6 bright. Base the light values with Sap Green + Raw Sienna + White. Base the dark values of the calyxes with Black + Sap Green. Base light values with same light mix as for leaves. Base the underside of branch with Raw Umber. Base irregularly along the upper outside edge with Black + Sap Green. Fill in the central area with White + Sap Green.

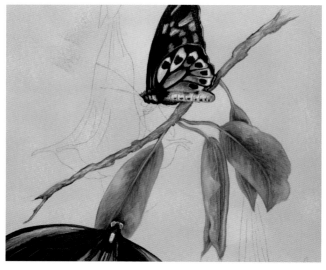

STEP EIGHT

Leaves/Calyxes/Branch: Blend the leaves and calyxes where values meet, following the growth direction. Highlight the leaves with the dark leaf mix + White. Highlight the calyxes with the light green mix + White. Use the chisel edge of the brush to chop the branch values where they meet, leaving plenty of texture for more interest.

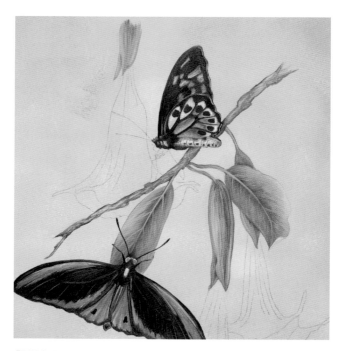

STEP NINE

Leaves/Calyxes/Branch: Blend the highlights on the leaves and calyxes where values meet. Highlight with the same mixes if needed. Reblend with the growth direction. Add the vein structure in the leaves with the light green mix used on the calyxes. Add striations and streaks within the calyxes with the light green mix.

Butterfly, wings spread: With a thinned mix of Black + Raw Umber on a no. 0 round, base the legs and antennae.

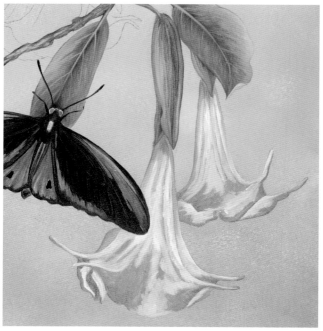

STEP TEN

Angel Trumpets: On the flared petals, basecoat the dark value areas with Burnt Sienna + White. Base the light values with White + Burnt Sienna. On the trumpets, base long lines of shadow with Burnt Sienna + White + Black. Base the top of the trumpet where it joins the calyx with a bit of Sap Green + Raw Sienna + White. Base the remainder of the trumpet with White.

STEP ELEVEN

Angel Trumpets: Angel trumpets have unusual growth directions that change within individual petals. Observe how the blending direction must follow the growth to achieve a sense of realism. Blend where values meet using the appropriate brush size for each area, using a no. 2, 4 or 6 bright. On the flared petals, blend each individual petal with its own unique direction, and leave a few light brushmarks to indicate that. Blend across the trumpets, again leaving light brushstrokes to indicate the direction.

STEP TWELVE

Angel Trumpets: Apply highlights with White. Important places to add lights are on the ridges of the trumpets, the upper parts of the flared petals and the long tips, as well as some within the petals themselves, to indicate rolls or ruffles.

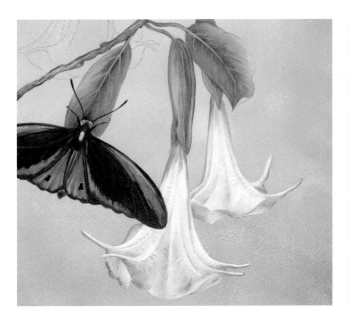

STEP THIRTEEN

Angel Trumpets: Blend highlights where values meet. Re-highlight if needed in the strongest light areas and reblend. Add green accents in the upper part of the trumpets near the calyxes for depth, using Sap Green + Black. Accent on sides of trumpets with Burnt Sienna + White + Black. Add accents on the flared petals with Burnt Sienna + Winsor Red.

Leaves: Accent the leaves with Burnt Sienna + White.

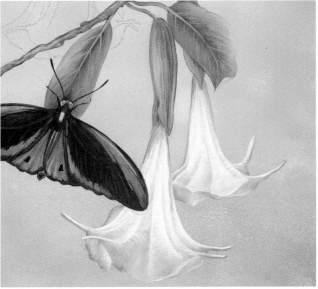

STEP FOURTEEN

Angel Trumpets: Blend where accents meet basecoats on trumpets and petals, being careful to establish the final growth direction correctly. Do final white highlights in center of trumpet if needed. Reblend.

Leaves: Blend accents on leaves with growth direction.

Finish: Before painting is dry, clean up any graphite lines or messy edges with a no. 8 bright dipped in odorless thinner and blotted on a paper towel.

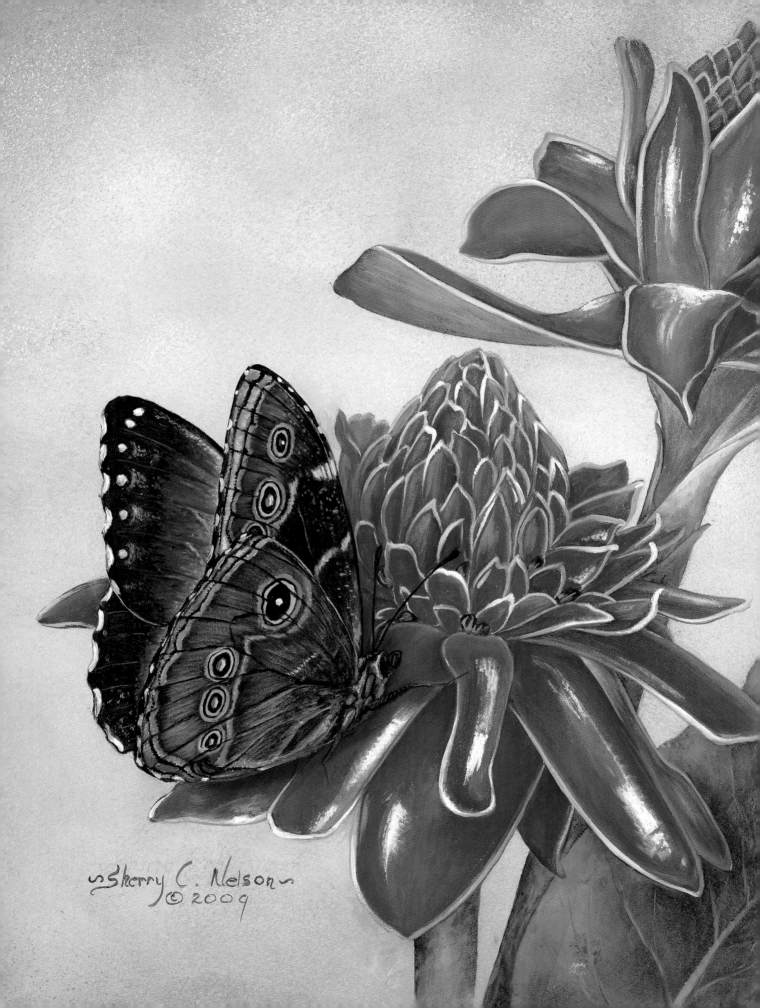

Sherry C. Nelson
© 2009

PROJECT TWO
Emperor Morpho & Torch Ginger

Photo by Deborah A. Galloway

THESE BLUE SCALES ON THE MORPHO'S WINGS are minute, and their complexity amazing. Each scale consists of a series of ridges that run the length of the scale, which allow the light to act on it in a variety of subtle ways. When the light comes from a somewhat oblique angle, for example, the blue may appear more true blue; another angle, more blue-green; and from a very low angle, the color may appear to be in the blue-violet range. Morphos are forest-dwelling butterflies, and the low light near the rainforest floor causes the iridescence to refract dramatically, like blue tin foil. The photo shows a Morpho (*Morpho peleides*) perched on the author's fingers. This one was found in Trinidad, as was the spectacular Torch Ginger, a plant cultivated throughout the tropics.

OIL COLOR MIXES

Phthalo Turquoise + French Ultramarine

Black + Raw Umber

Raw Umber + Black

Cadmium Yellow Pale + Raw Sienna

White + Raw Umber + Black

Previous mix + more White

Alizarin Crimson + Winsor Red + White + Black

Previous mix + more White + more Black

Alizarin Crimson + Winsor Red + Cadmium Yellow Pale

Previous mix + White

Alizarin Crimson + Sap Green

Winsor Red + Cad Yellow Pale

Black + Sap Green

Sap Green + Raw Sienna + White

White + Winsor Red + Cad Yellow Pale

White + Black + French Ultramarine

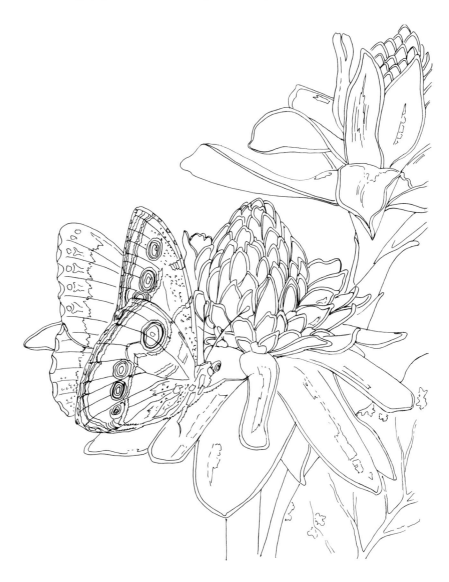

Enlarge at 154% to bring up to full size. Transfer this line drawing to your prepared background, using dark graphite paper.

MATERIALS & BACKGROUND

Surface:

11x14-inch (28cm x 36cm) hardboard panel, 1/8-inch (3mm) thick

Delta Ceramcoat acrylic paints:

Oyster White
Denim Blue
Eucalyptus

Winsor & Newton Artists' Oils:

Ivory Black
Titanium White
Raw Sienna
Raw Umber
Burnt Sienna
Sap Green
Cadmium Yellow Pale
Winsor Red
Alizarin Crimson
French Ultramarine
Phthalo Turquoise

Brushes:

nos. 0, 2, 4, 6, 8 red sable brights
nos. 0 and 1 red sable rounds

Background Preparation:

Base the hardboard panel, using a sponge roller, with Oyster White. Let dry. Sand well. Rebase with Oyster White, and while wet, drizzle on two 2-inch (51mm) stripes of Eucalyptus on opposite corners of the surface and two 2-inch (51mm) stripes of Denim Blue in each of the other corners. Use a fresh roller to blend the green softly here and there. Then blend the blue in the same way, working colors to balance across the surface. Add a little Oyster White in center of surface, and using original roller, control the stronger colors and work to achieve nice gradations between the colors. Let dry, sand well, and spray with Krylon Matte Finish, #1311. See page 14 for more information on preparing the surface.

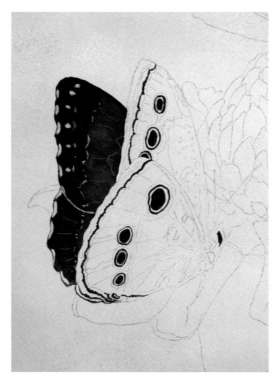

STEP ONE

Near fore- and hindwings: Base dark detail on hindwing eye-spots, the narrow bands at wing margins, and the eye with Black acrylic, using a no. 0 round brush. When finished, clean the acrylic paint out of the brush well before using it again with oils.

Far fore- and hindwings: Using a no. 4 bright, base the blue areas with Phthalo Turquoise + French Ultramarine. Base the wide dark wing margins with Black + Raw Umber. Avoid basecoating margin detail and white spots on forewing. Sketch in a few section lines with a stylus for a guide.

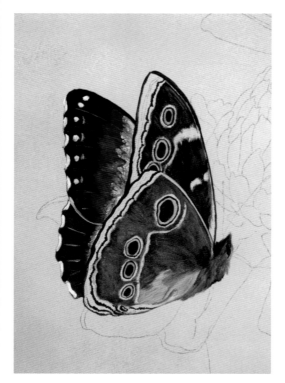

STEP TWO

Far wings: Using the flattened tip of the no. 1 round brush, stipple White into the base of the blue sections. Apply the color a bit thickly to allow enough paint to create texture and iridescence. Apply detail markings and small white spots with White, using a no. 1 round. Add section lines with Raw Sienna to establish form of far wings.

Near wings: Outline the wings with a narrow band of Black acrylic using a no. 0 round brush. Base yellow circles around the black acrylic eyespot with Cad Yellow Pale + Raw Sienna. Base dark on wing with Raw Umber + Black. Base light patch at base of hindwing with Raw Sienna.

Body: Base the body with Raw Umber + Black. Base the top of the head with Black.

STEP THREE

Far wings: Dry the round brush between the folds of a paper towel. Using the flattened tip, blend White where values meet, gently walking the White outward to create a value gradation on the blue wing sections. Detail inside the row of white spots, surrounding the inner portion of each spot with a gray mix of White + Black + Raw Umber, again stippling to give a little texture and interest. Add bits of gray stippling to soften the section lines on the hindwing.

Near wings: On the hindwing, blend between the Raw Sienna and the dark basecoat with the chisel edge. With a stylus or using the pattern, draw in section lines for a guide. Lighten the dark basecoat, highlighting between sections with White + Raw Umber + Black. Highlight with the same mix in the Raw Sienna area.

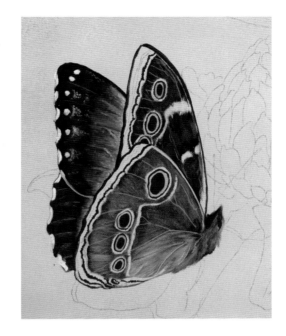

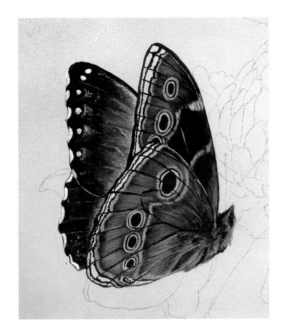

STEP FOUR

Near wings: Shade at the base of body with Black + Raw Umber on the hindwing. Add additional gray highlighting on the body and on wing sections to bring to the correct value. Concentrate highlights especially in the wing sections containing eyespots so they appear paler gray than the rest of the wing. Shade between white bands on forewing with Black + Raw Umber. Base white spots with White. Accent with Burnt Sienna on forewing margin just above body and at back of Raw Sienna patch on hindwing. With a gray mix of White + Raw Umber + Black on a no. 0 bright, lay in the irregular, narrow bands across the near hindwing. Base outer ring around eyespots with same gray mix. Establish all section lines with Black + Raw Umber mix, using the chisel edge of a no. 4 bright. With Black acrylic on a no. 0 round, lay in the narrow, irregular detail bands on the margins of the fore- and hindwings. Using acrylic in some of these very narrow areas will prevent picking up the darks and muddying the lighter values nearby.

STEP FIVE

Near wings: Stipple random detail dots with Raw Sienna in darkest area of forewing using a no. 0 round brush. Base the tiny white dots along margins of wings, breaking up the Black acrylic outline. Base the gray band in wing margins with White + Raw Umber + Black. Highlight with the same mix + more White. Add faint light bars in cell of hindwing with same gray mix. Base pink hindwing marginal band with Alizarin Crimson + Winsor Red + White + a tad of Black. Where this band wraps around the bottom edge of the hindwing, redden the base color with more Winsor Red. Base spots on body with Winsor Red + Alizarin Crimson + a little Cad Yellow Pale. Highlight all these with a stippled mix + White using a no. 1 round. Base the pale pink forewing band with White + Black + just a bit of the pink mix. In the small eyespots, inside spot, base half the spot with the pink mix and half with White. On the large eyespot, base the center spot with White only.

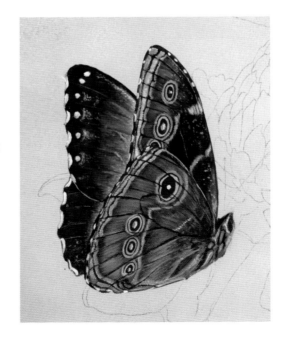

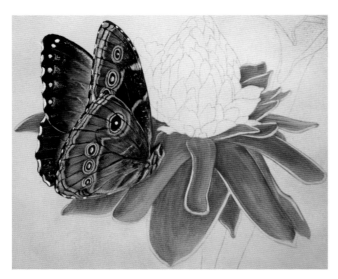

STEP SIX

Torch Ginger: Base the dark values on the torch ginger with Alizarin Crimson + Sap Green. Base the light values with Winsor Red + Cad Yellow Pale. Blend between values, following the growth direction of each petal. Lift out messy edges with a no. 8 bright dampened in odorless thinner. Removing petal color that intrudes will give cleaner, stronger shines and highlights on these hard, glossy petals.

STEP SEVEN

Petals/Calyx/Stems: Base darkest values on tiny, unopened petals with Winsor Red + Alizarin Crimson. Base light tips and some margins with Winsor Red. Lay in the brown tip of the stamens with Raw Umber. Using the same mixes as for bottom flower, base the dark and light values in the top flower. Where top flower comes up out of stem/calyx, base a portion of that area with Sap Green + Raw Sienna. On all petals, whether large or small, keep edges cleaned out with damp brush. Base dark values on green stems with Black + Sap Green. Base light values with Sap Green + Raw Sienna + White.

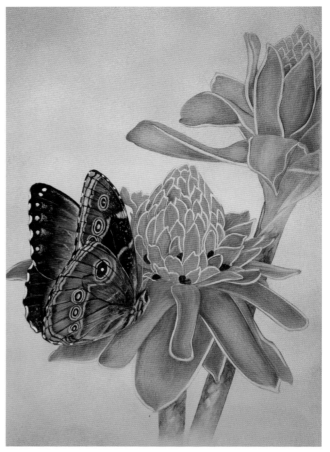

STEP EIGHT

Petals/Stems: Outline petals with the following mixes: White; White + Cad Yellow Pale + Raw Sienna; and White + Black + French Ultramarine. Make the light edges narrow in some parts of the petal, wider in others, and barely visible in yet others. Cool mixes are used primarily on the right side of the painting and right sides of the petals. The warmer yellow mix should be used on petal edges central in the painting. White may be used where needed, and as highlighting on the strongest light edges. Add medium-light values using Winsor Red in some petals and in others, White + Winsor Red + Cad Yellow Pale, adjusting the mix to appear as a medium-light value. On green stems, blend where values meet.

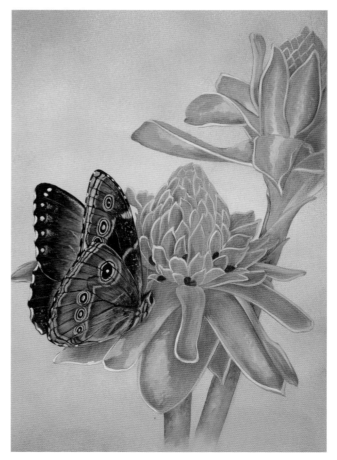

STEP NINE

Petals: Blend where medium values were applied. Soften edges of petal outlines, particularly those that appear too strong. Add additional dimension with more Cad Yellow Pale + Winsor Red if stronger accents are needed. Remember, once strong white highlights are added, little can be changed on the rest of the petal, so evaluate value and shape of all petals carefully before the next step.

STEP TEN

Petals/Stems/Butterfly: Highlight the major petals with the first strong White applied with a clean no. 2 bright. Highlight stems with Sap Green + Raw Sienna + White. Apply shadow under butterfly with Raw Umber and soften edges with cheese-cloth. With a thinned mix of Black, apply legs, proboscis and antennae using a no. 0 round.

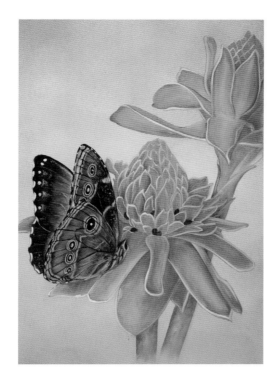
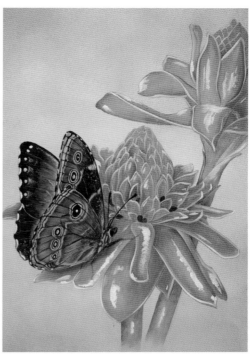

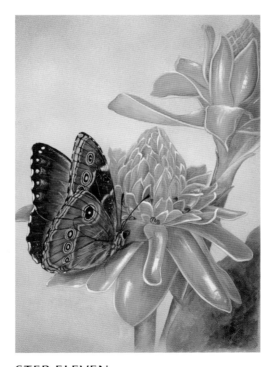
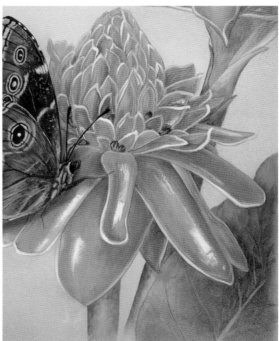

STEP ELEVEN

Petals/Stems/Leaf: With caution, soften highlights into petals. Some stay fairly hard and strong, so don't get carried away blending; overworking will turn them pink. Re-highlight with stippled strong white if needed in major shines. Highlight the Raw Umber stamen tips with the blue mix used on petal edges. Soften highlights in stems. Base the dark value of the leaf with Black + Sap Green. Base the light value with Sap Green + Raw Sienna + White.

STEP TWELVE

Leaf: Blend leaf values with growth direction where they meet. Establish vein structure using the light value green mix. Add a few accent speckles and spots of leaf damage with Burnt Sienna, and also with the dirty brush + White.

Finish: Before painting is dry, clean up any graphite lines or messy edges with a no. 8 bright dipped in odorless thinner and blotted on a paper towel.

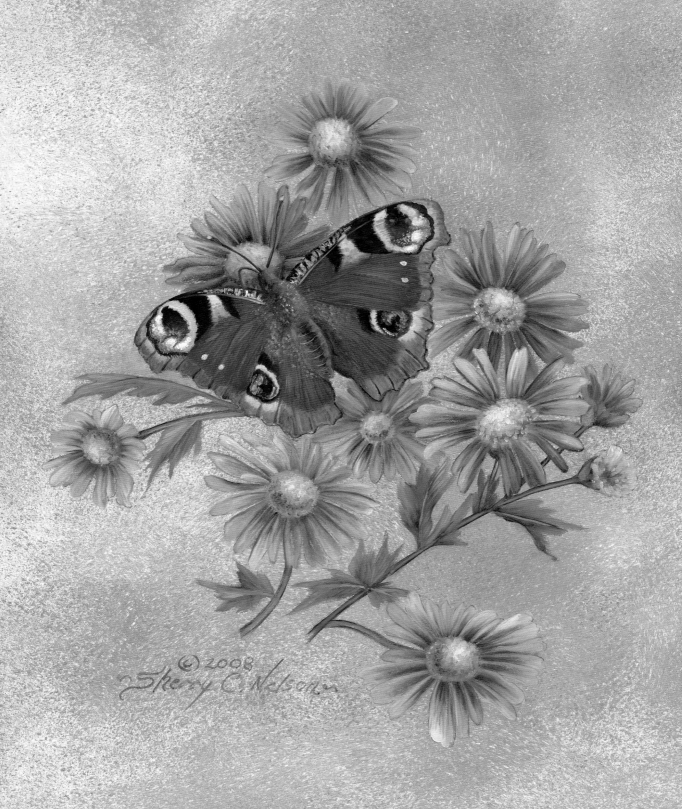

© 2008 Sherry C. Nelson

PROJECT THREE
European Peacock & Michaelmas Daisies

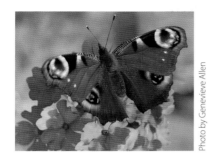

Photo by Genevieve Allen

THE EUROPEAN PEACOCK IS an excellent example of a butterfly that has evolved a complex and spectacular patterning on the dorsal or upperside of the wings, combined with a very cryptically colored and patterned underside. Once the Peacock goes to cover, it's almost impossible to see, yet it has all sorts of color and pattern to discourage the predator who tries to surprise it. The Peacock (*Ianchis io*) uses only a single plant, the Common Nettle, as the host plant for the caterpillars, which live communally in a web of silk. The photo at left was taken by Genevieve Allen in her beautiful cottage garden in southern England. The painting features Michaelmas daisies, known as blue asters in the U.S., providing a lovely complementary color to that of the Peacock.

OIL COLOR MIXES

Raw Sienna + Raw Umber

Raw Umber + White

Winsor Red + Cadmium Yellow Pale

Burnt Sienna + Winsor Red

Black + Sap Green

Previous mix + Sap Green + White

Previous mix + more White

Cadmium Yellow Pale + Raw Sienna

French Ultramarine + Winsor Red + White

French Ultramarine + White

White + French Ultramarine

White + Cadmium Yellow Pale

Black + Raw Umber

White + Black

Raw Sienna + White

Winsor Red + Cadmium Yellow Pale + Raw Sienna

Cadmium Yellow Pale + White

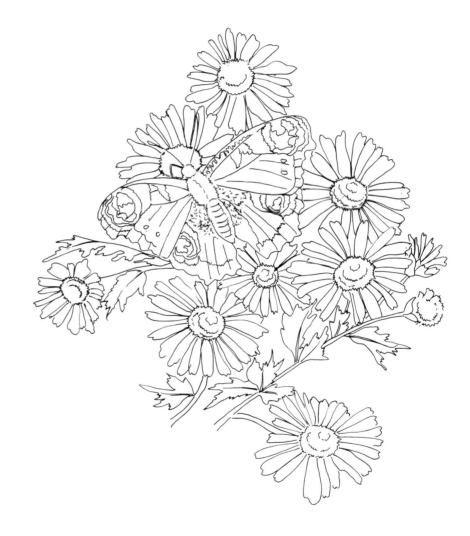

Enlarge at 123% to bring up to full size. Transfer this line drawing to your prepared background, using dark graphite paper.

145

MATERIALS & BACKGROUND

Surface:
11x14-inch (28cm x 36cm) hardboard panel, 1/8-inch (3mm) thick

Delta Ceramcoat acrylic paints:
Coastline Blue
Dolphin Gray
Green Sea

Winsor & Newton Artists' Oils:
Ivory Black
Titanium White
Raw Sienna
Raw Umber
Burnt Sienna
Sap Green
Cadmium Yellow Pale
Winsor Red
Alizarin Crimson
French Ultramarine

Brushes:
nos. 0, 2, 4, 6, 8 red sable brights
nos. 0 and 1 red sable rounds

Background Preparation:
Base the hardboard panel, using a sponge roller, with Coastline Blue. Let dry. Sand well. Rebase with Coastline Blue, and while wet, drizzle on a 3-inch (7.6cm) stripe of Green Sea in the middle of the surface. Use the same roller to blend the green softly here and there into the basecoat. Then put a little puddle of Dolphin Gray at the edge of the surface, blending again to balance colors across the surface. The gray will help tone down the intensity of the greens and blues a bit, so use the amount you like so the end result pleases you. Let dry, sand well, and spray with Krylon Matte Finish, #1311. See page 14 for more information on preparing the surface.

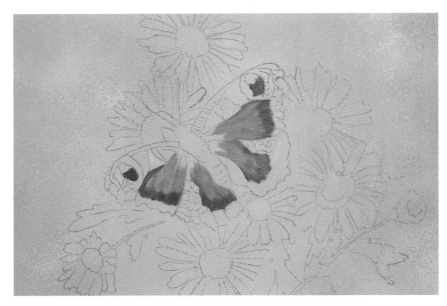

STEP ONE

Butterfly wings: Base the darkest red sections with Burnt Sienna + Winsor Red. Base the red-orange sections with Winsor Red + Cadmium Yellow Pale. Base the light sections with White + Cadmium Yellow Pale.

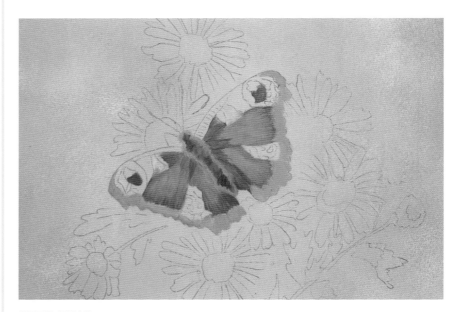

STEP TWO

Butterfly wings/Body: Blend between the red and the red-orange sections with the chisel edge of the brush where the values meet, following the natural growth direction. With a no. 1 round brush, tap a little of the edge of the red-orange over into the adjacent yellow. Let it remain a bit textured. Base the wing margins with Raw Umber + White. Edge a bit into the red with the chisel so they appear connected. Base the darkest values on the wings and body with Raw Umber. Base the lighter wing areas with Raw Umber + Raw Sienna. Base the light value on the body with Raw Umber + White.

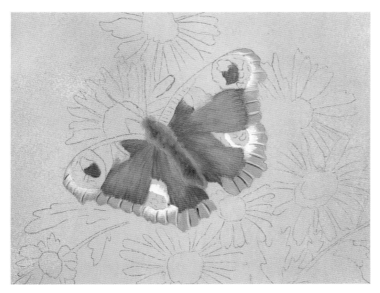

STEP THREE

Butterfly wings: Base White on the inner edges of the hindwings next to and slightly on the gray wing margin. Using a no. 1 round, stipple it into the gray wing margin creating a value gradation. Apply a partial band of white around hindwing eyespot. Add a lesser amount of White on inner edge of the gray in the apex of the forewings. Blend in the same manner. Add section lines with dirty White first, then Raw Umber to divide the gray wing margins.

STEP FOUR

Butterfly wings: With a little slightly-thinned French Ultramarine + White, lay a fine outline at the edge of the gray margins, using a no. 0 round. Use the corner of a dry no. 2 bright to edge the blue value into the gray a little. Highlight here and there on top of the blue outline with a lighter value of slightly-thinned White + Black, applied with the no. 0 round. With the chisel edge of a bright brush, streak the large red sections with Winsor Red + Cadmium Yellow Pale to obtain growth direction and a bit of texture. Add dark markings and outlines with Black + Raw Umber. On the forewing margin, base partially with the dark mix, leaving the edge irregular to interlock White into it later. Blend the dark inside eyespots just a bit into the red on the apex of the forewing. Allow the dark to connect just slightly to the edges of the red sections and the yellow sections where the colors meet.

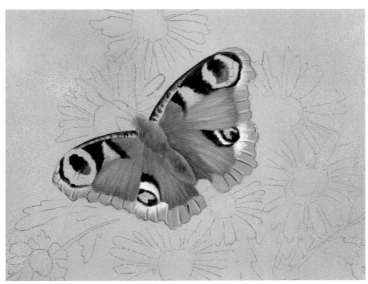

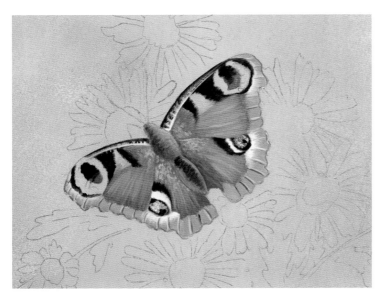

STEP FIVE

Butterfly wings/Body: Stipple the wings next to the body with Raw Sienna + White. The texture should be thicker closer to the body and become less concentrated away from the body. Base the hindwing eyespots with stippled French Ultramarine + White. Allow the stippling to barely soften into the edge of the dark "corner" of the eyespot. Finish by stippling in the lightest areas with a bit of White. Place a narrow band of White on the leading edge of the forewing with a no. 0 bright. Use the tiny chisel edge to tap White into the irregular edge of the black margin added in Step Four. Shade the abdomen with Black + Raw Umber. Highlight the thorax with Winsor Red + Cadmium Yellow Pale + White.

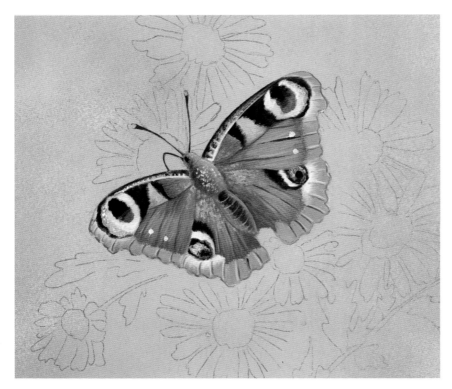

STEP SIX

Butterfly wings/Body: For the large eye-spots, base the outer half circle of blue with French Ultramarine Blue + White. Stipple with White to highlight. Base the rest of the circle with Cadmium Yellow Pale + White. Stipple with pure White to highlight. Base the small white spots on the wings with pure White, and make them very round. Set in section lines using the chisel edge of a no. 2 or 4 bright and Raw Umber. Tap the lines in, don't pull them. Allow them to vary in strength so some look naturally more faded than others. Stipple the body with dirty White using a round brush. Pull dirty white lines in half curves across the abdomen to indicate segments. With slightly-thinned Raw Umber on a no. 0 round brush, apply the antennae and proboscis. Tip the antennae clubs with a bit of Cadmium Yellow Pale.

STEP SEVEN

Flowers/Stems/Leaves/Calyxes: Base the dark values in the daisy petals with French Ultramarine + Winsor Red (3:1) + White. Base the dark values in the centers of the daisies with Raw Sienna + Burnt Sienna. Base the dark values in the leaves, stems and calyx with Black + Sap Green.

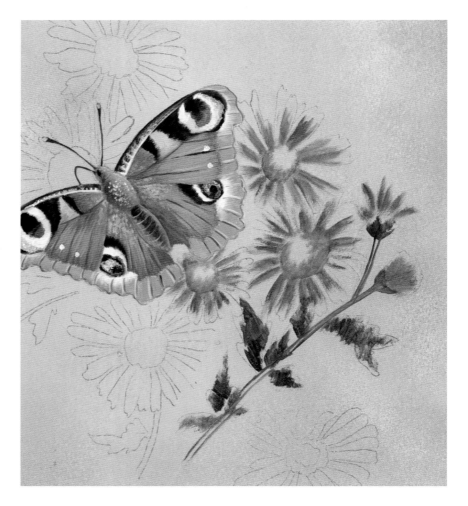

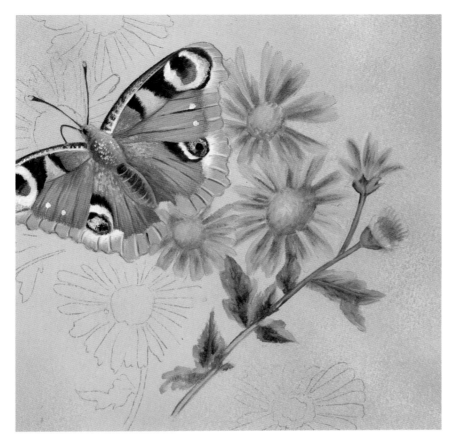

STEP EIGHT

Flowers: Base the light values on the daisy petals with White + French Ultramarine. Base the light values of the daisy centers with Raw Sienna + Cadmium Yellow Pale. Base the light values on the stems, leaves and calyxes with the previous green mix + Sap Green + White.

STEP NINE

Flowers: Blend between values on each daisy petal, using the chisel edge of a small bright brush. Do not overwork. Highlight the tips of most of the petals in light value areas with White and reblend. Don't highlight daisy petals that fall in the shadow areas. Shade where darker values are needed with French Ultramarine + Winsor Red. With a small bright brush, chop between the values in the daisy centers and on the bud. Strive for texture. Then using a round brush, stipple White + Cadmium Yellow Pale or White + Raw Sienna in the lightest part of the centers for more texture. With the flattened tip of a no. 1 round brush, tap the center highlights to soften. Blend within the leaves, stems and calyxes where values meet, using the chisel edge of a bright to establish the growth direction. Use the light value green mix for the center veins. Highlight some leaf edges with White + French Ultramarine and reblend.

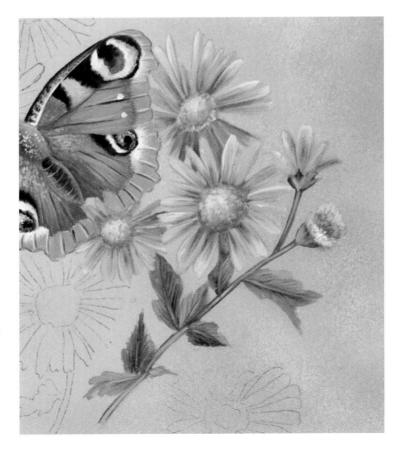

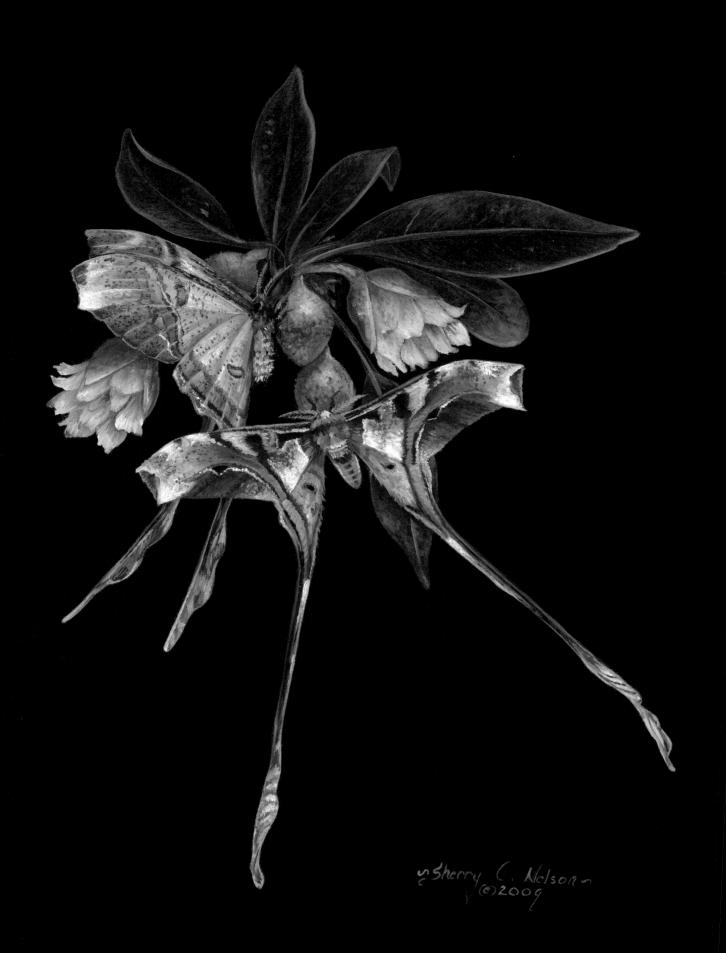

~Sherry C. Nelson~
©2009

PROJECT FOUR

Semiramis Tailed Silkmoth & Sapodilla

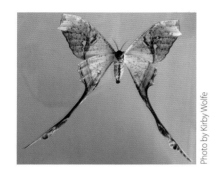

Photo by Kirby Wolfe

THE SEMIRAMIS SILKMOTH'S MOST impressive characteristic is the long tails of the male; the female's are considerably shorter but both have an average wingspan of about 4 inches (10.2cm). This silkmoth (*Copiopteryx semiramis*) flies late at night, preferring open fields and woodlands, in search of a mate, while females emit a pheremone that can be detected at great distances to attract the males. The caterpillars use host plants of the *Sapotaceae* family, of which *Manilkara chicle*, the tree that is the source of chicle for chewing gum, is one. The moths are painted here on a host plant, Sapodilla, which produces a very sweet fruit.

OIL COLOR MIXES

Black + Raw Umber + White

White + Black + Raw Umber + Raw Sienna

Burnt Sienna + Raw Sienna

Raw Sienna + Raw Umber

Raw Sienna + Cadmium Yellow Pale + White + Raw Umber

Black + Raw Umber

Burnt Sienna + Raw Umber

White + Black + French Ultramarine + Alizarin Crimson

Burnt Sienna + Raw Sienna + Winsor Red + White

Sap Green + Raw Sienna + White

Black + Sap Green

Sap Green + White

White + Burnt Sienna + Raw Sienna

Burnt Sienna + Winsor Red

Burnt Sienna + Winsor Red + Raw Umber

White + Raw Sienna

Sap Green + Cadmium Yellow Pale + White

Black + Sap Green + White

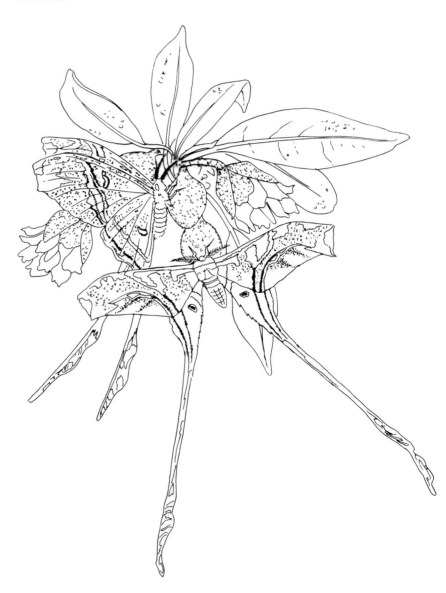

Enlarge at 133% to bring up to full size. Transfer this line drawing to your prepared background, using white graphite paper.

MATERIALS & BACKGROUND

Surface:
11x14-inch (28cm x 36cm) hardboard panel, 1/8-inch (3mm) thick

Delta Ceramcoat acrylic paints:
Black

Winsor & Newton Artists' Oils:
Ivory Black

Titanium White

Raw Sienna

Raw Umber

Burnt Sienna

Sap Green

Cadmium Yellow Pale

Winsor Red

Alizarin Crimson

French Ultramarine

Brushes:
nos. 0, 2, 4, 6, 8 red sable brights

nos. 0 and 1 red sable rounds

Background Preparation:
Base the hardboard panel, using a sponge roller, with Black acrylic. Let dry. Sand well. Rebase with Black acrylic. Let dry, rub with fine steel wool or a non-scratch sanding pad. Spray with Krylon Matte Finish, #1311. See page 14 for more information on preparing the surface.

STEP ONE

Female moth: Use these mixes for the basecoats on the wings, tails and body: Dark blackish values: Base with Black + Raw Umber. Medium value gray sections: Base with White + Black + Raw Umber. Rusty patches and sections: Base with Raw Sienna + Burnt Sienna. Creamy white sections: Base with a warm off-white made with White + Black + Raw Umber with a bit of Raw Sienna if needed for warmer tone. Golden brown sections, trailing edge and bands on body: Base with Raw Sienna + Raw Umber + Cadmium Yellow Pale + White. Bottom edge of wing next to body: Base with Raw Sienna + Raw Umber.

Body: From top, base bands or sections of the following mixes in this order: blackish mix, then medium gray, then golden brown, then creamy white, another band of blackish mix, then golden brown, then gray, then golden brown and finally tip with gray.

STEP TWO

Female moth: On the wings and tail, blend where values meet, just enough to connect the sections. Then place the following shading and highlight mixes: On medium value gray sections: Highlight with White. Rust areas: Highlight with the creamy white used as the basecoat mix. On creamy white sections: Shade with Raw Sienna + Raw Umber on hindwing. Highlight all with White. Golden brown areas except margin: Shade with Raw Umber. Highlight with White. Golden brown margin: Shade with Raw Umber + Raw Sienna. Section lines: With chisel edge, lay in off-white lines in gray and rust and golden brown areas.

Window: The gray double spot inside the forewing cell is actually a translucent window. Add a narrow irregular band of Raw Sienna + Raw Umber to the left of it.

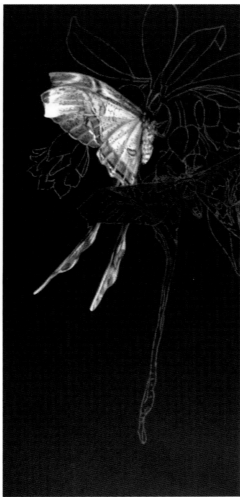

STEP FOUR

Female moth: Detail between the white, gray and golden brown sections with irregular narrow bands of color applied with round brush and slightly-thinned paint so they act as dividers between values. Use Raw Umber for the dark borders around the windows, Raw Umber + Raw Sienna (between white and gray) and dirty White detail lines on the hindwing margin.

Highlight the apex of the forewing with strong White; stipple to blend. Highlight within the gray "windows'" so they look more translucent, and wherever extra spark is needed.

Blend between the color bands on the abdomen. Highlight with off-white. Detail the head and legs with dirty White.

Add the many dots on the wings using very thin Raw Umber and Raw Umber + White applied with a no. 0 round brush.

STEP THREE

Female moth: In all wings, soften the white section lines so they become less distinct. In the hindwing, for example, blend a portion of each white section line from the line downward, letting the color highlight the gray band, the white sections and the brown margin. When all are finished, the wing will look ridged rather than flat, enhancing the form. Blend a bit more where values meet so the varied sections appear more connected.

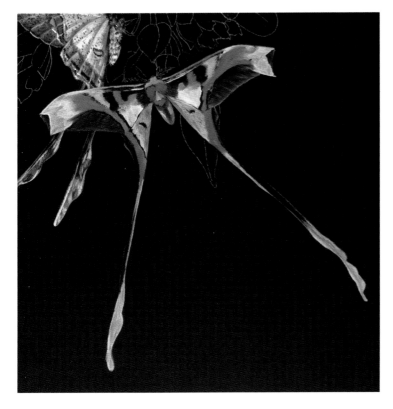

STEP FIVE

Male moth: Use these mixes for the basecoats on the wings, tails and body: Dark blackish values: Base with Black + Raw Umber. Dull violet bands: Base with White + Black + French Ultramarine + Alizarin Crimson. Golden brown sections: Base with Raw Sienna + Cadmium Yellow Pale + Raw Umber + White. Creamy white sections: Base with a warm off-white made with White + Black + Raw Umber with a bit of Raw Sienna if needed for warmer tone. Medium value gray sections: Base with White + Black + Raw Umber. Dark reddish brown sections: Raw Umber + Burnt Sienna. Base the light values within the reddish brown sections on the trailing edges of the wings with Raw Umber + Raw Sienna.

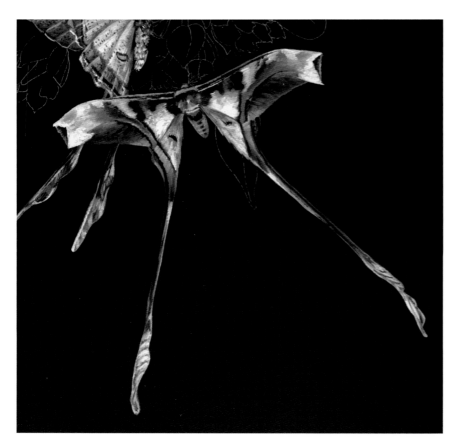

STEP SIX

Male moth: Blend on wings where colors meet if they form a gradation. If not, use the chisel edge to slightly connect the various sections. Dull violet bands: Shade with Raw Umber. Highlight with White. Golden brown sections: Shade with Raw Umber. Highlight with White + Raw Sienna. Dark red sections: Connect to adjacent colors with irregular chisel blends. White sections: Highlight with White. Underwing: Highlight with Raw Sienna + White.

Tails: Place crosswise narrow bands of dark gray. Add rusty detail markings with Burnt Sienna. Highlight in between gray bands and along inner edge of tails with White.

Body: Shade head with Burnt Sienna. Highlight thorax with White. Pull curving lines across abdomen with dirty White to suggest segments.

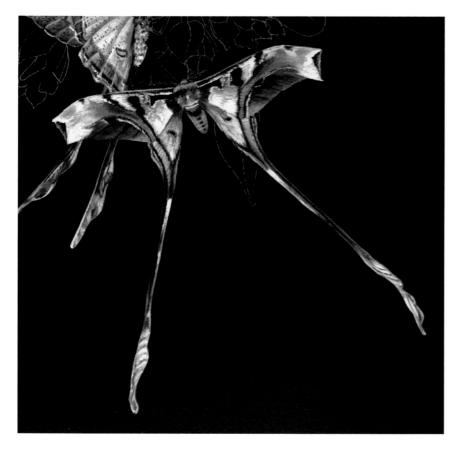

STEP SEVEN

Male moth: On the wings, blend the White highlights placed in the previous step. Add irregular, messy White detail lines on all wings with slightly-thinned White applied with a no. 0 round. Add irregular bands of Raw Umber + Black to divide sections, using a round brush and slightly thinned paint. Shade the underwing and add dark section lines with Black + Raw Umber. Outline the "windows" with Burnt Sienna on the hind-wings and dirty White under the curve of the forewing.

Tails: Highlight at top of tails with White.

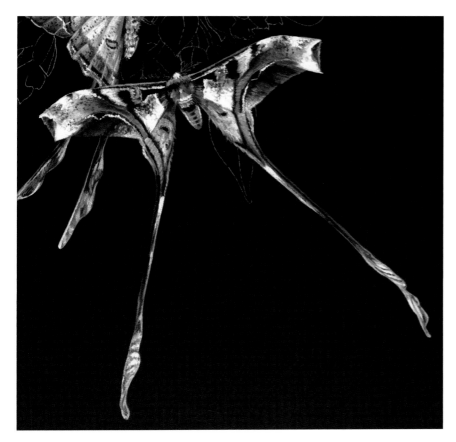

STEP EIGHT

Male moth: Stipple the dull violet apexes on the forewings with slightly thinned dull violet mix + more Black. Stipple the underwing with Black + Raw Umber around and on the dark section lines. Stipple the strongest whites with more White for final highlights. Stipple golden brown areas with Raw Umber + Burnt Sienna.

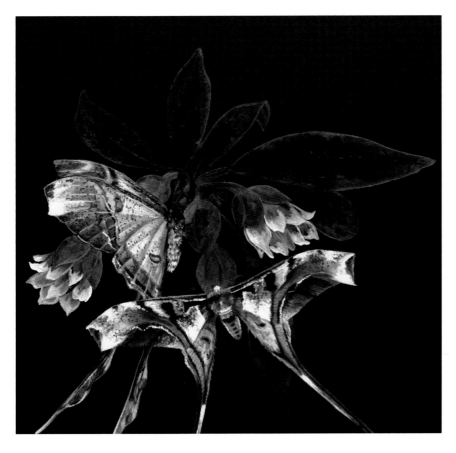

STEP NINE

Fruits and Calyxes: Base the dark values with Burnt Sienna + Raw Sienna + Winsor Red. Base the light values with Sap Green + Raw Sienna + White.

Blossom petals: Base the dark values with Black + Sap Green + White. Base the light values with White.

Style: Base with Sap Green + Raw Sienna + White.

Leaves: Base the dark values with Black + Sap Green. Base the light value around the outer leaf edges with Sap Green + White.

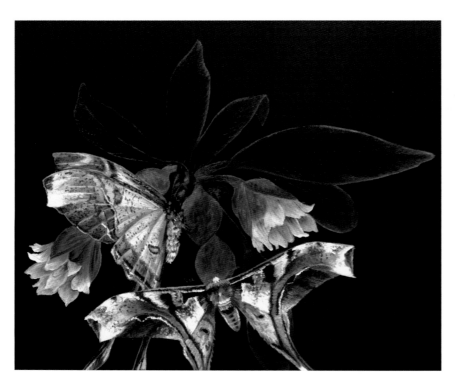

STEP TEN

Fruits and Calyxes: Blend with choppy strokes with the growth direction where values meet.

Blossom petals: Blend with choppy strokes with the growth direction where values meet.

Leaves: Blend where values meet, with the lateral growth direction, using the no. 6 bright.

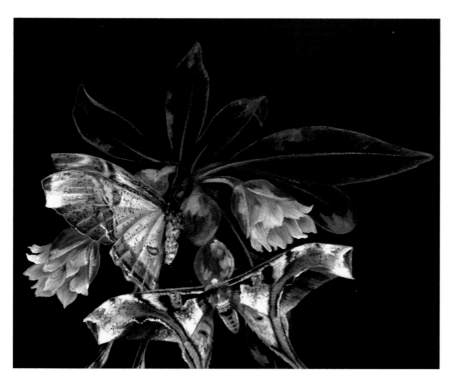

STEP ELEVEN

Fruits and Calyxes: Apply rough, choppy highlights with White + Raw Sienna using a no. 2 bright.

Blossom petals: Highlight with White.

Style: Highlight with White. Blend to soften.

Leaves: Highlight with Sap Green + Cadmium Yellow Pale + White.

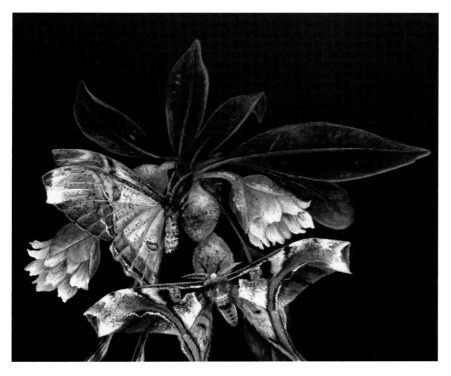

STEP TWELVE

Fruits and Calyxes: Blend where values meet, using the same choppy stroke of the no. 2 bright. When all are blended, soften by stippling in the strongest highlight areas with White + Raw Sienna, using a no. 1 round brush. With the flattened tip of the round brush, soften the highlights. The Sapodilla fruits are "scurfy," meaning they have a fuzzy, flaky surface coating, which we want to indicate with the casual blending. (The "scurf" is rubbed off before the fruits are washed for eating!)

Blossom petals: Apply White highlights, then with a small brush, roughly blend, allowing them to be textured.

Leaves: Blend the highlights with the growth direction. Establish the vein structure with the light green mix. With the light mix, add some surface interest on the leaves, patting and chopping here and there to add detail. Accent with Burnt Sienna + a bit of Winsor Red and reblend.

Moth legs/antennae: Allow the fruits to dry before adding the moths' legs and antennae. Use slightly-thinned Black + Raw Umber for the legs, applying with a round brush. Place the antennae shaft with Raw Umber. With the no. 0 round, use a thinned mix of Raw Sienna + Burnt Sienna + White to pull the short feathery strokes on each side of the shaft line.

STEP THIRTEEN

Fruits and Calyxes: When the painting is dry, rub a little Burnt Sienna + Winsor Red into the fruits to enhance the color.

Blossom petals: Use Burnt Sienna + Winsor Red to accent the tips of the petals. Blend a little between accent and basecoat. These rich touches of color make a big difference—compare this final step with Step Twelve above.

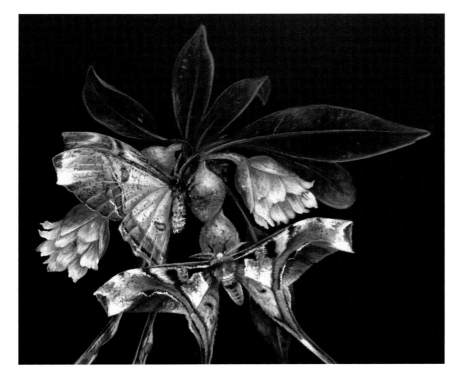

Index

The Best in Art Instruction is from North Light Books!

Painting Songbirds with Sherry C. Nelson

No one paints the beauty and grace of birds quite like Sherry Nelson. In this inspiring guide, Sherry reveals the secrets of her signature painting style, showing you how to capture every feathery feature of 15 delightful songbirds. Whether you're a beginning painter or skilled artist, you'll enjoy painting a range of beautiful and popular birds, including robins, wrens, sparrows, doves, meadowlarks, scarlet tanagers, painted buntings and more.
ISBN-13: 978-1-58180-876-6, ISBN-10: 1-58180-876-3, paperback, 144 pages, #Z0231

Painting Flowers A to Z with Sherry C. Nelson

When it comes to painting flowers, Sherry Nelson definitely has a green thumb! In this handy reference guide, Sherry shows you step by step how to create the realistic shapes and textures of 50 of your favorite flowers. Each demo includes a clear reference photo, traceable line drawing, and complete color mixing chart. Then follow along as Sherry paints each beautiful bloom in 4 to 6 easy steps. You'll find all your favorites here, from azaleas to lilacs, orchids to peonies, roses to zinnias. Bonus demos show how to pull your floral paintings together into gorgeous compositions of mixed bouquets.
ISBN-13: 978-0-89134-938-9, ISBN-10: 0-89134-938-3, paperback, 144 pages, #31534

Brilliant Color: Painting Vibrant Outdoor Scenes

Let go of what you see, and paint what you feel! *Brilliant Color* reveals a new way of thinking about color, empowering you to push the envelope beyond ordinary realism into bold landscapes full of life and energy. Award-winning artist Julie Gilbert Pollard shows you how to liberate your use of color from run-of-the-mill color choices. Simply follow along with 10 complete demonstrations in oils over acrylic underpaintings. Color wheels, diagrams and side-by-side visual comparisons make learning easy and fun!
ISBN-13: 978-1-60061-058-5. ISBN-10: 1-60061-058-7, paperback, 144 pages, #Z1677

Naturescapes: Innovative Painting Techniques Using Natural Materials

Bring your acrylic paints and some flowers from your garden—let master artist Terrence Lun Tse show you how create the most ethereal and stunning nature paintings you've ever seen. Terrence introduces a unique new way to paint that is fun and satisfying. Artistic expertise and brush control are not required—just your creativity and some natural materials from your own backyard. Fifteen step-by-step demos show you how easy it is to create nature paintings for all four seasons.
ISBN-13: 978-1-60061-794-2. ISBN-10: 1-60061-794-8, paperback, 128 pages, #Z5253

These books and other fine North Light titles are available at your local arts and crafts retailer, bookstore or from online suppliers, or visit our Web site at www.artistsnetwork.com.